VISIONS OF ILLINOIS

A series of publications
portraying the rich heritage of the state
through historical and contemporary works
of photography and art

Books in the Series

Prairiescapes
Photographs by Larry Kanfer

Nelson Algren's Chicago
Photographs by Art Shay

Stopping By
Portraits of Small Towns
Photographs by Raymond Bial

Chicago and Downstate
Illinois as Seen by the Farm Security Administration
Photographers, 1936–1943
Edited by Robert L. Reid and Larry A. Viskochil

The Many Faces of Hull-House
The Photographs of Wallace Kirkland
Edited by Mary Ann Johnson

Beneath an Open Sky
Panoramic Photographs by Gary Irving

Billy Morrow Jackson
Interpretations of Time and Light
Howard E. Wooden

BILLY MORROW JACKSON

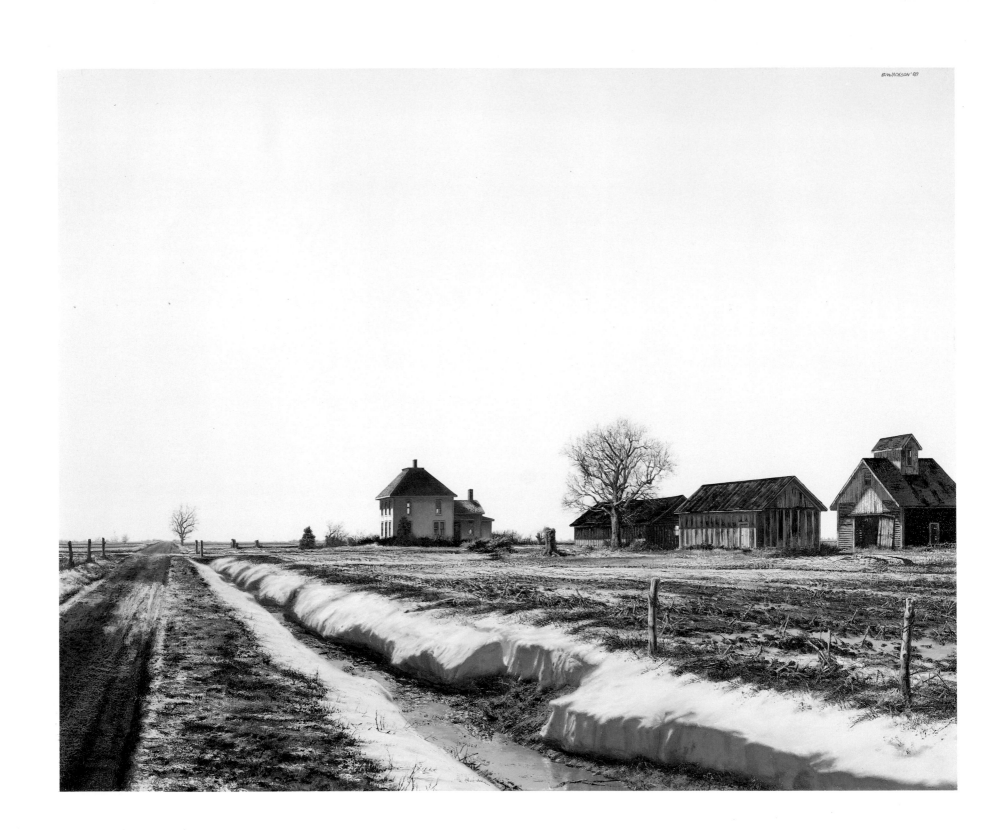

Beyond Kankakee, 1989

BILLY MORROW JACKSON

Interpretations of Time and Light

Howard E. Wooden

UNIVERSITY OF ILLINOIS PRESS *Urbana and Chicago*

Publication of this work was supported in part by a grant from
the Illinois Arts Council, a state agency.

Library of Congress Cataloging-in-Publication Data

Wooden, Howard E.
 Billy Morrow Jackson : interpretations of time and light /
Howard E. Wooden.
 p. cm.—(Visions of Illinois)
 ISBN 0-252-01735-8
 1. Jackson, Billy Morrow—Criticism and
Interpretation.
 I. Title. II. Series.
 N6537.J29W6 1990
 760′.092—dc20 90-10826
 CIP

To my wife, Virginia

Contents

Preface

It was in the very late 1950s that I first became acquainted with Billy Morrow Jackson and with his paintings and prints, which even in those early years were quite remarkable. By then Jackson had to his credit at least ten active and quite successful years of experience as a professional artist. He was especially respected as a printmaker; indeed, his prints had been exhibited widely and had been acquired for numerous private and public collections, including the Library of Congress and several major museums. In addition to producing superb black-and-white prints, he also had begun to execute a number of most interesting color woodblock reduction prints. In terms of his enviably refined draftsmanship, and from the manner in which he interpreted light and employed color relationships, these works clearly spoke to his future as an artist of major consequence.

Although Jackson demonstrated eminent skill as a printmaker, his real interest was in painting. In his early paintings he was readily able to capture the flavor and the deeper significance of the natural setting and of the human experience, elements that would obsess him throughout his career. But he also experimented with style and technique and content, and it was through his experimental ventures and his patience that a remarkable manner of painting unfolded. Jackson carefully observed and developed an intelligent understanding of incidents in everyday experience and then skillfully used his art as a vehicle for communicating the character and universal meaning of the human condition in general.

To make his statements, Jackson turned directly to the human setting, which he presented in a fully recognizable, representational manner, rather than adopting the devices of an expressionistic vision that had gained wide currency during his formative years (and which he himself had once practiced). However, he soon focused his attention exclusively on painting scenes of everyday activities, both indoor and outdoor, and views of the natural setting, with human beings sometimes physically present and other times simply inferred. But his works are not simple transcriptions that aim to document events or places in literal illustrational terms. His subject is always humanity—so evident in the very early works that derived from his visit to Mexico and so characteristic of his artistic output to the present day.

In the text that follows, an interpretation of Jackson's works is presented largely from an art historical standpoint. Specifically, my objective has been to trace the development of his style and technique while commenting on his thematic types and their uses. I have also endeavored to show how thematic content and aesthetic form are interdependent entities that have less to do with communicating factual data regarding issues of contemporary interest and far more to do with expressing the deep and most fundamental human feelings of the epoch in which they are produced. Without doubt, it is to those feelings that Jackson has always been so very intelligently sensitive. And it is in those terms that his place in American art has been established.

Over a period of more than forty years, Jackson has produced an enormous quantity of competent works, a representative selection of which is reproduced here. Many of his works are among the holdings of private collections in scattered locations across the country. And, of course, over the years museums and other art institutions have acquired major pieces for their permanent collections. To all of the collectors, both private and public, I extend my warmest appreciation for the active cooperation and interest they have demonstrated, and most especially for their generosity in allowing their treasured works of art to be illustrated in this book.

Several individuals in particular deserve special recognition for their kind assistance. Billy Morrow Jackson has, of course, cooperated quite fully. Fortunately, he has retained a selection of early exhibition catalogs and brochures, newspaper and magazine clippings, and other invaluable documents, all of which he willingly placed at my disposal. I am very much beholden to Jackson's most competent and energetic gallery dealer, Jane Haslem, president of the Jane Haslem Gallery in Washington, D.C., who has ably represented him for more than twenty-five years. She has been indispensable to this endeavor, graciously making available to me her extensive library of photographs and a wealth of factual data without which so many problematic details could never have been satisfactorily unraveled. Allen S. Weller, professor emeritus of art and design at the University of Illinois at Urbana-Champaign and director emeritus of the Krannert Art Museum, has my deepest gratitude for his wise counsel and for the interest and cooperation he so consistently displayed as this project unfolded. After reading an early version of the manuscript, he furnished the most helpful and lucid comments I could ever have hoped to receive.

There are, of course, others whose expertise and cooperation contributed enormously to this undertaking. In particular I wish to acknowledge the many photographers—and most expecially Henry Nelson, staff photographer of the Wichita Art Museum—for their outstanding technical skills so evident in the photographic reproductions of Jackson's works that are included in this book. Similarly, I owe a debt of gratitude to my University of Illinois Press editor, Theresa L. Sears, for her tireless efforts, her enviable patience, and her sound insights . . . and certainly for her well-directed imagination and her keenly critical eye. It has been my privilege to work with her. I also extend gratitude to Richard Wentworth, director of the Press, and to other members of his progressive staff for their capable input.

I am honored at this time to acknowledge the keen vision of the late H. Lester Cooke, who was curator of painting at the National Gallery of Art in Washington, D.C., at the time of his death eighteen years ago. Lester Cooke was a cherished personal friend of mine, and for many years it was he more than I who recognized Jackson's potential as a representational artist of sensitivity and mastery.

Finally, I openly confess that I have never undertaken a project of this scope without the active participation and loyal assistance of my wife, Virginia. She has supported this particular effort in so very many respects—but most especially by her sincere admiration of Jackson's art. If my memory serves me correctly, she met Jackson and his family shortly before I did, and she advised me to keep my eye on this promising young artist. That was advice well taken.

Howard E. Wooden
Wichita, Kansas

BILLY MORROW JACKSON

Beginnings

Billy Morrow Jackson has won acclaim in the world of art for his highly developed technical virtuosity, his creative talents, and his professional discipline, all of which have resulted in enviable successful aesthetic achievements over a period of four decades. As an artist, he is widely recognized by virtue of his profoundly sensitive feeling for life and his dedicated confidence in the human spirit. He treasures nature and respects tradition but vehemently protests against hypocrisy, bigotry, brutality, and all manifestations of social injustice and discriminatory behavior. A thoroughly progressive thinker, his philosophy of life has constituted the very essence of his art, both thematically and stylistically, throughout every stage of his career.

Jackson is known as a realist, but that term is basically inadequate and, in truth, fully inaccurate. Admittedly, he is a representational artist who produces recognizable imagery and whose images derive directly from reality. But he is not a copyist or an imitationist; he never paints in a photographic manner. Indeed, like all true artists, he creates works that are basically abstractions in the sense that the dynamics of each of his paintings, drawings, or prints issue from a system of geometric relationships that include the interaction of compositional elements, a varying degree of physical distortion, and a powerful psychological component—which in Jackson's case constitute the strongest and most meaningful aspects of all his work.

Born in Kansas City, Missouri, in 1926, Jackson displayed considerable competence in sketching as a young child. But he received little encouragement from his family, for his formative years coincided with the years of the Great Depression, when funds were scarce for anything beyond the barest necessities. On the advice of an elementary school teacher, however, he was enrolled in Saturday art classes conducted by the Nelson Gallery in Kansas City. Thus began his first formal instruction in drawing, albeit temporary and brief.

Jackson was twelve years old when his parents divorced. His mother later remarried, and in 1941 the family moved to St. Louis. While still in his teens, Jackson became employed; he also enrolled in night classes at Washington University, where he studied drawing under the noted artist Fred Conway and made admirable progress. In 1944, at the age of eighteen, he enlisted in the Marines and served as a rifleman in Okinawa. Twenty months later, after suffering extreme combat fatigue, he was honorably discharged. The war over, Jackson returned to St. Louis and resumed his studies in art at Washington University.

It was during his undergraduate years at Washington University that he was much influenced by another of his teachers, Max Beckmann, the internationally famous German expressionist who had recently emigrated to America and accepted an appointment as artist-in-residence at the university's School of Fine Arts. As a teacher, Beckmann was highly disciplined and uncompromising in his demands on his students. His own painting style was characterized by the use of strong colors and bold, slightly distorted forms, vigorously drawn with dark, broad outlines—one of the stylistic features that quickly caught Jackson's attention and appears in many of his student exercises of the late 1940s. Beckmann also emphasized the importance of learning to draw the nude human form, which he fittingly regarded as a living landscape rather than simply a naked body. Undoubtedly, his teachings account in no small measure for Jackson's early mastery in drawing the nude and his interest in employing the nude as a thematic vehicle for conveying deep human emotions. Indeed, the nude would assume a prominent compositional role in Jackson's oeuvre.

Even as a student, Jackson showed exceeding promise in modeling the human form in general and in handling varying surface textures as well as body folds and flesh tones. As early as 1948, one of his more typical nude paintings (fig. 1) was reproduced in the school catalog. In addition to his interest in drawing the isolated human form, he also produced a number of rather whimsical student compositions, including several small murals that focus largely on circus themes containing sideshow illustrations (fig. 2), directional arrows, informational signs, and mannequinlike figures, all of which today bring to mind aspects of the efforts of pop artists in the late 1950s and early 1960s.

Shortly after receiving his B.F.A. degree from Washington University in 1949, Jackson married Blanche Trice. With meagre savings accumulated from various odd jobs, as well as occasional minor commissions undertaken as a student, Jackson

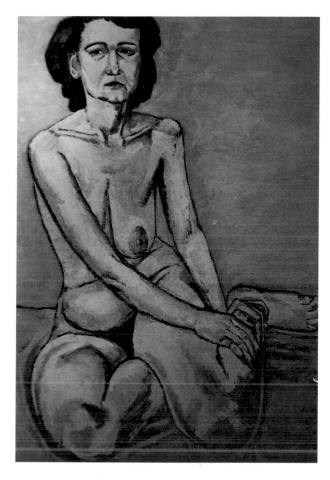

1. *Nude,* 1948

and his wife were able to leave St. Louis in 1949 and spend the next several years first in Mexico and thereafter in southern California. The Mexican experience had a sobering impact on both of them, for they saw the Mexicans as a kind and gentle people, but also as a people who suffered extreme poverty, deprivation, and oppression. The pathos Jackson felt was sensitively registered throughout the art he produced in Mexico and more particularly during the several years following his return to the United States.

During his stay in Mexico, Jackson began a series of quite handsome and exciting woodcuts and linocuts, which he finished only after his return to this country. All of these clearly reflect the German expressionist manner Beckmann had consistently stressed in studio instruction; indeed, Beckmann's influence lingered on in Jackson's work for quite a while. It is entirely evident from the prints Jackson produced that he was well acquainted with Beckmann's own early woodcut style.

Jackson's woodcuts are as striking in vitality and as thematically gripping to the viewer as are those by Beckmann. His imagery is, of course, completely representational, but at the same time the bulky and overemphasized human features, and especially the large almond-shaped eyes found in Jackson's works, readily impart an iconic power that commands immediate viewer attention and suggests the artist's sensitive awareness of indigenous pre-Hispanic forms. In every instance the prints are rendered with technical precision in broad, flat, two-dimensional patterns, showing a consciously intended economy in the modeling as

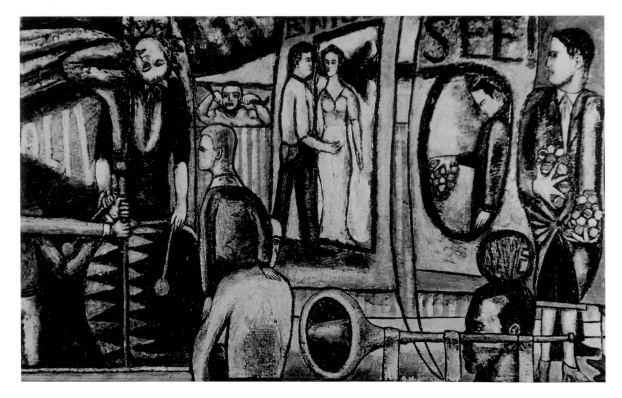

2. Detail from *Circus Mural*, 1949

well as in the treatment of detail. At the same time, there is a lively interplay of curves and angles and a corresponding contrast of broad areas of black and white.

As a series, these woodcuts offer accurate documentation of the colorfully entertaining, but often disenchanting, scenes of everyday peasant life on the streets of Mexico—from the toy vendor and the serenading beggar to the blind vocalist, the fire-eater (fig. 3), and the tragic street spawns

(fig. 4), who with abandon, night after night, play out their bizarre and sadly meaningless lives. During 1951 and 1952, after his return to the United States, and for several years thereafter, Jackson entered many of these woodcuts in the graphics section of numerous regional and national exhibitions, receiving major awards ranging from honorable mention status to top prize.

Toward the close of his stay in Mexico, and during 1951–52, which he spent in California, Jackson continued to produce prints, especially lithographs, that also reflect the lingering influence of Beckmann. Among the most compelling of his lithographic images from this period is an extraordinarily dramatic work titled *Lost Child* (fig. 5), which he drew in 1951. A year or so later, Jackson settled in Champaign, Illinois, but for quite a long time he was inspired by his experiences in Mexico and southern California. Indeed, in Champaign he produced a remarkably sophisticated series of etchings, one of which, *Birth of La Ventosa* (fig. 6), executed in 1953, was subsequently acquired by the Library of Congress.

By 1951, Jackson clearly had begun to establish himself in the world of art. Although he continued to execute many prints, his principal interest was actually in painting. He had already focused efforts on some rather large, complex oil and encaustic paintings, which generally consisted of close-up views of Mexican subjects. Stylistically, these are reminiscent of his earlier black-and-white woodcuts and are invested with symbolism that effectively reinforces the poignancy of the subject matter. One portrays a blind Mexican child; another, a young Mexican newsboy (fig. 7) who is blowing bubbles while supporting himself on a crudely carved wooden crutch that is tucked beneath his right shoulder. Both of these works, like other, similar paintings in the series, record grievous aspects of what Jackson had seen and been inspired by in Mexico—visions from which he could never escape.

Jackson treasured these paintings and continued to work on many of them over the next several years, even after his return to the Midwest in 1952. Apparently, he spent only a brief period in St. Louis, but while there he produced a large-scale mural study of the city (fig. 8), for which he received second prize in the mural design section of an exhibition sponsored by the St. Louis Artists' Guild. Jazz musicians, steamboats, bridges, churches, stop signs, and telegraph poles are among the vast inventory of landmark features he introduced to create a montagelike assemblage of what he felt most fittingly served to identify the city where he had first systematically studied art.

The next step for Jackson was to undertake additional study in what he knew would be his lifelong profession. Thus, in the autumn of 1952, he and his wife and their recently born son settled in Champaign, where Jackson enrolled in the graduate school of the fine arts department at the University of Illinois.[1] What he did not know was that, once he had received his graduate degree, he would join the university faculty and remain there until his retirement thirty-three years later.

3. *Fire Eater, Mexico,* 1950

4. *Street Spawn*, Mexico, 1950

5. *Lost Child, Mexico,* 1951

6. *Birth of La Ventosa*, 1953

7. *Mexican Newsboy with Bubbles,* c. 1951

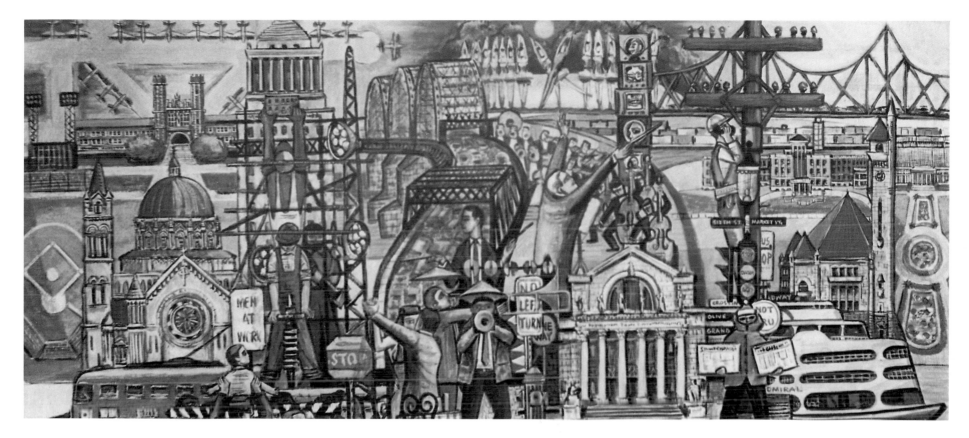

8. *Mural Study: St. Louis, Missouri,* 1952

2

Understanding the Self

During his undergraduate years at Washington University, and in the years spent in Mexico and California, Jackson had focused little or no attention on landscape painting or on thematically naturalistic work in general. When he entered graduate school at the University of Illinois in 1952, he fell under the influence of teachers who were energetically pursuing the prevailing expressionistic idioms of the day. Momentarily, Jackson appeared to be in tune with the times, so to speak. Without doubt, many of the paintings and prints he produced during the three year period 1952–55 were enviable, creditable accomplishments that display an entirely sympathetic appreciation for the contemporary manner he was assimilating from his instructors. Among these works are the engraving *Conjur Man* and the oil painting of the same name, as well as several other oils, including *Blue Note,* executed in 1953–54. But his most important achievement of this period was his M.F.A. thesis painting, *Duet* (fig. 9), which he completed in 1954.

Duet, a large, impressive work, portrays a drummer, a jazz horn player, a piano man, and a dancing female figure. Powerful light floods the composition, which is filled with bright, airy spaces and glowing colors. Although a debt to Philip Guston is surely evident, especially in terms of figural distortions, the composition itself has individual merit and deserves careful scrutiny for us to fully comprehend and appreciate the multiple forces that in the end contributed to Jackson's artistic development.

When he submitted his thesis painting, Jackson was required to furnish a written report as well. That report, though concise, provides penetrating insights into his basic philosophy of art and the direction much of his future work would take. In it Jackson emphasizes that the essence of painting in general is not to be found in the anatomy of composition but in the "personality" of the painting, in "the breath . . . the livingness." He advises that "the elements, the grammar in painting" should be "dominated by the total expression," or what he calls the "prayer" of a painting.[2]

A second, related aspect of his discussion concerns the thematic elements themselves: in the case of Duet, the drummer and the man with the horn. Jackson acknowledges that they "are important only as a means to an end; the subject might just as well be stop lights, card players, locomotives, a landscape, or a side of beef. As words are in poetry so are certain 'props' . . . in painting. . . ." He also considers subject images in terms of their symbolism, classifying the horn man as somber, muted, melancholy, or, more particularly, as the "presence of measured doom," a "veiled anticipation." By contrast, he regards the drummer as an expression of the complex rhythm of life. The two are thus symbolically opposing poles, or, in Freudian terms, the coexistence of life and death—which Jackson refers to as symbiosis. He acknowledges, however, that it is the observer who determines the interpretation given to this coexistence. He thus justifies relative in-

terpretations, and in so doing initiates the use of equivocation and ambiguity, which he introduces into so many of his later works.

From a stylistic standpoint, Jackson's abstractions are far removed from the work for which he has become widely known today. Yet Duet, as well as all of his abstractly visionary work of the early 1950s, helped him discover himself as an artist and find direction in his professional career. He continued to learn about color and composition, and he was gaining entirely new insights into the role of light, not only as a source of illumination and a means of defining form, but also as an autonomous compositional entity.

Soon after receiving his degree in 1954, Jackson was appointed to the teaching faculty of the art school at the University of Illinois. Over the ensuing two or three years, he gradually abandoned his expressionistically distorted mode of painting and began to paint clearly recognizable subjects. However, under the influence of Abraham Rattner, who was briefly on the university faculty, Jackson also experimented with built-up mosaic surfaces of irregularly shaped, jewel-like patches of bright, contrasting pigments (fig. 10). At the same time, he often made use of a free and loose technique, imparting a sweeping exuberance to his compositions by means of bold impasto, as so effectively expressed in Still Life with Postage Stamp (fig. 11), one of the more interesting works from about 1955.

In a very real sense, Jackson soon reached a dead-end, or so he thought. He recognized that his works possessed a formal vitality but that they lacked any naturalistic impact—a quality he most wanted to discover and to employ thereafter as a basis for self-expression.

A 1957 grant application submitted to the university for summer research funds represented Jackson's call for a return to regionalism: "The Central Illinois Landscape as Subject Matter for Contemporary Art." One year later, in an expanded grant request, he presented his case more firmly by stating that "regionalism in contemporary art seemingly is being ignored or almost wholly neglected by the painter and printmaker. His personal identity to his immediate environment and his intimate reaction to it are playing a minor role. . . ." The essence of Jackson's claim was simply that the artist must identify with "direct visual experience."[3]

This approach was a marked departure from existing contemporary trends. Indeed, in hindsight it seems almost revolutionary in that Jackson's statements were made in a moment of serious cultural anxiety during the height of the abstract expressionist movement in postwar America.

Jackson himself was fully progressive in his general philosophic outlook. Throughout the previous decade he had been professionally associated, directly or indirectly, with such avant-garde artists as Fred Conway, Paul Burlin, Max Beckmann, Philip Guston, and Abraham Rattner—men who often preached and taught what appeared to be rather extremist aesthetic doctrine, essentially in diametric opposition to traditional regionalism in art. Equally interesting, however, is the fact that Jackson still acknowledges that he grew professionally as a result of his serious approach to abstractionist theory and practice during his early years. He regards that period objectively, as a time of intense, often jolting experimentation that nevertheless was a formative experience through which his aesthetic vocabulary developed and was refined.

It must be noted that Jackson also appears to have regarded the international abstract art movement as an unnecessarily prolonged experiment. In several project proposals submitted for summer research during the late 1950s, he repeatedly argues that "one tires of tireless experiments and yearns for a more meaningful and total human experience."[4] That echoes the conviction of an increasing number of artists of the same period who, during the ensuing decades, have come to acknowledge that so many of the various modes of "realism" encountered today are largely based on, if not entirely derived from, the tenets of abstractionism formulated in the 1950s.

In the end, Jackson may have abandoned his experiments in abstractionism out of a sense of boredom, though he could hardly abandon experimentation altogether. Indeed, his yearning for "total human experience" as a condition of artistic creation, and his devotion to the natural image and the natural event, inevitably demanded more and more experimentation in the form of painstaking explorations of nature, of the world around him. Jackson followed numerous directions, at one point turning to the seminatural setting of landscapes with foreground views of strange twisting roads and road direction signs, telegraph poles, and billboards (fig. 12). In these compositions, hills, houses, and farmlands are introduced in the distance, but the landscape setting itself is invariably presented as having been invaded and almost totally obscured by a chaotic collage of banality that the roadway characteristically invites as it functions to capture the traveler's attention.

In viewing Jackson's work of that period, we tend to see prototypical examples of pop art. Yet the intrusion of banality, with its often deplorably destructive impact on the environment, afforded Jackson an opportunity to discover the natural setting itself, as well as its compositional potential. As a result, he promptly began to look increasingly closely at the prairie, with its beckoning flatlands, distant houses, farms, and occasional trees.

It is especially interesting that, for an extended period of time, Jackson was captivated by trees. Both in the paintings and the prints executed during his early Illinois teaching years, he repeatedly used the image of heavy clusters of trees, some in bloom, others barren; some in thick, wavy daubs of green impasto (fig. 13), others with tall thin trunks, grouped closely together and capped by mazes of dark, intertwining branches silhouetted against a vast embracing sky. He also executed a number of color woodblock prints, most notably *Rocks and Roots* (fig. 14), which depicts the base of a large tree with exposed, twisted roots. It is evident that he had closely examined the basic anatomy of tree roots, including the way they penetrate deeply into the earth and become entangled with whatever pebbles, stones, and rocks are strewn about within the soil. *Rocks and Roots* clearly illustrates Jackson's urge to discover hidden details and aspects of nature and the natural setting, a characteristic feature of his work throughout the ensuing decades.

At this fundamental level, while searching and discovering, Jackson became more deeply entrenched in experimentation. Indeed, in contrast with the boredom of which he had complained earlier, he developed a zest for experimentation that continues to guide, and even dominate, his work regimen. Of course, many of his experimental pieces, when reviewed chronologically, reveal a steady development during the late 1950s.

One work in particular demonstrates Jackson's proficiency in accomplishing a clear thematic conceptualization: *A.D.* (fig. 15), an oil on panel executed in 1959. At a superficial level, the subject matter, though clearly morbid, is fully recognizable and understandable. The work depicts a deceased male lying in an open casket that is surrounded by huge masses of funerary floral arrangements. Behind the casket is a veritable gallery of traditionally framed landscapes and floral still life paintings. Occupying the right third of the composition is the seemingly arrogant figure of a man—essentially a caricature of Jackson himself—and to that figure's left is a small table bearing a vase of flowers and a commercial periodical on the subject of art. The work evidences early but highly commendable technical proficiency. It also demonstrates an interest in rather biting social commentary: metaphorically, the theme likely is the death of art, with *A.D.* signifying *after death* or perhaps *art's death.*[5]

Jackson acknowledges an intention to equivocate here, to allow the spectator to decide the meaning, although he certainly supplies the thematic devices for focusing on an interrelationship between death and notions about the prevailing modes of art. Moreover, that meaning clearly coincides with his own attitude at the time, and with the attitudes of many other artists who, by the late 1950s, were beginning to look disdainfully on the prevailing stylistic mode of abstract expressionism as signifying what they considered to be the death of art. That this painting is quite masterfully executed is obvious; indeed, its execution demonstrates Jackson's tremendous success in achieving his technical and stylistic objectives as the decade drew to a close. That the work also voices the artist's personally scornful outlook on a mode of art he had come to regard as sterile cannot be denied.

9. *Duet*, 1954

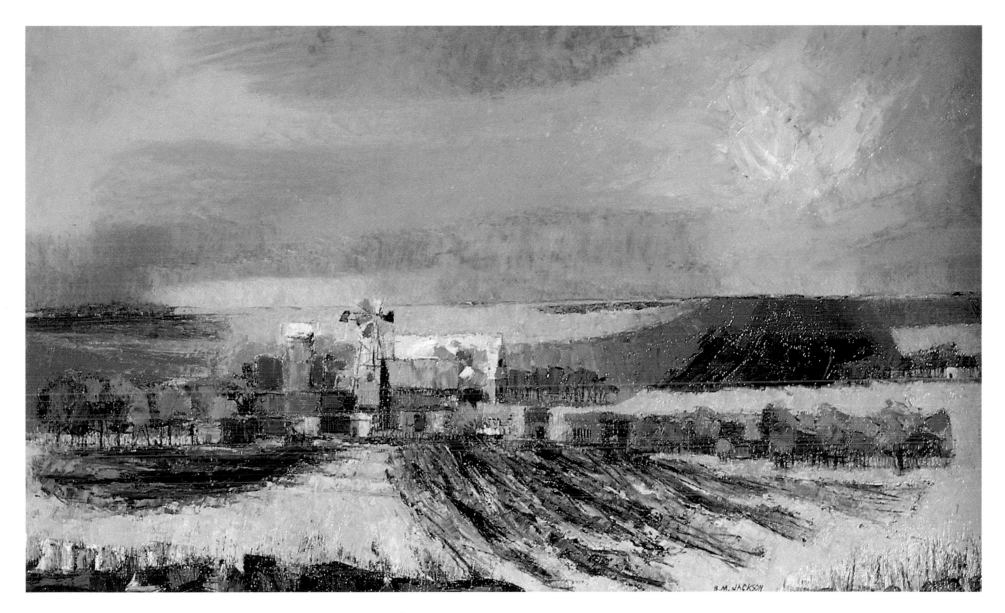

10. Untitled landscape, c. 1956

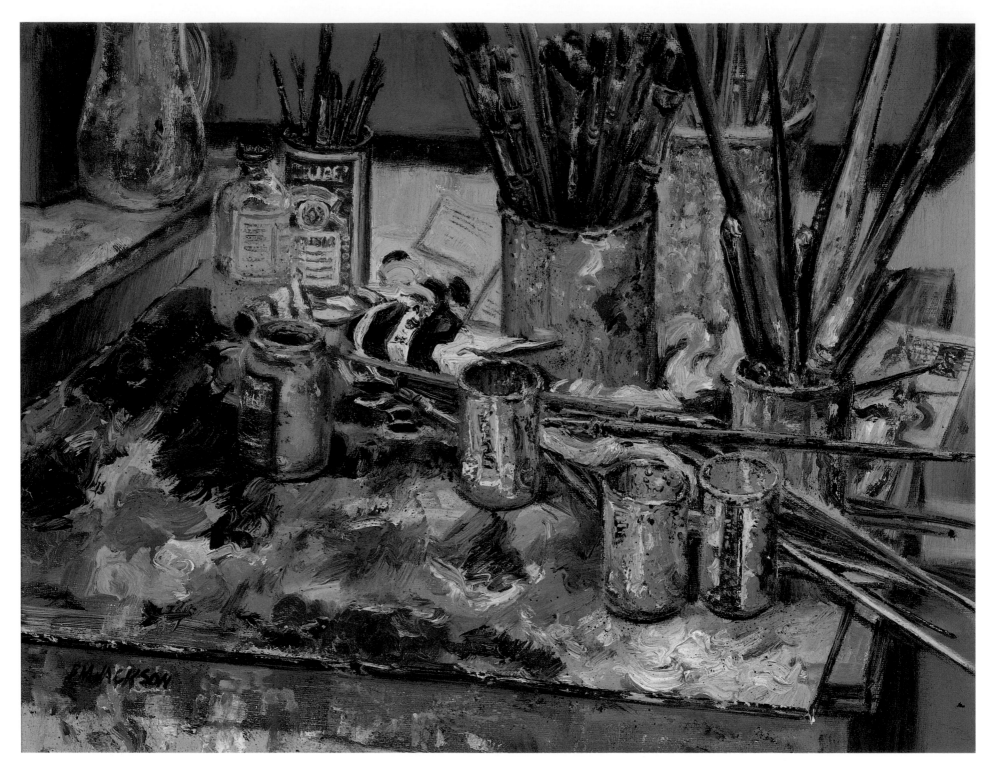

11. *Still Life with Postage Stamp*, 1955

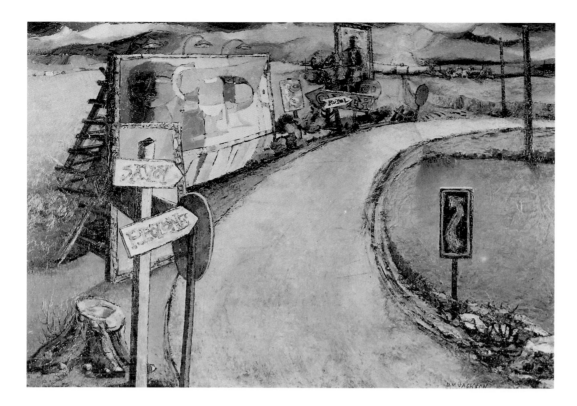

12. *Curved Road with Signs and Landscape*, c. 1956

13. *Landscape with Blowing Trees*, c. 1956

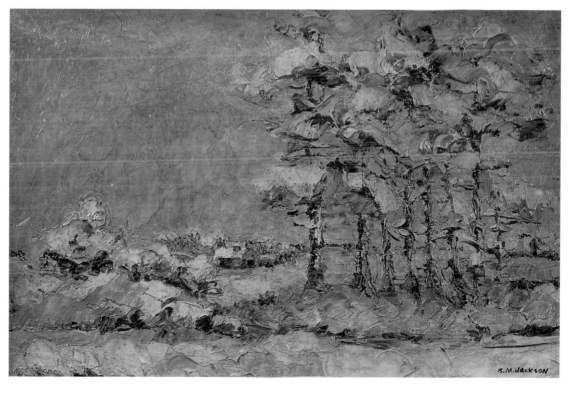

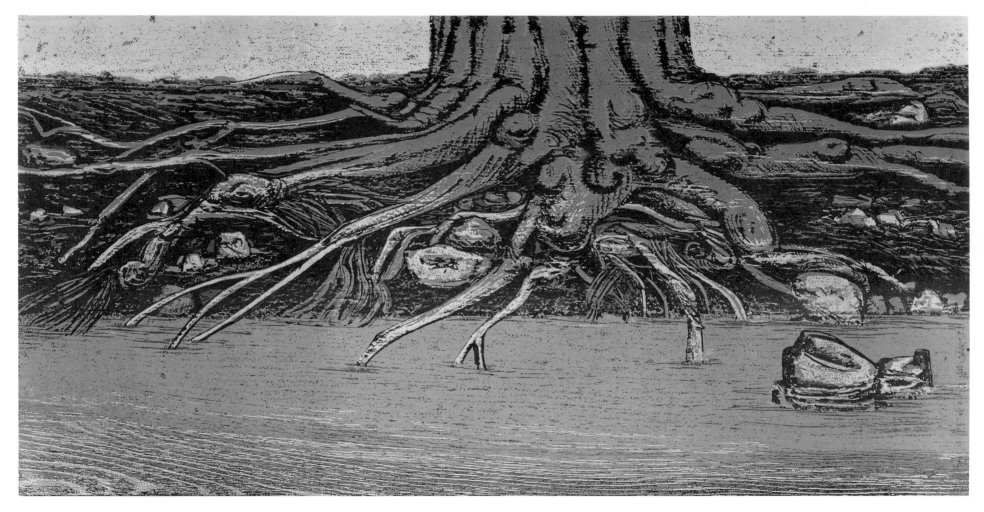

14. *Rocks and Roots*, c. 1958

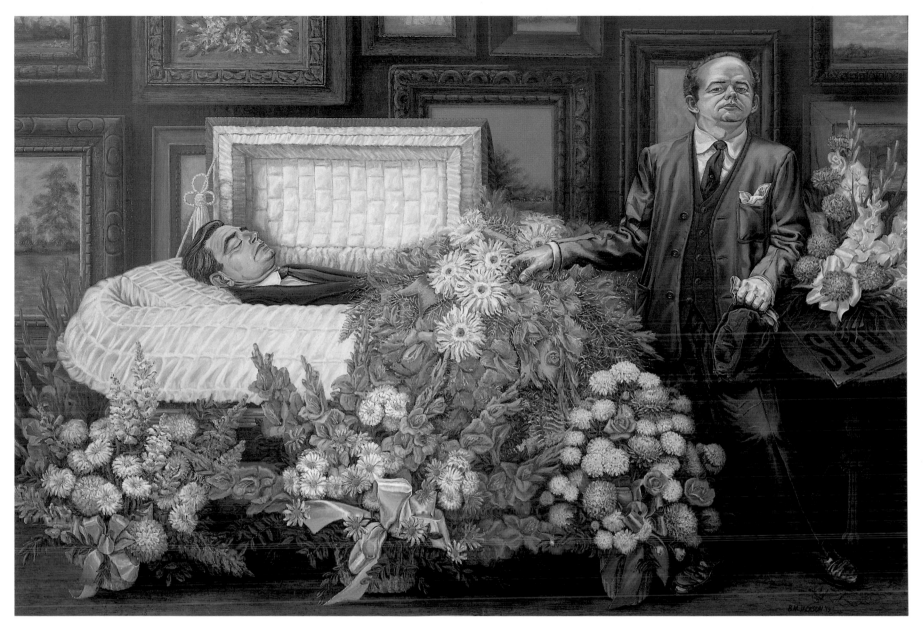

15. A.D., 1959

3

Regionalism Revisited

Jackson's thematic interests during the late 1950s shifted steadily from expressionism toward a naturalism that was rooted in direct visual experience—in the use of his eyes as a means for collecting data that could ultimately be transformed into a work of art. Indeed, it was during the several previous years, when Jackson successfully explored abstract concepts, that he learned how to avoid imitation when using natural data and how to transform the visual imagery of experience into pure aesthetic expression without the loss of objective recognizability.

Certainly, *A.D.* illustrates the advanced level of Jackson's technical attainments by 1959, for every detail reflects his careful, objective scrutiny and his exactitude in rendering subject matter clearly and convincingly. In addition, the mood and the possibilities for interpretation of subject matter in his work of this period are enviable and suggest an imagination in quest of new outlets of expression. But it should be remembered that Jackson's principal thematic interest at the time was the landscape of central Illinois, and it was essentially the landscape to which he turned his attention in relentless pursuit of themes, of meaning, and of the formal devices through which he could best express deep human feelings and convey meaningful aesthetic experiences.

In late 1958—just a few months before he finished *A.D.*—Jackson completed another oil on panel painting, *The Interloper* (fig. 16), also known as *Autumn Interloper*, a truly pivotal composition in the evolution of the prairie landscape series for which he has come to be so well known. *The Interloper* is rendered in a relatively loose

technique with rather agitated brushwork across much of the surface. The left two-thirds of the composition furnishes a deep, expansive view onto an autumn farm, with emphasis on the high horizon line. To the right, a young man leans against the corner of a weatherworn corncrib, as if waiting for something; pictorially, he serves as a repoussoir figure, introducing the spectator to the composition. The deep, swirling folds of his overcoat, and the knarled fingers and bulging veins on his hands, create a pattern that echoes the dried cornfield and formally links this lone figure with the landscape section of the composition.

It is worth noting that both *The Interloper* and *A.D.* are similar in terms of organization. The major thematic focus occupies the left section of each composition, while the repoussoir figure—in both instances the artist himself—is at the extreme right. (This traditional repoussoir device is repeated more than a decade later in several of Jackson's major street scenes, as we shall see in chapter 5.) Another important point with regard to *The Interloper* is that the spectator's attention is focused on both the prairie and a human form seen against an architectural backdrop. In addition, interest in sharply focused detail—for example, the splintery wood surfaces of the corncrib—indicates the new direction of the artist's work.

The development of Jackson's early prairie landscapes in fact dates back as far as about 1954–55 and consists of both oils and a large number of color woodblock prints. These include distant farm buildings with large trees occupying the near foreground but, in almost every instance, no human forms. By the time he painted *The Interloper*,

however, Jackson had purposely begun to introduce figural subjects into the landscape setting.

In a 1958 grant application for special summer study, Jackson stated: "I hope to creditably proceed from the purely regional landscape to a peopled terrain, so to speak, and bring to the scene a new drama and contrast."[6] In that same request he specified the need for funds with which to reimburse models, thus indicating his intention to include figures in future compositions—something he would gradually abandon during the next decade. Indeed, a change in attitude was already suggested semantically by the term *interloper*, which Jackson equated with *intruder*. By the early 1960s, he would begin to diminish the human figures in his compositions, both in scale and in thematic importance, and to place increasing emphasis on close-up architectural forms located against broad prairie vistas.

Completion of *The Interloper* did not open the way to an immediate or clear-cut, step by step evolution toward what would become Jackson's prairie landscape formula. There were many intervening stages, as in the early 1960s when Jackson became fully immersed in experimental exercises and readily pursued a wide variety of themes that were not primarily pure landscapes yet, in one way or another, were related to natural phenomena. All of these steps would eventually be assimilated into the cultivation of a mature style that found expression not only in the artist's prairie landscapes but also in other compositional types, such

as interior views, cityscapes, protest commentary, and direct portraiture.

Throughout this period, Jackson closely scrutinized plants, flowers, and insects. Such efforts were, of course, not new to him. His controlling endeavor now was to deepen his understanding of color relationships and to steadily refine his drawing skills—objectives that were often accomplished as a result of detailed experiments initially executed in color woodblock prints and then freely transferred to his paintings.

During the early 1960s, Jackson continued to search for new compositional possibilities, and for a time he found considerable inspiration in many of the well-known vertical still life paintings by his University of Illinois colleague Nicola Ziroli. But Jackson's works were far more exciting, for the series of still lifes he developed were actually surrealist assemblages of wild flowers, dried prairie grasses, and mixed fabrics, sometimes mingled with totally unrelated objects that included dolls and various other foreign materials. Composition, texture, color variation, and mood proved to be distinguishing dimensions. Such works as *Images and Forecast* (fig. 17), painted circa 1960, and *Idiot and Affluence* are illustrative of this series and are important as examples of Jackson's interest in nature and of his refined, highly developed skill in rendering detail with incredibly meticulous accu-

racy and of unifying diverse forms into a harmonious composition. Perhaps the most masterful of this entire series is a work titled *Homage to Prophets* (fig. 18), painted circa 1962–63, which clearly epitomizes all of these accomplishments and at the same time projects a truly beguiling transcendental presence.

Jackson seriously pursued other experiments in composition and drawing, spending several years creating a lengthy series of small paintings in both oil and watercolor that deal with views through windows (fig. 19), where interiors are obscured by thin curtains behind which ghostlike forms are suggested but rarely defined. Such undertakings were essentially optical experiments. Concomitantly, he produced a lengthy series of extremely interesting compositions that show various arrangements of paper sacks. One of the most intriguing and entirely original of these is a watercolor, executed in 1967, titled *Sacks and Others* (fig. 20). Obviously, he had learned a great deal about the translucent properties of various papers and about trompe l'oeil.

One of Jackson's earliest works from the 1960s, *The Young Widow* (fig. 21), sometimes called *The Window Widow,* is an oil on panel executed in 1960–61. In this painting, a solitary blonde female nude with a grievous facial expression is shown seated adjacent to a wide window hung with sheer, open curtains. Her view through the window is of a rather desolate prairie stretched out beneath a gloomy, threatening sky. Yet the notion of hope and renewal is symbolically suggested by a

slightly rolling surface of green grass in the foreground. Dangling from the window sill is a long, narrow red ribbon, and nearby stands a small table with an empty flower vase, a bouquet, and an open envelope.

We can, of course, only guess at the meaning of this work, for it contains certain ambiguous aspects—as do many of Jackson's paintings—whose interpretation are subject to each person's imagination. From the standpoint of constituent compositional elements, however, it is evident that *The Young Widow* is related to *The Interloper* in that an architectural component is brought into close association with a prairie view to produce a setting into which the human figure has been introduced. These three elements—architecture, prairie, and human form—go hand in hand in so many of Jackson's paintings until near the end of the 1960s.

Another work from this period, and one of great interest, is *Winter Walkers*, executed during the winter of 1961–62.[7] Here, a snow-covered landscape includes a stretch of leafless trees, arranged diagonally in the middle ground, and a long horizontal row of trees in the distance, barely visible through the hazy winter atmosphere. Near the foreground, fifteen people (adults and children) are walking slowly or running or romping or struggling against the wind and the slippery underfooting in the aftermath of a blizzard. (Appropriately, an alternate title by which this work was originally known is *Snow Walkers*.) What is so different about this painting is the tiny scale of the human figures and the contrasting expansive setting. Indeed, in this respect the work represents one more experiment for Jackson. Nevertheless,

it is most effective when viewed as a study of the various gestures and postures assumed by people as they play or trudge through the heavy snows dressed in weighty winter clothing.

Technically more advanced, yet stylistically reminiscent of *Winter Walkers,* is the small landscape *The Passers-by* (fig. 22), no doubt executed in 1962. The setting is an open prairie on a cold and windy winter day. Near the center of the composition, a man, two women, and three children trudge against the wind along a narrow roadway. The man and woman who lead the group are carrying a long-handled broom, a closed umbrella, and several heavily packed sacks of groceries. A third woman trails behind, struggling to assist a small child who apparently has fallen. Immediately ahead is a young girl with outstretched arms who appears to be dancing joyfully in the bracing chill. Visual interest is emphasized by the varied patterns of color and texture throughout the terrain and in the subtle variations in atmospheric density—a stylistic tendency frequently found in Jackson's landscapes of this period but one that, by the end of the 1960s, was in marked contrast to his preferred use of delicately modulated color tones in the rendering of the sky.

As in *Winter Walkers,* the scale of the human forms in *The Passers-by* is quite small when compared to the expansive breadth of the open prairie, although here the gestures of the figures seem considerably more natural. Unlike the relatively cool colors otherwise used throughout the

scene, the dash of red pigment on the man's cap accents the centrally clustered group, which in turn serves as the focal point for the entire composition. Pigment has been applied in lively, free-flowing brushstrokes, imparting bravura to the human figures. A feature of special interest is the marked contrast between the green and yellow stretches of prairie grasses and the white snow along the relatively narrow pathway.

Thematically, Jackson's successful handling of the wind, as seen in *Winter Walkers* and *The Passers-by*, must have been a factor in inspiring him to plan a large-scale work, *The Windwalker* (fig. 23), which he executed in 1963. Here, Jackson focuses on a lonely young woman who, with an expression of despondency, is walking against the wind with a myriad of leaves, seeds, butterflies, and other insects blowing toward her. With infinite detail Jackson expresses the texture of each leaf, each insect, each piece of clothing, yet all of this is subordinated to the central concept that alludes to enduringly relevant protest messages so appropriately voiced in the sixties and, most especially, of Bob Dylan's "Blowin' in the Wind," written in 1961 and first recorded in 1962.

In 1963–64, Jackson executed a handsome painting titled *Who Is Sylvia?* (fig. 24) that clearly points up his continuing search for compositional arrangements that would accommodate the effective use of the experimental efforts with which he had been involved since the late 1950s. *Who Is*

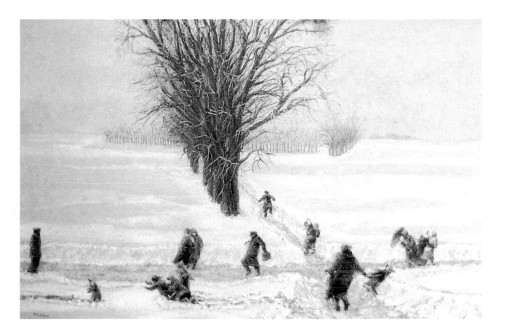

Sylvia? is a relatively large work depicting a close-up frontal view of the façade of a house and, to the left, a beautiful, almost entirely nude young woman standing in an open, enframed doorway, her hands resting on the back of a small chair immediately in front of her. As in *The Interloper*, *A.D.*, and *The Young Widow*, the human figure here is relegated to one side and occupies approximately a third of the length of the composition, while the remainder is devoted entirely to architectural and naturalistic detail.

Jackson painted two works of major significance in 1964, both of which may be regarded as veritable triumphs in experimentation. Yet, while it is evident that in these works he was profoundly engrossed in uncovering alternative solutions to specific technical problems, it is also evident—at

least in retrospect—that both paintings must be regarded not only as successful and rewarding studies but also as completely finished compositions. One is titled *Before My Time*; the other is *Class of '64*.

Before My Time (fig. 25) depicts a section of an old, dilapidated stucco building, perhaps someone's house. A large sash window, with wooden enframement, occupies the central space of the composition. Peering into the open window, past

a narrow section of an old lace curtain, we encounter a dark, seemingly empty room. If we look more searchingly, however, and fix our attention on the interior emptiness, a human figure looking toward us is faintly—and rather ominously—suggested. Only barely visible, its existence can never be doubted, though at first we may have thought we had imagined its presence. Such built-in ambiguity contributes to the success of the painting, for it gives rise to a mysterious quality that grips our attention.

That there is life within the house is also suggested by the hollyhock growing beneath the window and topped by a bud that tilts just slightly in the direction of the dark, foreboding interior. In addition, there is an eerie sense of time implied by the flaking paint and the splintery, weatherworn wood, as well as by the cracked and fallen patches of stucco that are scattered across the surface of the building. The minute detail, rendered with such amazing precision, serves to intensify our vision and force us to see what might otherwise completely escape our notice. This skillful technique never fragments our attention, however, but remains totally subservient to the central theme and the purely aesthetic issues the artist has chosen to explore. *Before My Time* presents a compellingly powerful image, which Jackson repeated the same year in an etched version that was a frequent recipient of awards in competitive exhibitions.

Class of '64 (fig. 26), which may have been among the most well received paintings ever ex-

ecuted by Jackson, was most unfortunately destroyed in a fire in 1979.[8] Again, Jackson's primary interest was in using the weatherworn wood of a vacated old farm building as a means to convey a sense of time. To achieve that effect, he introduced an enormous amount of detail into every aspect of the work.

The painting seemingly displays a powerful Hopper-like consciousness in its interest in bold geometric forms combined with broad abstract patterns of light. The surfaces of the two-story structure are scarred, some of the clapboards have entirely disappeared and one hangs precariously across the upper story, most of the narrow shutter slats are missing, window panes are broken, and several sections of tile roof have fallen. In every sense the architecture functions as a measure of change in time, even though the building's physical character and some degree of its dignity linger in the present. Here and there the surface itself is enlivened by scattered variations in the intensity of reflected light, and real drama is introduced into the composition by the dark vertical shadow that falls across the left edge of the building, imposing a bold and irregular geometric shape on the otherwise repetitious distribution of surface forms. An even more dramatic element is found within the narrow lean-to on the extreme right, where, almost lost in the deep shadows, two people—most likely members of the graduating class of 1964—are deep in conversation. This young man and woman, juxtaposed against the rapidly deteriorating building that otherwise dominates the composition, convincingly symbolize renewal and the promise of vitality and continuing life.

By the end of 1965, Jackson had produced some of his most compelling paintings and had made steady progress in mastering composition, color relationships, and drawing methods and techniques. He had learned much about light as a natural phenomenon and as a means of object definition and spatial illumination. Through his years of searching for a knowledge and understanding of nature, he had discovered the extraordinary in the ordinary. With the employment of such compositional devices as the waiting figure or the weatherworn architectural feature, he had found appropriate symbols for expressing time. And his almost uncanny ability to introduce ambiguity and mystery into his compositions had proven effective as a means of evoking psychological responses on the part of viewers and commanding their attention. By the mid-1960s, his principal accomplishment clearly was that his work stimulated both the mind and the eye.

Years of perseverance and experimentation brought Jackson success as a teacher of art and culminated in a distinctive style of drawing and painting. He was now self-confident and well prepared to follow the course he had set for himself. From the principal works he executed over the next several years, it is clear that he was continuing his relentless search for an art form through which he could meaningfully celebrate human reference to the natural environment in accord with

his philosophical and cultural outlook. In the process, he produced a series of paintings, each depicting a human incident enacted in an architectural setting and in turn viewed against a prairie landscape.

Philo Bound (fig. 27), completed in 1965, apparently was begun soon after he completed *Class of '64*. The architectural element that is located on the right and occupies approximately half of the long horizontal format of the painting is fundamentally identical to that seen in *Class of '64*, although here the building is viewed from the opposite side. Moreover, *Philo Bound* includes the same human incident depicted in *Class of '64*—two people quietly conversing. The other half of the composition reveals a deep view of the open prairie, with scattered trees in the distance. And, in contrast to *Class of '64*, the architecture in *Philo Bound* stands considerably back from the frontal plane, with the eye being led directly toward the lean-to by foreground tire tracks in the prairie soil. A second man, silhouetted against the prairie, is walking toward the left edge of the painting, away from the house.

Primary (fig. 28), painted in 1965, is thematically similar to *Philo Bound* except that architectural emphasis is placed on the side view of what is assumed to be an old country store with a frontal overhang, beneath which stand a man and woman who appear to be waiting for something. The pictorial function of this couple remains am-

biguous—clearly, this is not a rendezvous of two young people—yet we are forced to notice their presence since, although the prevailing color scheme is relatively drab, they are flanked by a broad section of rusted, colorfully stained patches of siding tiles and by an American flag hanging from the eave. It is especially noteworthy that, beginning with this painting, the American flag would be featured in many of Jackson's works, particularly his cityscapes and street scenes.

Homer's Crib (fig. 29), executed a year later, includes many of the same compositional elements as seen in the earlier works. Here, the dominant motif is the corncrib, centrally placed in a prairie setting, with a young couple enclosed within the deep interior shadows.

In 1967–68, Jackson painted *Eve* (fig. 30), one of his most intriguing works of the decade and the one that most recalls the work of Edward Hopper in making a situational statement without depending primarily on the use of excessive detail.[9] The massive late nineteenth-century American farmhouse in the composition appears to be in a satisfactory state of repair, although the wooden siding and the gable's shingles are somewhat weatherworn. Of the numerous windows, complete with lace curtains and window blinds, some dark, others a light yellow, the center window on the second story captures our attention, for the lace curtain has been pulled to the side to reveal a phantom-like figure looking outward. The porch, with its painted Tuscan columns standing on tall brick bases, is obviously a later addition to the house. But it is also one of the more noteworthy features of the composition, for beneath the porch roof,

draped across the entire width of the gabled wing, is an American flag waving ever so slightly in a gentle breeze. The woman seated on a swing suspended from the porch roof appears to be waiting for something—assuming this is not her home—since it is hardly the season for casually sitting out-of-doors; moreover, we see no signs of interior furnishings.

When we look more carefully at the painting, in an attempt to discern all possible meanings and feelings potentially associated with it, we quickly recognize that not only is the large farmhouse standing at the edge of a prairie but it is also standing at the edge of a parking lot. Thus, the woman might be waiting for the climactic moment of an inevitable change she is about to experience—a change in the wake of technological progress that perhaps includes the imminent demolition of the house. Indeed, the title of the painting might be the name of the woman on the swing, or the word *eve* might refer to the moment immediately preceding the jolting change in the woman's life situation, for which she must prepare herself. From a thematic standpoint, then, this work is one more instance where Jackson intentionally equivocates, allowing us to search for meaning and reach our own conclusions.

It is noteworthy that, just a year before this painting was executed, Jackson—who was then an associate professor of art—requested a full-time appointment for one academic year in the university's Center for Advanced Study, to pursue a theme he called "The Waiting Man." For him that meant "a lone figure in one painting, while in another it might be one of several. . . . Perhaps 'static poise' brings to mind the kind of body gesture I propose; a posture on the verge of animation but arrested, so to speak, by the act of waiting." Other comments in his proposal have even more direct relevance to *Eve* and to the relationship between the architecture and the woman on the porch swing. He states that the role of the waiting figure "could be so relegated in relation to the visual environment that, when interpreted from a poetic point of view, the very structures in which man is housed might seem to absorb and reflect man's anxiety, frailty, tragedy, etc. more readily than man himself." [10]

A final step in the evolution of the artist's landscape genre is at hand in *Thawville* (fig. 31), painted in 1968. This work represents the imminent conclusion of Jackson's lengthy search for the most feasible way to pictorially establish human reference to the natural environment in accord with certain philosophical tenets. The resulting shift in emphasis that we find in *Thawville* bodes a change of far-reaching significance: the human incident—the meeting of a young boy and girl, she carrying her schoolbooks and he seated on his bike—is overshadowed by the stately late nineteenth-century farmhouse, rendered with the utmost care. The farmhouse, which is the boldest, most distinct form in the composition, is given increased dignity by virtue of the comparatively small size of everything else. Such use of selected elements would become one of the controlling characteristics of Jackson's more mature landscape paintings, as well as of other works by him.

Of special interest in *Thawville* is the harmonious balance between the farmhouse and the vast expanse of prairie to the right, ensuring compositional unity while also allowing the viewer's attention to play back and forth between the house and the landscape. Moreover, the delicate tonal qualities of the sky, the delight and fascination derived from the thawing snow, and the detailed treatment of the snow fence combine to invite us to become more and more absorbed in the landscape itself. Indeed, unlike all of the other landscapes discussed so far, *Thawville* may be viewed as a pure prairie landscape into which the bold form of a farm dwelling and the closely associated human incident have simply intruded. Alternatively, the young couple and the massive farmhouse, both situated at the extreme left, seem to be retreating, slowly fading out of the picture altogether, leaving behind only the isolated image of a prairie with scattered man-made features.

By the time Jackson completed *Thawville*, he had recognized the full pictorial potential of the prairie itself, and it was then that he embarked on a program of painting pure nonfigurative landscapes. No longer insistent on introducing the human figure into his paintings, he now sensed a new kind of drama in which the natural landscape could be experienced visually with humanity inferred rather than seen. He adopted this form beginning in about 1968, and he continued for almost two decades to use it in his landscapes. [11] At the same time, he began to express in his paintings of street scenes and interior views an interest in human incidents staged within architectural settings.

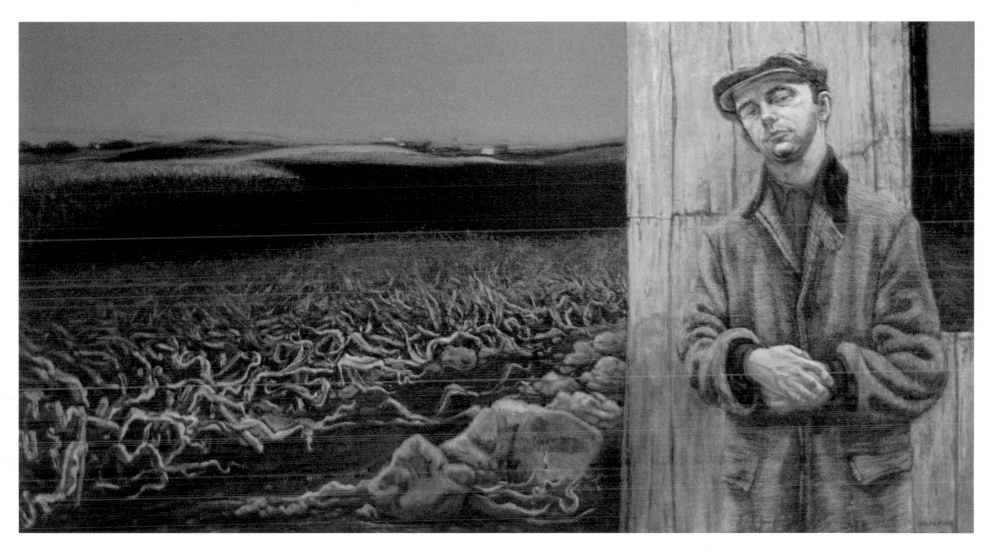

16. *The Interloper*, 1958

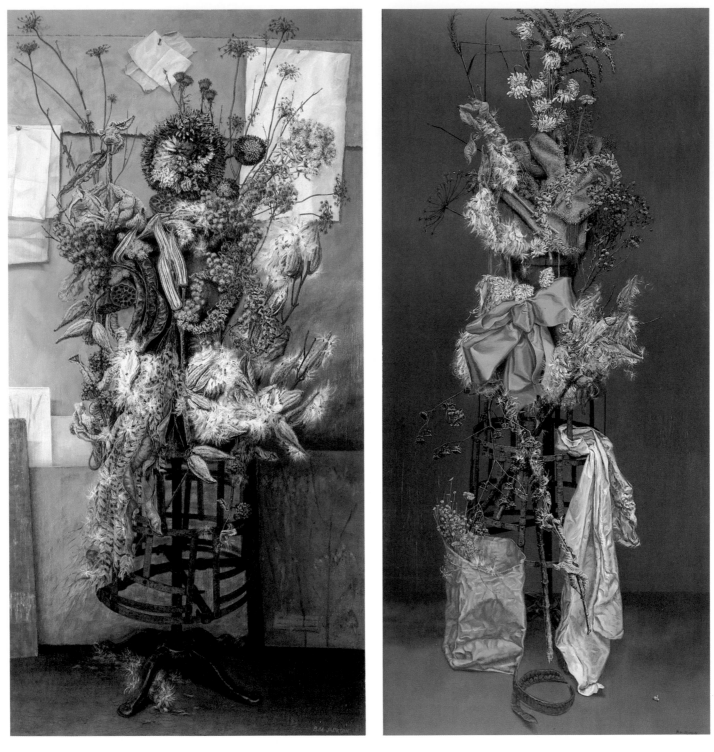

17. *Images and Forecast*, c. 1960 18. *Homage to Prophets*, c. 1962–63

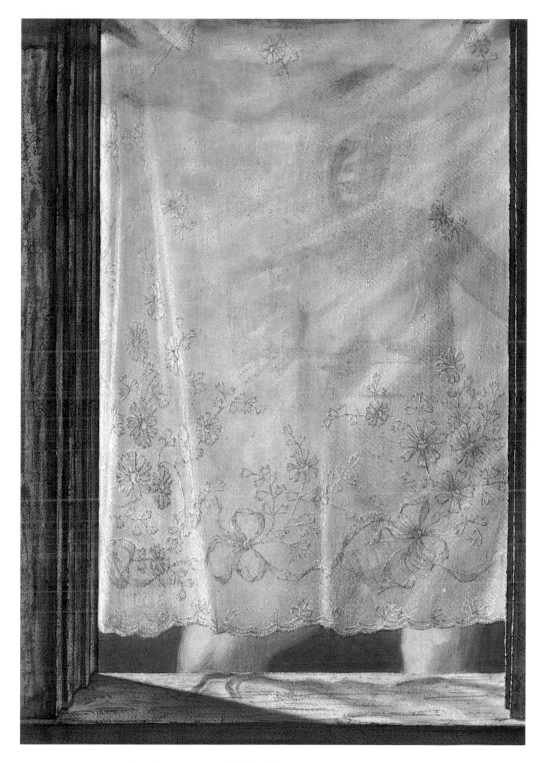

19. *Curtains*, c. 1962–63

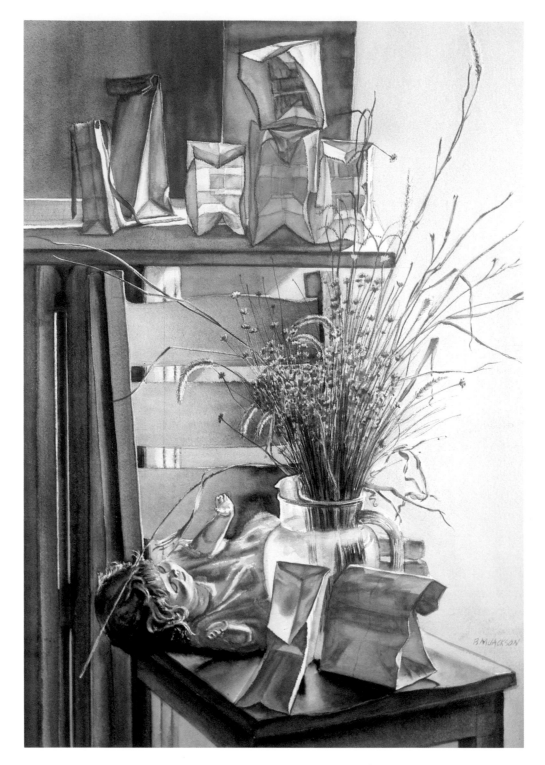

20. *Sacks and Others,* 1967

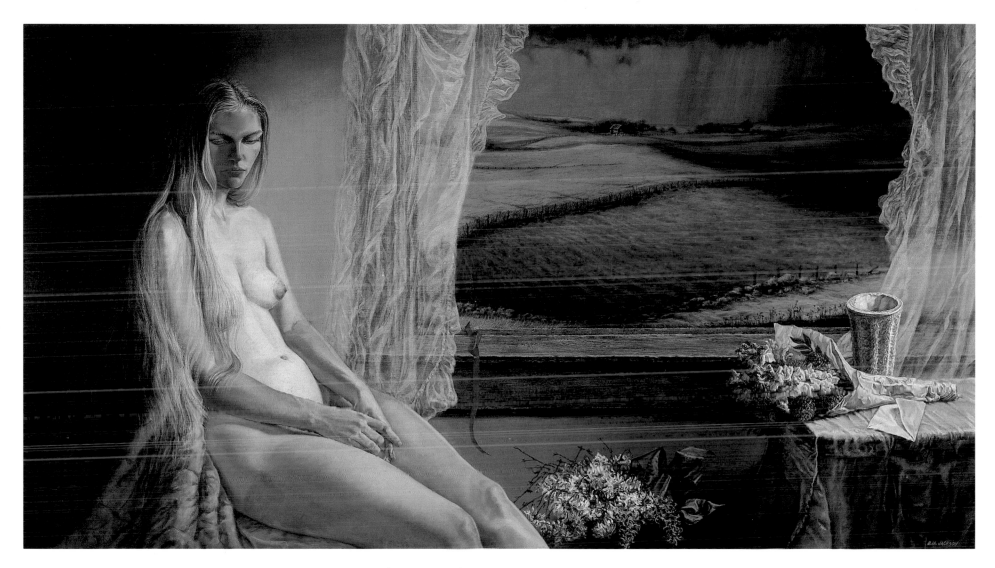

21. *The Young Widow*, 1960–61

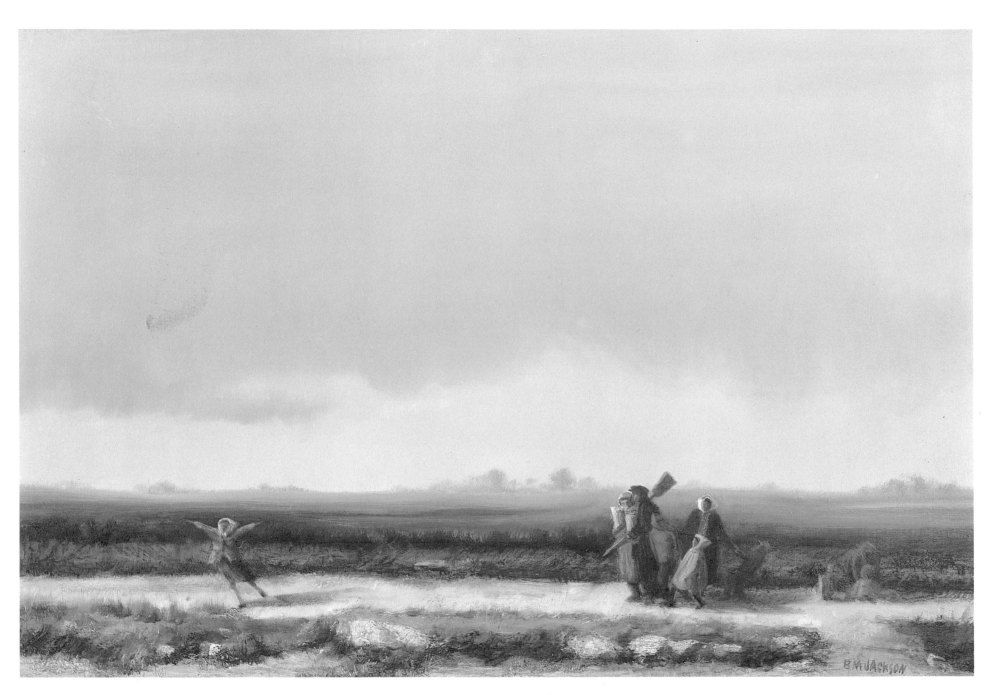

22. *The Passers-by*, 1962

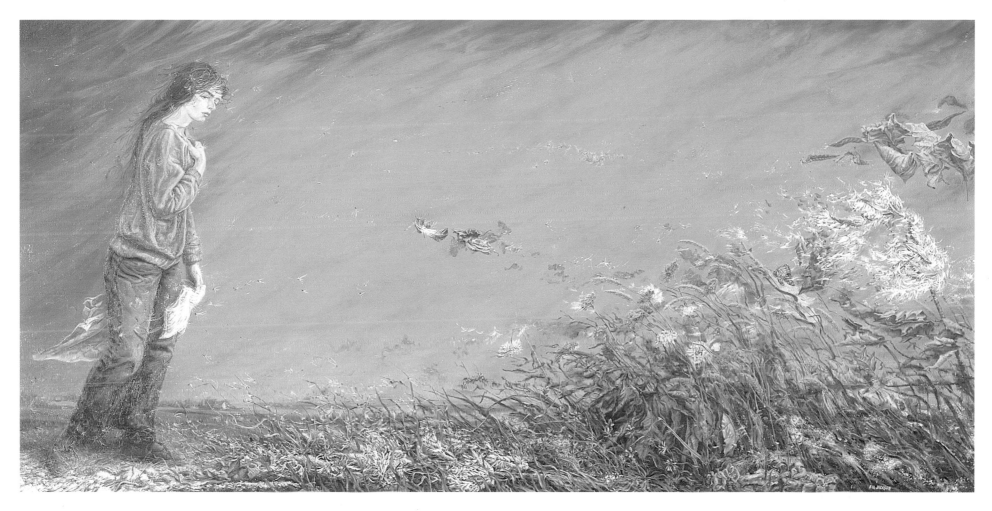

23. *The Windwalker*, 1963

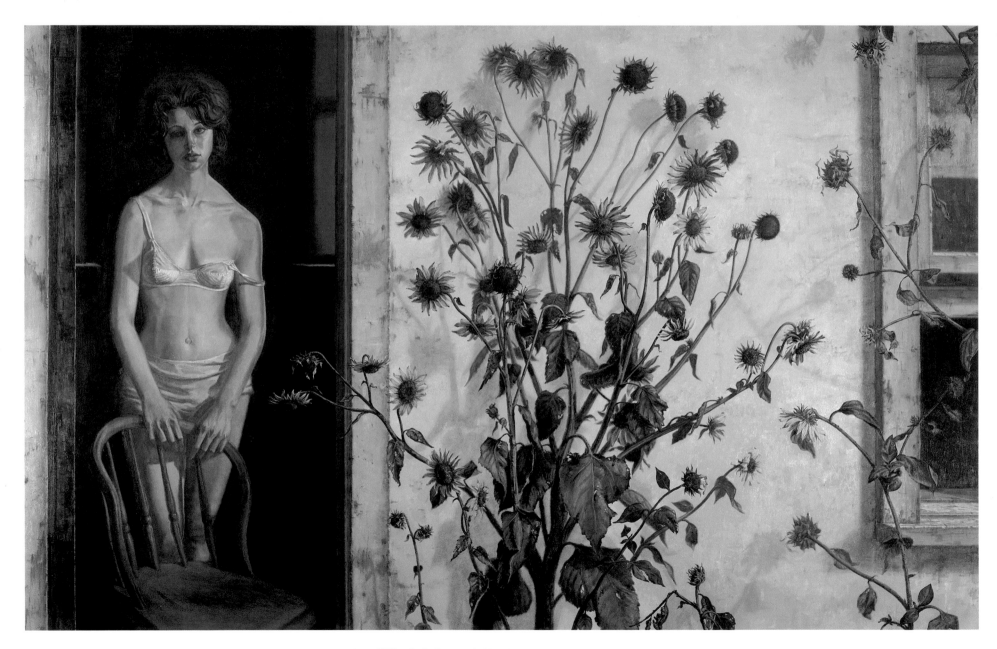

24. *Who Is Sylvia?* 1963–64

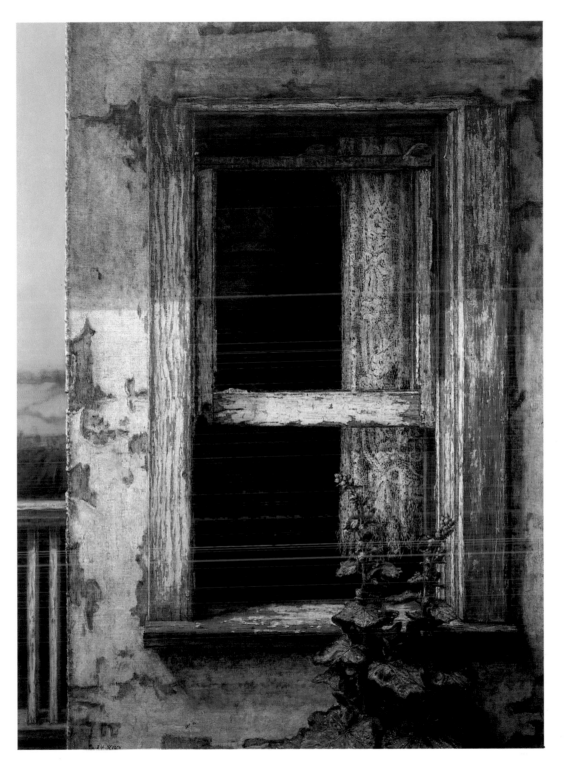

25. *Before My Time*, 1964

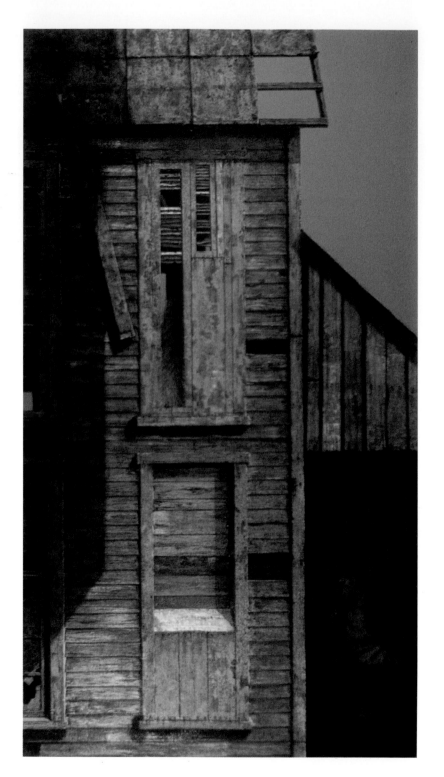

26. *Class of '64, 1964*

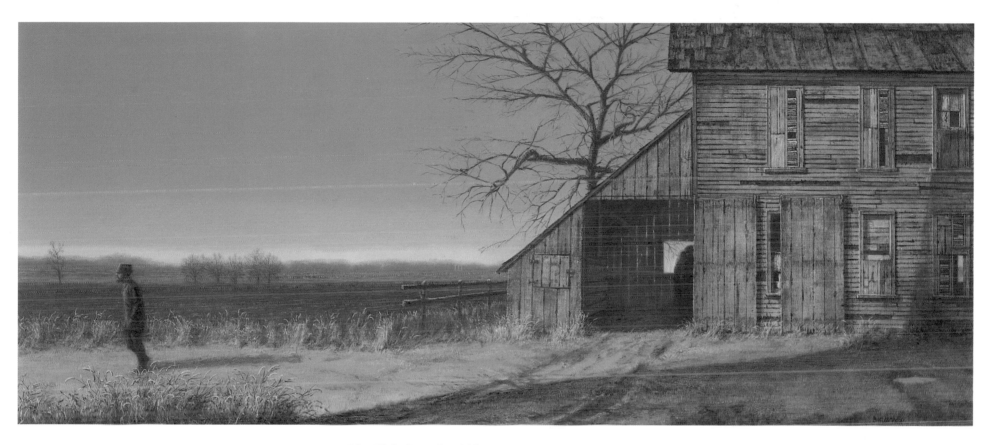

27. *Philo Bound*, 1965

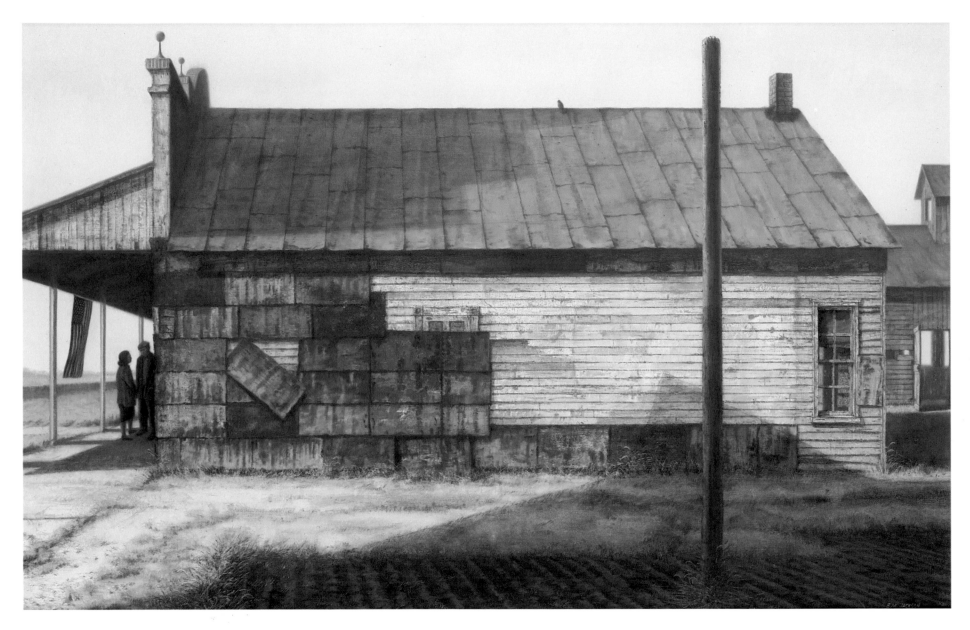

28. *Primary, 1965*

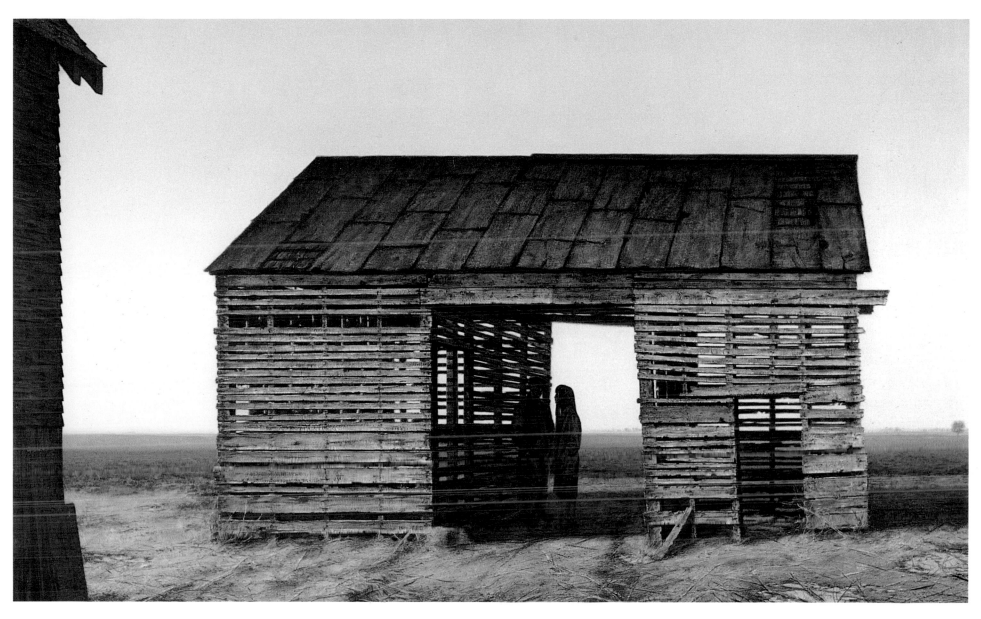

29. *Homer's Crib*, 1966

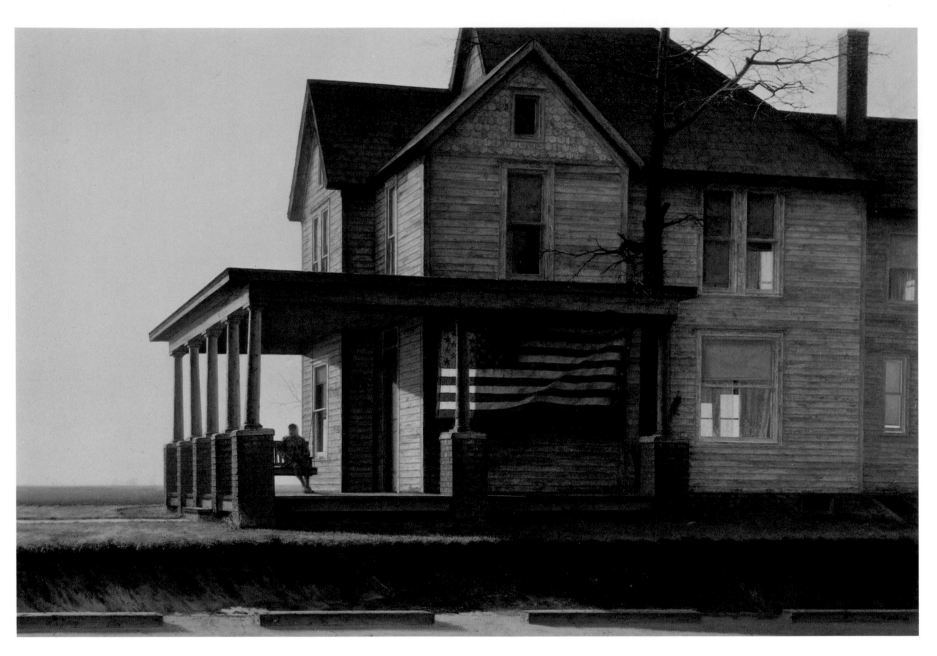

30. *Eve, 1967–68*

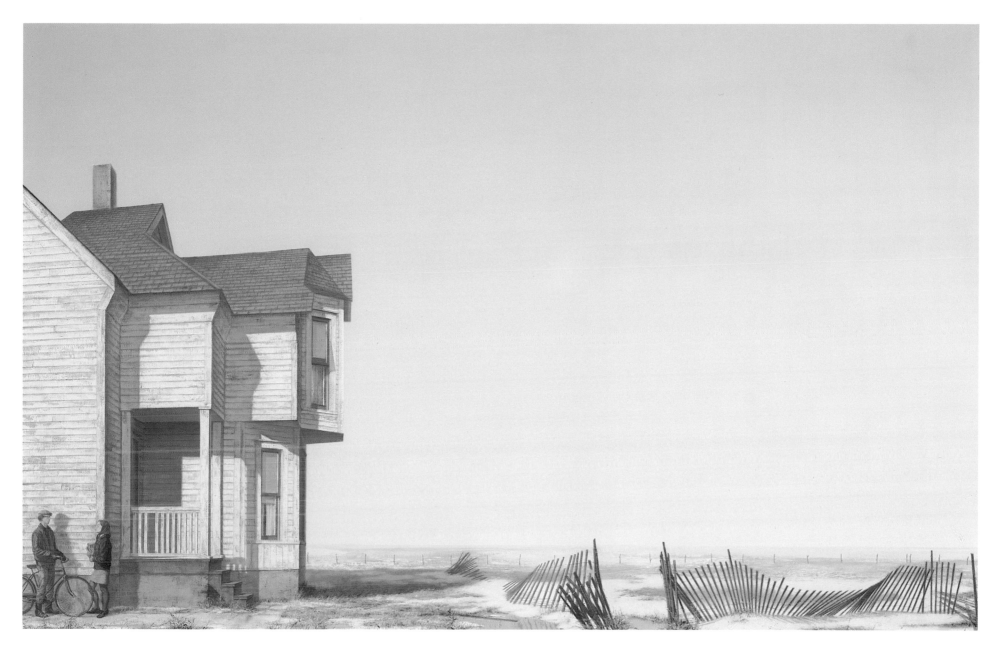

31. *Thawville*, 1968

4

Pure Landscapes

In many respects, an art form reflects the basic beliefs and persuasions of the society that has adopted it and that makes use of and supports it. When those beliefs and persuasions change, the traditional art forms are replaced (or pushed aside) by other forms more relevant to the changing social climate. The landscape genre, a conventional symbol of humankind's relationship with nature (whether harmonious or competitive), had fallen into rapid decline, beginning in the late nineteenth century, as the scientific-technological revolution forcefully altered the face of life in America and, indeed, in much of the civilized world. Wrenched from their customary natural environment, people began to experience irretrievable losses without consciously realizing what was being taken away.

It is surely surprising, then, that landscape artists could succeed in such an inauspicious social milieu or that, given the escalation of high technology in the twentieth century, a number of American painters in the last few decades would turn again to the natural landscape setting as a source of imagery. This is not to say that the landscape has returned as one of the dominant themes among contemporary American representational painters; nor can it be claimed that all of these painters work in a "realistic" representational manner. Yet the list of contemporary landscapists is impressive and includes a diversity of types.

Among the most prominent of the landscape painters of the 1950s and 1960s was the noted artist-critic Fairfield Porter, whose sweeping brushstrokes and freely applied dashes of delicately refreshing color tones produced clearly recognizable, though certainly not imitative, subject matter in which attention to detail is altogether lacking, the focus being entirely on the essentials of selected forms in space. Landscapes from the 1960s and 1970s by the noted painter Ivan Albright, which are as fascinating as most of his earlier portraits and genre scenes, include entirely recognizable—though highly distorted—forms, presented in a unifying light but generally conveying a disturbing sense of decay and despair. Compositionally, Albright's works display a reuse of *horror vacui* which, like excessive clutter, diminishes definition of form.

In direct contrast to the work of both Porter and Albright is the oeuvre of Andrew Wyeth, who places approximately equal emphasis on the treatment of each and every detail found within his field of vision. Undoubtedly, his meticulousness accounts in part for the high popular esteem in which he is held and for the fact that he is generally regarded as America's most masterful "realist" painter. Yet it is that uniform and meticulous treatment of detail—much in the manner that stylistically recalls American Folk painting so typical of Wyeth's work— by which compositional heirarchy is often violated in his paintings. As a result, all forms, regardless of their size or location within the space of the painting, tend to adhere

visually to the frontal plane, thus contributing to an overall impression of a flat, two-dimensional composition. What is so odd, therefore, is that from one point of view Wyeth's paintings often seem to be technically linked to works by such ideologically unrelated painters as Jackson Pollock.

There are, of course, many other American painters who in recent years have produced numerous landscapes of high quality. Among them are Sidney Goodman, Rackstraw Downes, Neil Welliver, Chuck Forsman, and Lawrence Hofmann—all of whom claim to be factual objectivists. They repeatedly insist that they paint precisely what they see; and furthermore, they acknowledge their use of color photography to make visual notes while preparing major works of art. (Of course, the latter practice does not disqualify them from their claim, since photography had been used in this way even before Thomas Eakins.)

Today, artists such as Gregory Gillespie produce among other genre some extremely interesting landscapes that give the impression of "representational realism." On close study, however—and especially in Gillespie's case—these paintings seem rather like psychic explorations into the hidden mysteries of reality; as such, they often physically resemble the realism of Breughel's sixteenth-century works, rather than factual presentations by artists who commonly claim themselves to be "objective realists" in the Eakins tradition.

Much of Billy Morrow Jackson's work is clearly within this newly re-established but highly varied tradition of the landscape as a legitimate artistic theme. Quite possibly, along with these other artists, he is fulfilling a felt cultural need to recover regretted losses, to regain a sense of humanity, of a unified societal whole. Still, his work sets him apart from most of the others. Pictorially, his landscapes communicate tranquility and a renewed confidence in nature, as well as pleasureful aesthetic experiences of light, color, and spatial release. Perhaps his most unique accomplishment is his apparent ability to endow natural settings with the rare attributes of both fertile vitality and the protective, healing powers of ritual.

Quite soon after the completion of *Thawville* in 1968, Jackson began in earnest to produce pure landscapes rather than peopled prairies. He has, in the two decades since then, painted an extraordinary series of landscapes, both in oils and watercolors, that have earned him widespread and justly deserved recognition.[12]

One of Jackson's early color woodblock prints, executed circa 1956 and poetically titled *Prairie Tapestry* (fig. 32), is of much significance in the development of his pure landscapes and illustrates

his interest in using printmaking not only as an independent art form but also as a means of experimenting with new ideas that he would subsequently adopt in the production of major oil paintings. The print features at the lower left a small farm complex that includes a windmill, a few green trees, and a cluster of farm buildings, treated together as a mosaic of colorful geometric shapes that bring to mind the influence of Abraham Rattner, who at the time was a member of the art faculty at the University of Illinois. What is most noteworthy about *Prairie Tapestry* is the extremely low horizon line—approximately one-fourteenth, or just 7 percent, of the total height of the work, which leaves a vast sky area that the artist has covered with a network of dark, exuberant lines of motion, some sweeping upward from ground level at the right edge of the print while others crisscross throughout the sky, creating the impression of violent winds typical of a prairie storm in summer. At the top of the composition, a yellow-orange mass suggests a sun totally blocked out by the storm that hangs over the small farm below.

The extremely low horizon line in *Prairie Tapestry* predates by at least a decade what would become the most evident feature in Jackson's non-figurative landscapes. In fact, in some of the early works in this series the narrow strip of land occupies less than a twenty-fifth of the vertical measure of the composition, and in only a few instances

32. *Prairie Tapestry*, c. 1956

does it occupy as much as one-fifth of the painting. The resulting expanse of sky is rendered in delicate tones, creating an almost imperceptible gradation of color—from dark to light, intense to pale, warm to cool—and introducing an all-embracing (and thus unifying) element. The flat terrain furnishes an equally absorbing field for discovery and contemplation. A seemingly endless horizon is punctuated by barely visible farm buildings and scattered trees and bushes, all silhouetted against a glowing sky. And an infinity of depth is suggested by what is actually a narrow strip of pigment that carries the eye steadily across the terrain and into the distance via horizontal strata of level ground, meticulously tiered and alternating from light to dark and dark to light.

The profusion of factual information within the terrain register of each of his landscapes clearly demonstrates Jackson's ability to scrupulously observe every detail of the environment. Because he continues to search for hidden truths and unseen realities in the environment, and thanks to his skillful handling of particularistic detail, our own awareness and vision are significantly heightened and we are able to see and feel more deeply. This is essentially the objective Jackson set for himself as a young instructor at the University of Illinois—and the one toward which he continues to work.

nineteenth-century farmhouse with adjacent barns and a cluster of leafless trees and frost-covered bushes. Lights glimmering through the tiny windows of the farmhouse add mystery and suggest life within, while serving as a foil to the scale and color depth of the composition. The artist's attention to minutiae is all the evidence we need that, after years of relentless study of the details of nature, he has deliberately chosen to ignore no part of his own world and, moreover, that he is able to integrate all of these data into a harmonious, aesthetically meaningful whole.

Jackson has always taken a special personal delight in the distinctive character of each season, so it is not surprising to find numerous winter settings among his prairie landscapes. Winter forces us to be patient, to allow what our minds know to supercede what our eyes see—namely, that nature has not deserted the earth in winter but instead furnishes a period of rest. We sense how simply yet convincingly Jackson states this profound reality in the handsomely executed *Argenta* (fig. 39), from 1972–73. A broad expanse of snow-blanketed prairie is punctuated by upright fence posts and barren trees, a massive farm dwelling with auxiliary buildings stands in the immediate background, and in the distance rises what appears to be a tall church steeple whose rather copious surface trim suggests that it is decorated to celebrate Christmas. The entire scene invites our participation and readily arouses a nostalgic response.

Another truly exquisite winter landscape is *Then North to Neoga* (fig. 40), executed in 1975. In it, we can vicariously experience the chilling cold of winter, which is reinforced by the neutral color tones dispersed evenly across the entire composition: the sky is pale; the ground, except for broken fence posts and occasional clods of frozen black earth, is covered with snow; and even though a tiny interior light glows dimly from within the farm dwelling, the house itself is dark and barely noticeable. The eerie monotony that would otherwise prevail is offset by the trembling touches of light yellow that cling to the branches of the otherwise barren trees and impart a bit of magic to the entire work.

In a slightly earlier work titled *Monee* (fig. 41), painted in 1973, we encounter a completely unpretentious farmhouse with a nearby corncrib and a towering windmill in the distance.[13] A recent rainfall has left extensive puddles that stretch from the corncrib to the foreground of the composition and reflect the bluish-white light from the subtly colored sky. What is of special interest is the rendering of the land itself. The pigment in the left foreground was applied so as to give the appearance of a loose, uneven surface of rather soft (perhaps muddy) earth, whereas in the distance a long stretch of what may be winter wheat is represented by a narrow ribbon of evenly applied green pigment that appears as a hard, unarticulated surface. Jackson would employ this stylistic change, however slight, in numerous later works.

South of Sidney (fig. 42), executed in 1974–75, reveals some of the same stylistic traits found in *Monee*, especially in the comparatively hard appearance of green grass in the middle distance as opposed to the loose, muddy gray-brown earth in the foreground. However, in *South of Sidney* the whole is embraced by a ravishingly beautiful sky of imperceptibly changing color tones that range from a delicate pink-orange at the horizon to a light blue. As we explore the landscape, we momentarily become entangled in the detailed depictions of a cornfield, a silo with a parked truck nearby, and a thick cluster of handsomely shaped trees bearing an array of colorful autumn leaves—before muddy tire tracks lead us more deeply into the composition. Of special note is the fact that this painting is the first of only two nonfigurative landscapes in which Jackson includes a motorized vehicle.[14]

A rather typical, yet in some respects quite unusual, example of Jackson's landscape genre from the 1970s is *Class of '77* (fig. 43), painted in 1977–78. All of the basic stylistic aspects and repertorial ingredients we encounter in earlier works are present here, including a long slab road leading into a farm property, a luxuriant cornfield, distant trees, and tire tracks in the muddy foreground. What distinguishes this work, however,

is the pair of red-wing blackbirds perched on the fence near the foreground. Their color is more vivid than anything else in the composition. Even though they are comparatively small, they immediately attract our attention, pulling us more deeply into the painting itself, as we search for additional factual material from which to derive fresh insight and visual pleasure. Many of the things we see we would likely ignore but for the keen eye of the artist.

A landscape painting that has received considerable praise since its completion in 1980 is a well-known work titled *Mansfield* (fig. 44). Obviously, the vitality and freshness of atmospheric clarity, as well as the unwavering attention by the artist to sharply focused detail throughout, contribute to the success of this particular work. But it is also the case that *Mansfield* represents the culmination of a series of strikingly similar works— including *After Fithian* (fig. 45), completed in 1974, *Homer Bound* (fig. 46), in 1975, and *Winter Wheat* (fig. 47), in 1978—all of which contain compositional elements quite closely related both in form and treatment to those in *Mansfield*. Atypical, however, is the noticeably high placement of the horizon line, such that the landscape in *Mansfield* occupies nearly two-fifths of the composition. The diminished sky is nonetheless masterfully brushed, with color ranging tonally from a cool pinkish area near the horizon to a delicate purple-blue in the uppermost section.

Once again, deep tire tracks carry our eyes past the snow fence and onto the farm. Although placed at a considerable distance from the frontal plane, the various farm buildings are large in scale and rendered in great detail. One especially intriguing detail is found in the crystal-clear reflections in the puddles near the foreground. Although puddle reflections are commonplace in Jackson's landscapes, heretofore they have not been handled so skillfully. Moreover, the precision in rendering these reflections adds a note of ambiguity, since the viewer must study the painting with special care in order to differentiate actual objects from their reflections. Further ambiguity is apparent in the title of the painting—which is at once the name of an Illinois town and the inference of a human presence in a nonfigurative landscape.

Near the close of 1980, Jackson painted a small, quite handsome work titled *Early Snow* (fig. 48), which in some respects is reminiscent of *October Eve*. What makes *Early Snow* so interesting is that it seems to be a kind of pictorial essay on how reflected light can be represented in a painting. The theme is a farm landscape; the season is late autumn. Light pervades the entire composition, ranging from a rather pale light that originates in the illuminated heavens to a more intense orange light that shines directly from the rising sun. Multicolored autumn leaves are splashed with bright sunlight, as are the faces of several of the nearby farm buildings. To the right is a tree whose branch ends carry a light yellow glow, much in the manner of the trees so exquisitely painted in *Then North to Neoga*. The broader

patches of white snow reflect the sky in varying degrees of intensity across the flat foreground, and in some spots, where snow patches are just beginning to melt, a few tiny puddles reflect the pale blue of the sky and impart variety and interest to the otherwise white and brown expanse of land.

Early Snow, executed very late in 1980, was never intended to represent an advance either in style or technique. Rather, it became an exercise in summarizing some of the devices Jackson had developed and used at various times in painting landscapes throughout the previous decade. In retrospect, however, *Mansfield*, also painted in 1980, must be regarded as a pivotal work because it both summarizes many of these artistic developments and signals certain distinct changes that would appear in Jackson's work in the ensuing decade.

During the 1980s, much of his attention was devoted to painting a number of large-scale cityscapes, interior views, and unusual fantasy scenes. But Jackson remained extremely active in producing prairie landscapes, with one of his most notable periods occurring in 1983–84. During that time, he executed *Rising* (fig. 49). Here, a series of directional lines, including shallow and muddy tire tracks, several long stretches of snow patches, a wide and deep puddle that dominates the frontal geometry of the composition, and a drainage ditch filled with water together carry the viewer into the distance, where the eye pauses among the multiple buildings and scattered trees of the farm. These

devices are essentially the same ones employed in the artist's earlier works, although the dynamic organizational pull into the distance is perhaps more powerful here. Colors are also brighter than those used in earlier landscapes, and the sky, which occupies approximately two-thirds of the composition, is masterfully brushed with delicate pink-orange tones that produce a warm, embracing glow above the vast stretch of farmlands.

Another rather large work from this period is *La Place* (fig. 50), which depicts a farm setting dominated not by landscape as much as by the large-scale, carefully detailed treatment of the farm buildings in the near foreground and by the tangle of cornstalk stubs that stretch fencelike across the entire width of the frontal plane. Indeed, the forceful emphasis of the frontal plane represents a very significant stylistic change that has taken place in Jackson's work. A second farm is seen in the distance, and numerous puddles offer detailed reflections of the surrounding natural features as well as the delicate light of the sky, thereby amplifying the sense of space and enlivening the composition.

One quite unique piece among the major works from 1983–84 is simply titled *August* (fig. 51). It, too, is a prairie landscape, but it is unlike any of the others produced up to that time. In the distance are several farm buildings that go largely unnoticed because of the luxuriant, dense tangle of trees, bushes, weeds, prairie grasses, and colorful late summer flowers. This work is also unusual by virtue of its contrasts: a generous section of largely bare soil punctuated by a few scattered grasses and a cluster of small blooms lies to the right of an area of harvested cornstalks that have been trampled to the ground, creating a network of interlocking forms that clearly echo the woven mesh of growth covering the fields just beyond the small section of adjacent fence posts.

Contrast not only in form and composition but also in theme is often part of the underlying ambiguity in many of Jackson's paintings and is well expressed in *Champaign* (fig. 52), which he painted in October 1984. The time is late fall, and most of the trees bear handsomely colored leaves, yet we experience a taste of winter with the frost-encrusted grasses along the roadway and snow on the rooftops of the farm buildings on the left.

As with many of his paintings from the mid-1980s, such as *August* or *La Place*, in *Champaign* Jackson concentrates technical interest on or near the frontal plane rather than in the distance. The same compositional dynamics appear to be at work, with the spectator being pulled into the painting by the wide and open roadway yet unable to resist focusing on the refined, carefully executed detail that is present throughout the entire left sector of the composition. Jackson's typically delicate handling of the vast sky takes on a new dimension, with tonal gradations occurring not only from the horizon level upward but also laterally—almost imperceptibly—from the right side, where the colors are yellow-orange, to the left, where they become a cool, pale blue.

Jackson's *Prairiescape* series of sixteen numbered watercolors, executed in 1986, retain the comparable style and aesthetic feeling of his landscapes from the late 1960s and 1970s. All are typical farm scenes, and all consist of large-scale forms with visual detail concentrated primarily in the frontal plane, as seen, for example, in *Prairiescape #5* (fig. 53) and *Prairiescape #6* (fig. 54). Of special interest, however, is the snow scene in *Prairiescape #5*, which includes a piece of farm equipment, making this the second of only two paintings by Jackson (the other being *South of Sidney*) in which a motorized farm vehicle appears. Even more noteworthy is the truly unexpected appearance of a human figure at the open barn door, an element that has been absent from Jackson's landscapes since the late 1960s. We must therefore ask whether *Prairiescape #5* signals a potential change in terms of style and thematic content. Time alone will tell.

In concluding this discussion, certain general observations on the evolution of Jackson's landscapes are appropriate before we move on to other thematic types with which he has been deeply concerned during the past twenty years. Consistency throughout the landscape series is fully evident, yet a chronological review of the works

themselves indicates that the artist's style, once established, has in no sense remained static. For example, the early landscapes done prior to 1968 show an indebtedness to Edward Hopper and are fundamentally backdrops for an architectural setting that thematically includes a human incident. Gradually, the architectural component has receded into the distance and the human incident has been eliminated altogether, giving free play to the development of the natural or pure prairie landscape. In recent years, this tendency has been steadily relaxed and in some instances almost entirely reversed, with attention focusing on the architectural elements, which have increased considerably in scale and have been brought steadily forward toward the frontal plane. With the single exception of *Prairiescape #5*, the human incident has been eliminated, and the landscape itself again serves in most instances as a simple backdrop.

A comparison of the aesthetic content of the earliest pure landscapes with that of more recent works is also revealing. In such early paintings as *Flatville*, *November Vista*, and *Royal*, we are exposed to an awe-inspiring experience that is seemingly associated with the extremely low horizon and the enormous distance that appears between us and the overall scene, as well as all of the objects in that scene. Our awe is intensified when

we realize that, while the scale of those objects is minute, the objects themselves are rendered with impeccable clarity and precision, though never overemphasized in the total composition. We are struck by the all-embracing sky with its rhapsodic subtleties of color; indeed, we are struck by the immensity of creation.

With the attention to detail that is evident in almost all of his paintings executed since just before 1980, Jackson has exposed us more to a material reality than to a spiritual reality. In one sense, the change has been from the universal to the particular, for with the later works we tend to participate in a specific situation, while the earlier works bring us more directly—and more immediately—into the realm of a purely aesthetic relationship. Of course, it would be erroneous to conclude that Jackson's recent pieces lack an aesthetic quality, for the aesthetic dimension remains the paramount objective in all of his work. Still, the fascination with minutiae might cause us to dwell on the factual data at the expense of the poetic qualities implicit in the handling of those data, thus depriving us of the discovery of a broader, more fulfilling aesthetic experience. And it is at this point in the development of Jackson's landscapes that we begin to recognize the momentary appearance of a somewhat closer stylistic relationship with the work of Andrew Wyeth—a relationship that has, however, never stylistically interferred with Jackson's independent growth.

A devotion to the natural setting and to the landscape in particular is an undeniable part of Jackson's thinking and, correspondingly, of his oeuvre. Certainly, the prairie landscape phenomenon has in some ways dominated his planning of almost every painting of the past three decades or so, including his many interior views and cityscapes, where more often than not a landscape is added as a secondary, supportive feature. In such instances the landscape is not intended as a decorative element but rather serves as an integral part of a broader compositional context. Indeed, as we shall see in the next two chapters, when a supporting landscape appears as part of an exterior setting, the landscape heightens the awareness of space within the exterior setting itself. By the same token, the landscape seen through a window provides a sense of freedom and escape beyond the restricting limits of the interior.

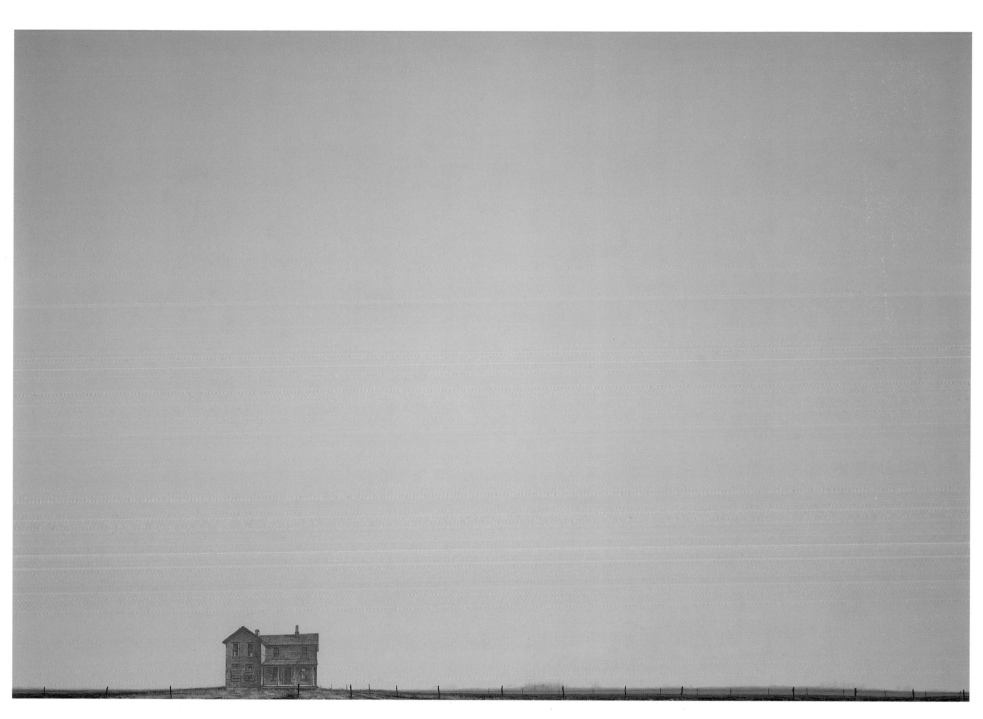

34. *November Vista,* 1969

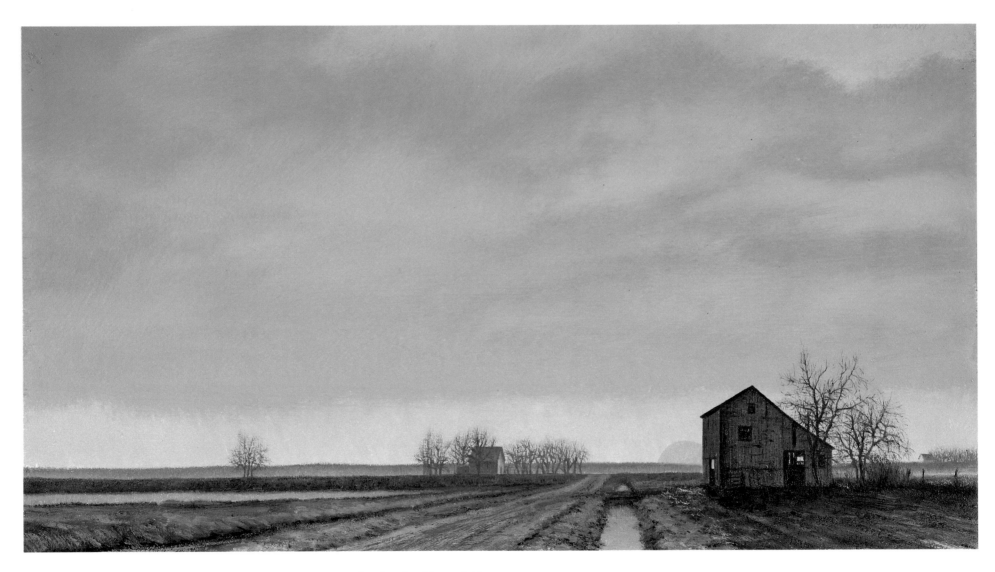

35. *October Eve*, 1969

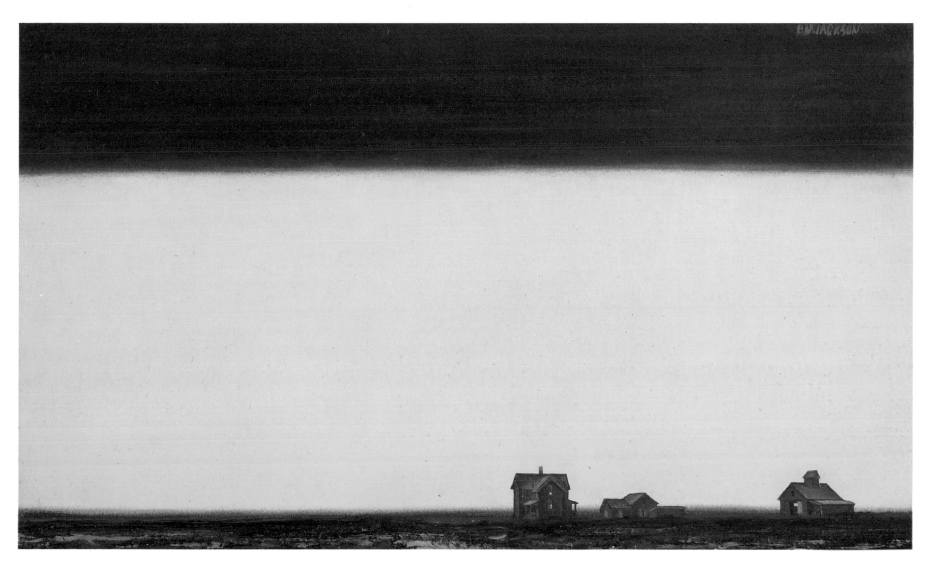

36. *Forecast*, 1969

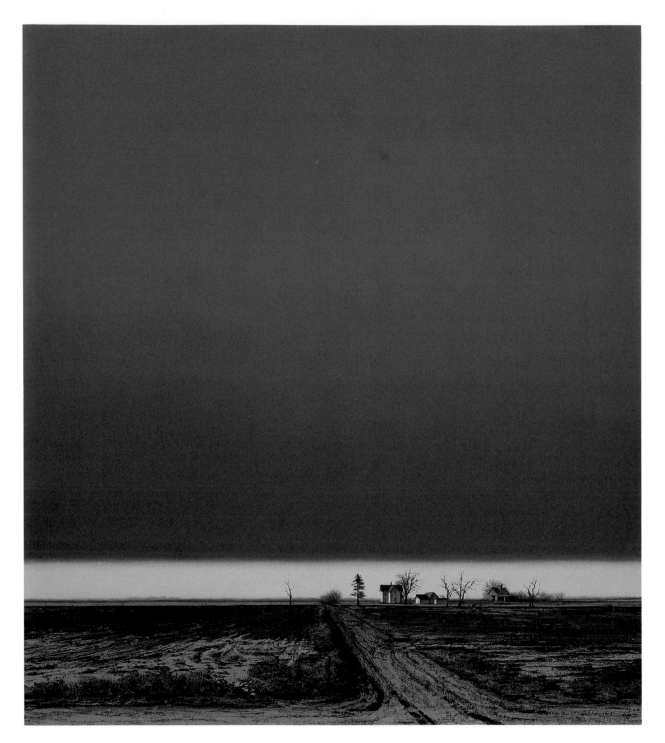

37. *Spring Field,* 1971

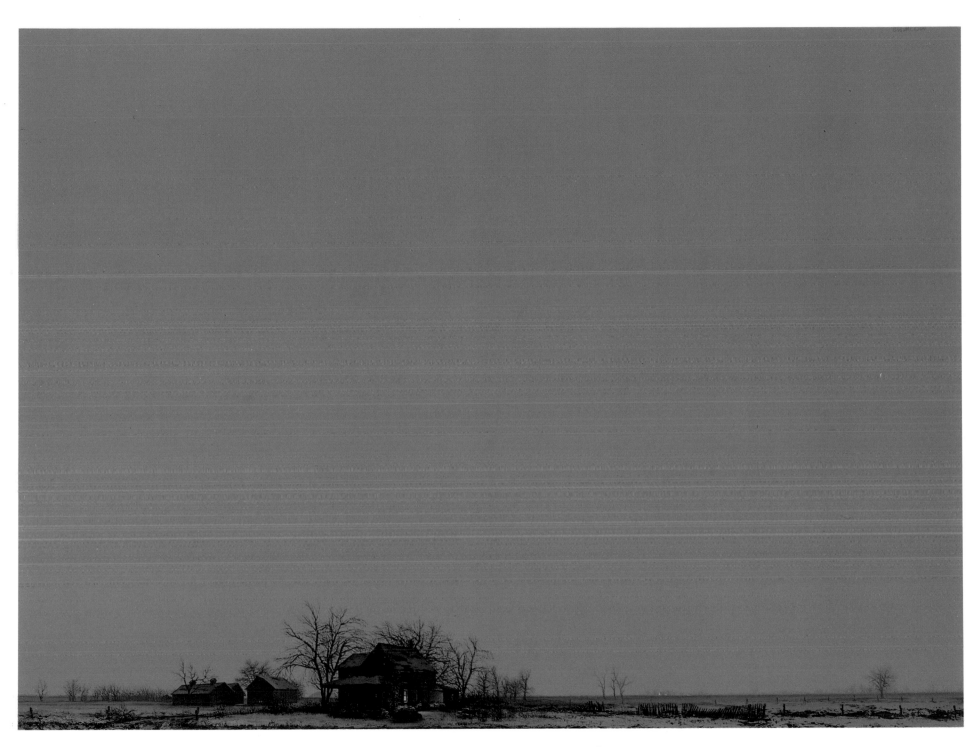

38. *Royal: Sunset on a Prairie Farm, 1970–71*

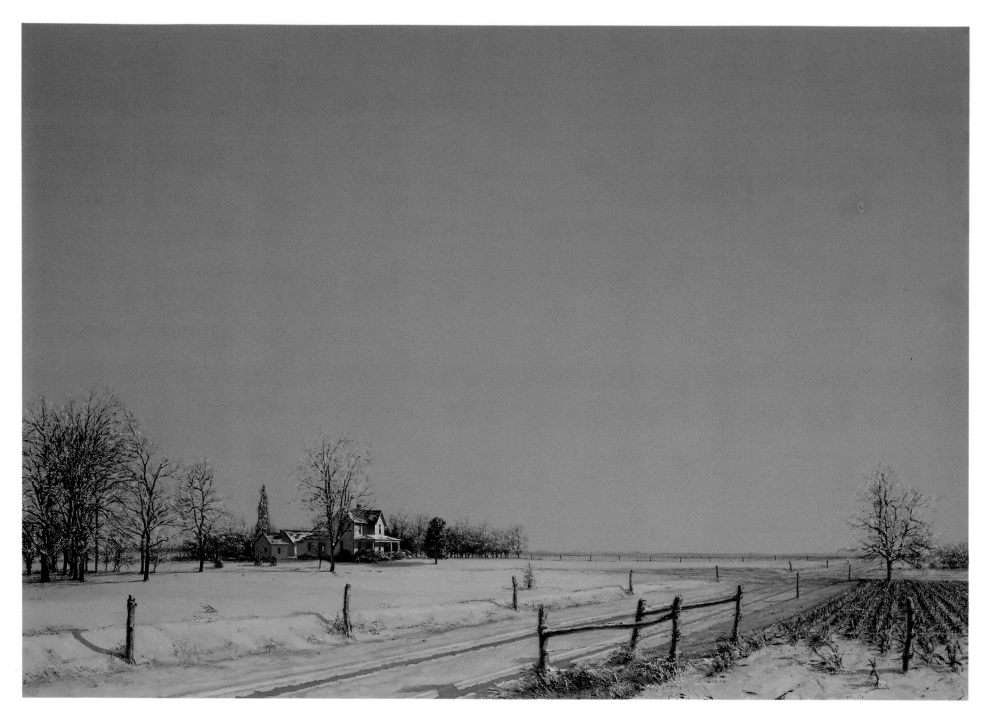

39. *Argenta, 1972–73*

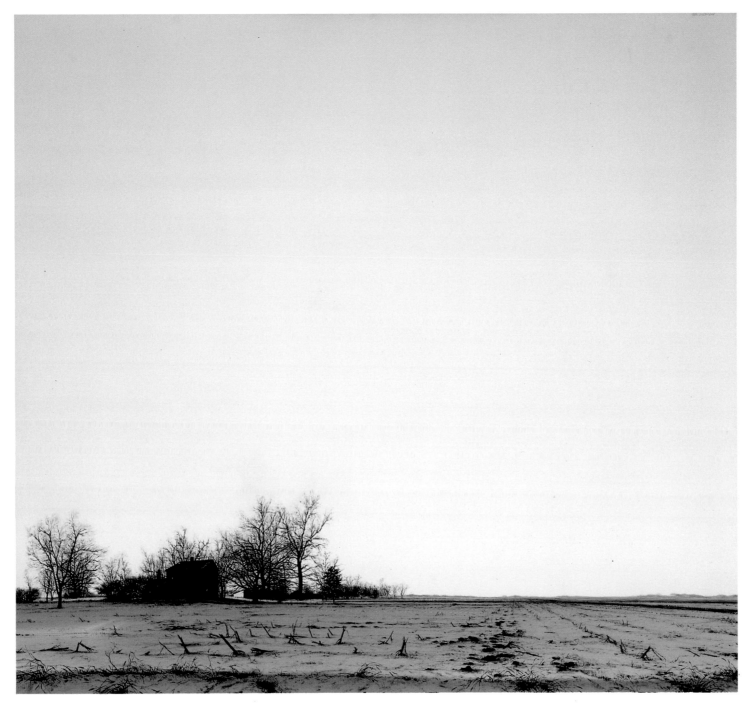

40. *Then North to Neoga,* 1975

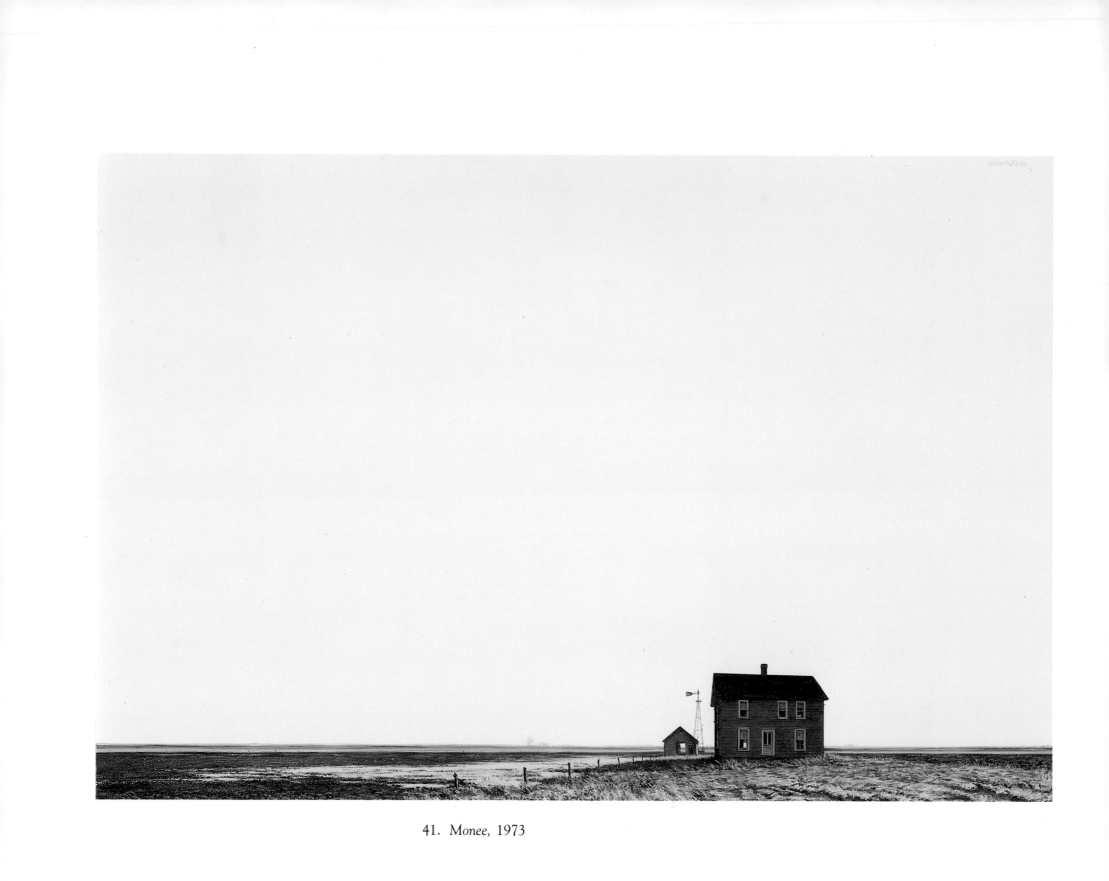

41. *Monee*, 1973

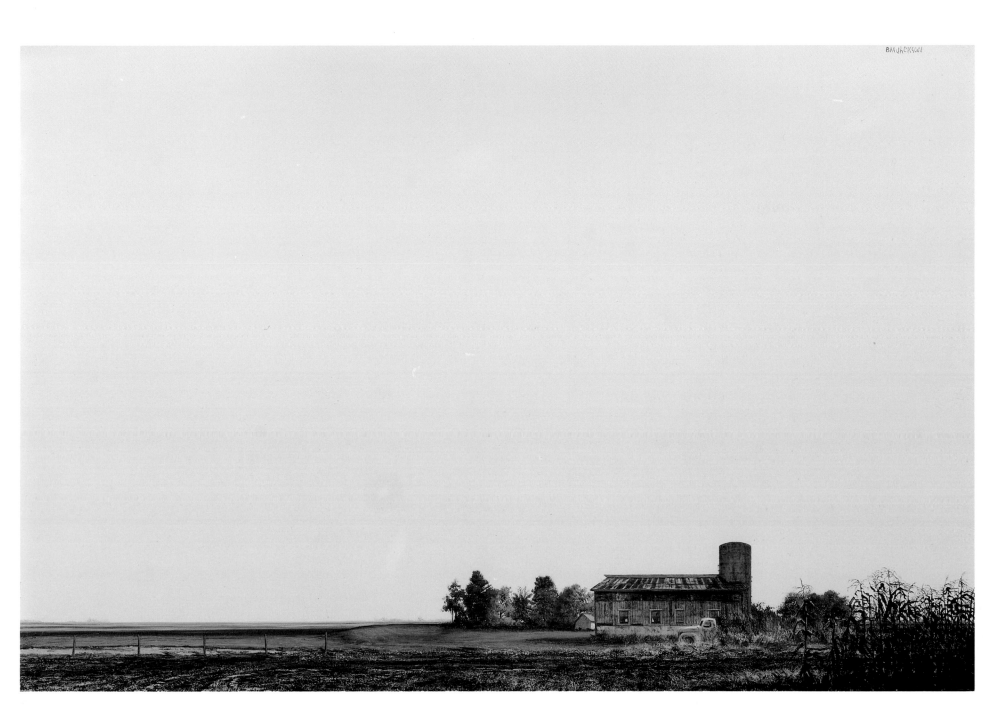

42. *South of Sidney, 1974–75*

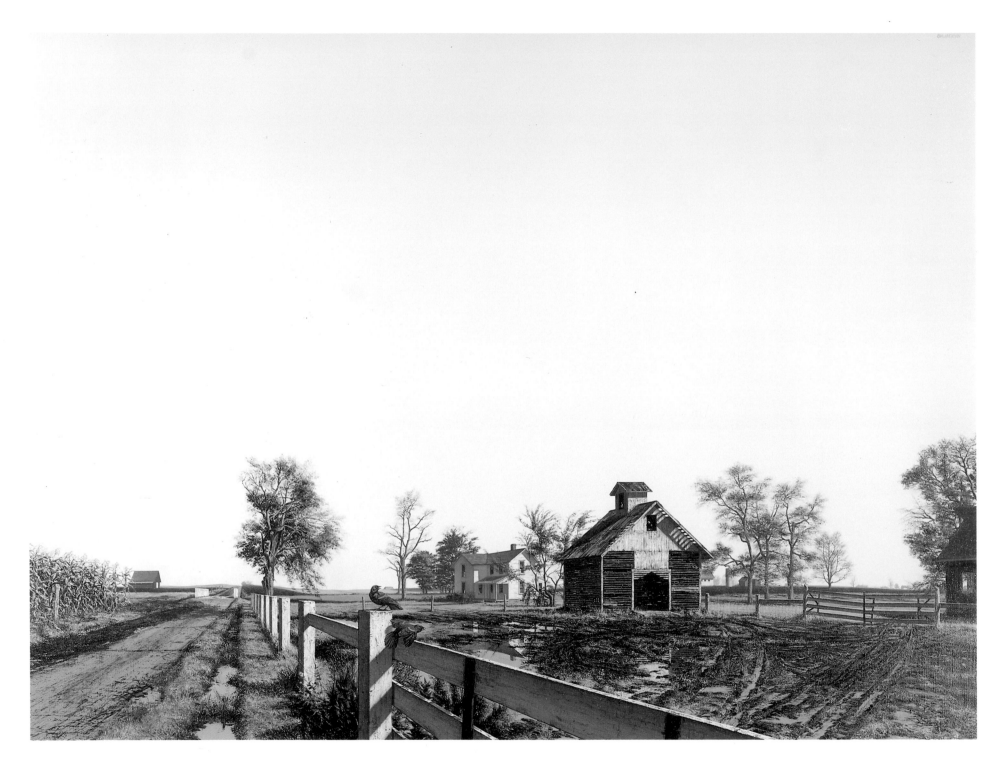

43. *Class of '77, 1977–78*

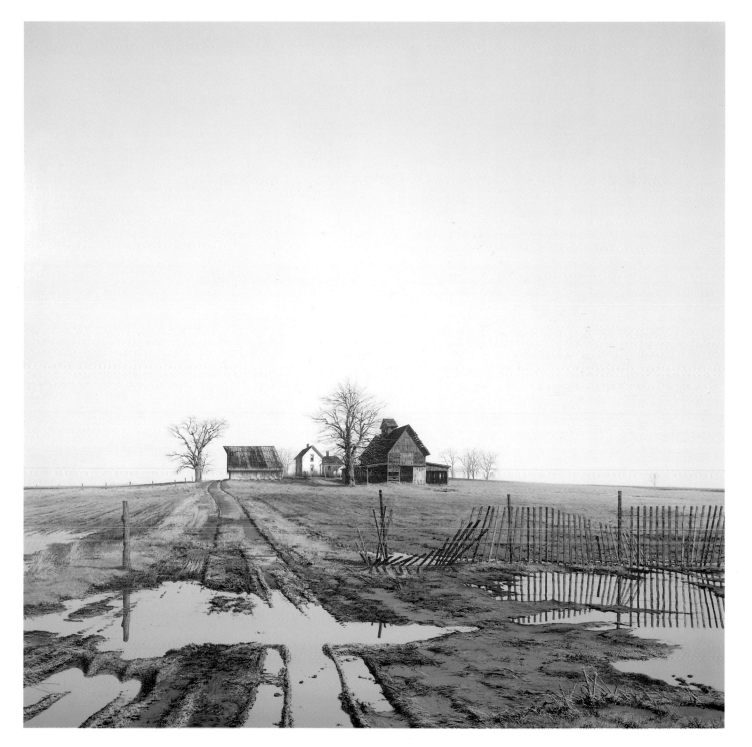

44. *Mansfield, 1980*

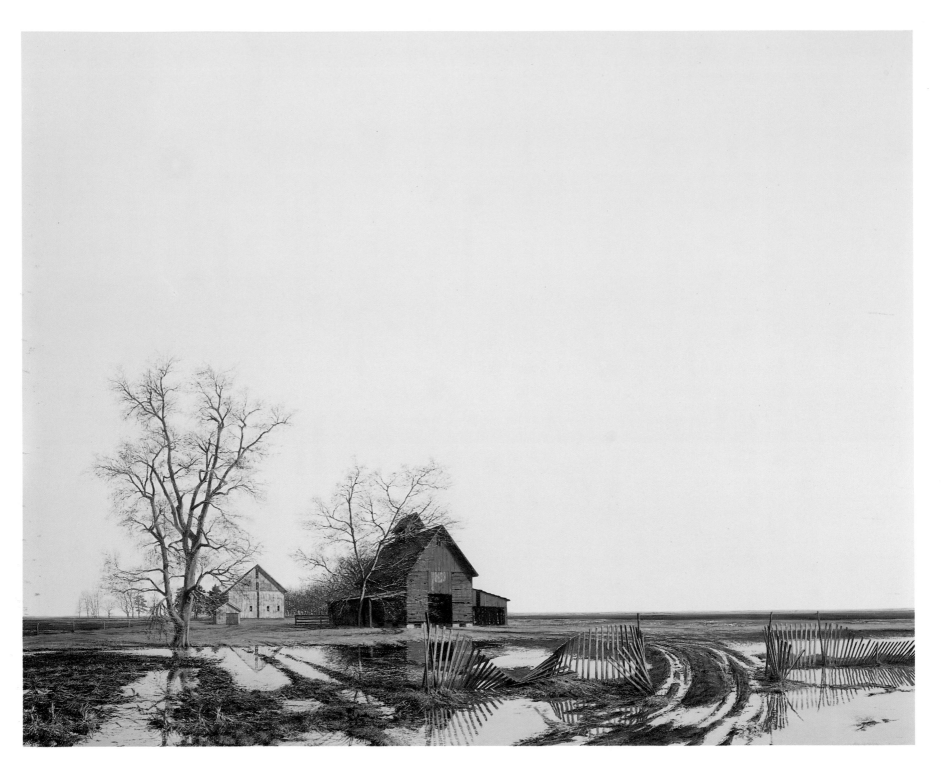

45. *After Fithian*, 1974

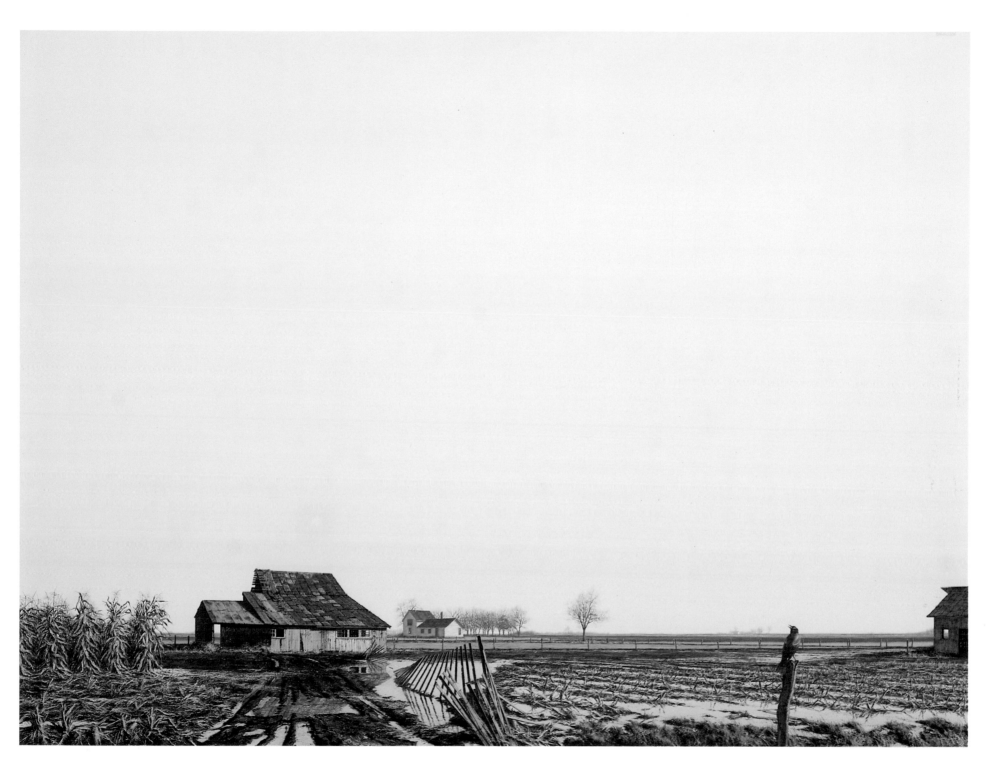

46. *Homer Bound, 1975*

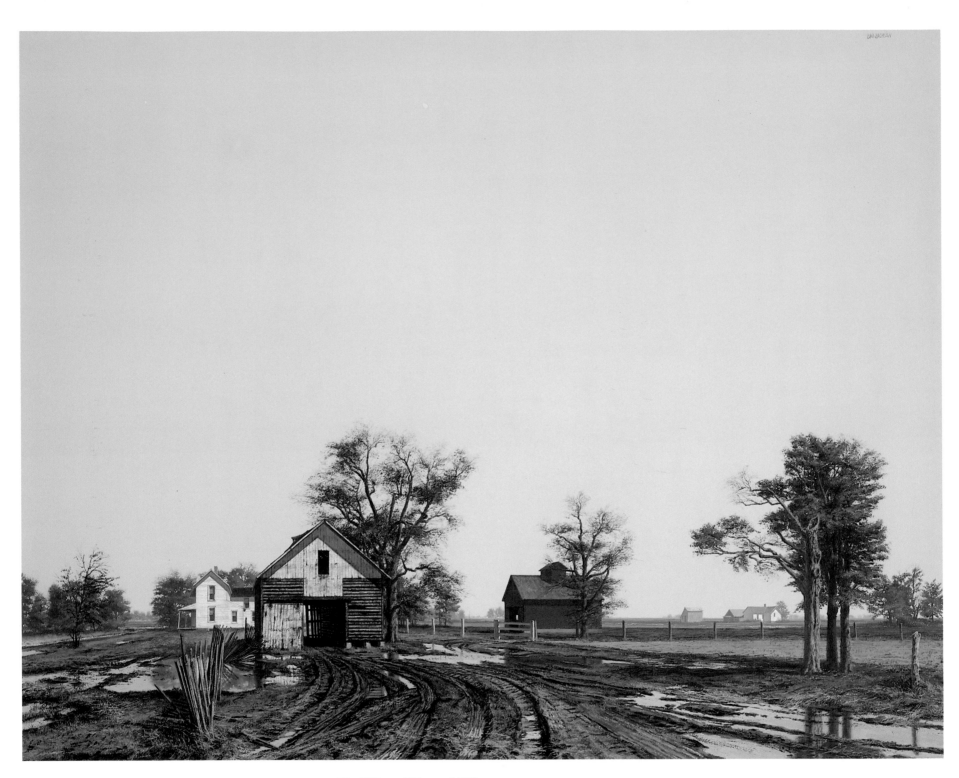

47. *Winter Wheat, 1978*

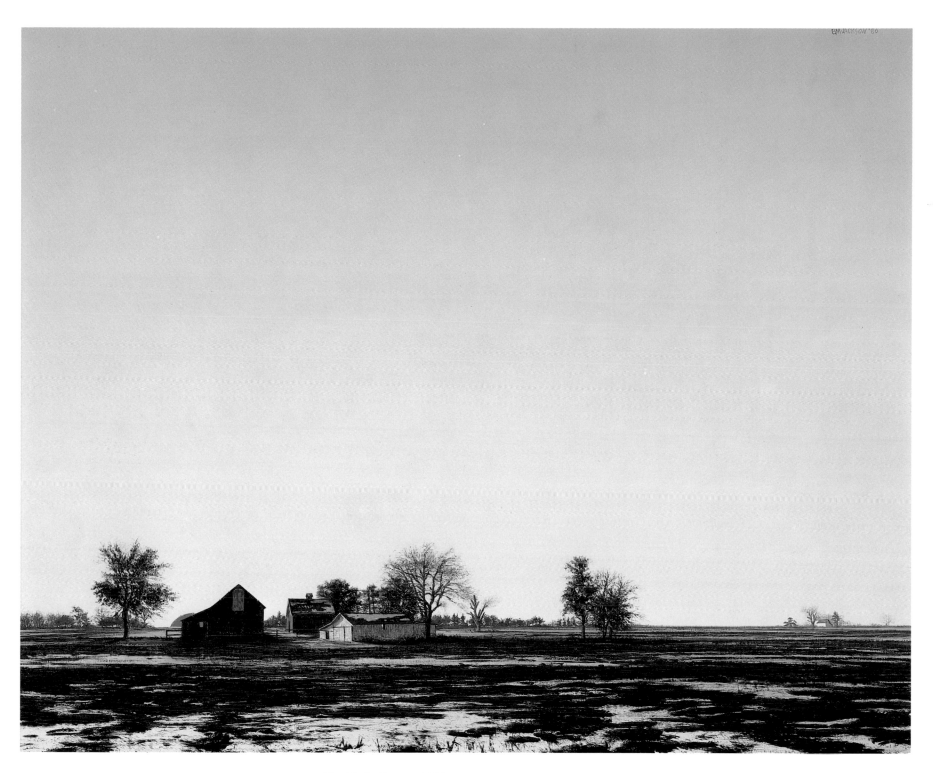

48. *Early Snow, 1980*

67 / PURE LANDSCAPES

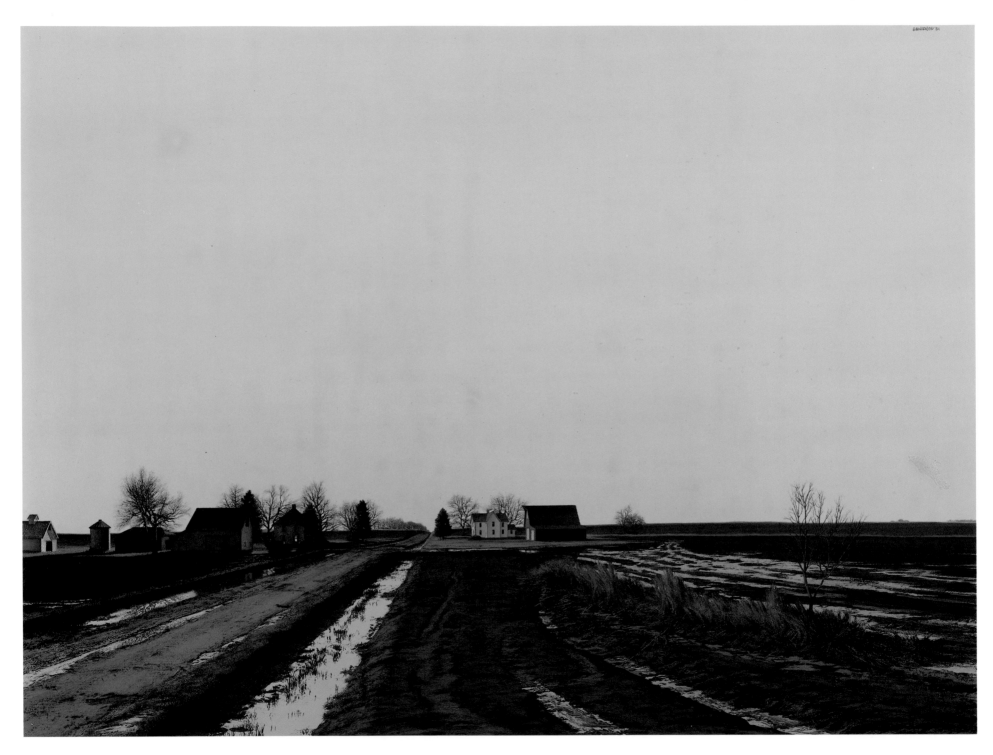

49. *Rising*, 1984

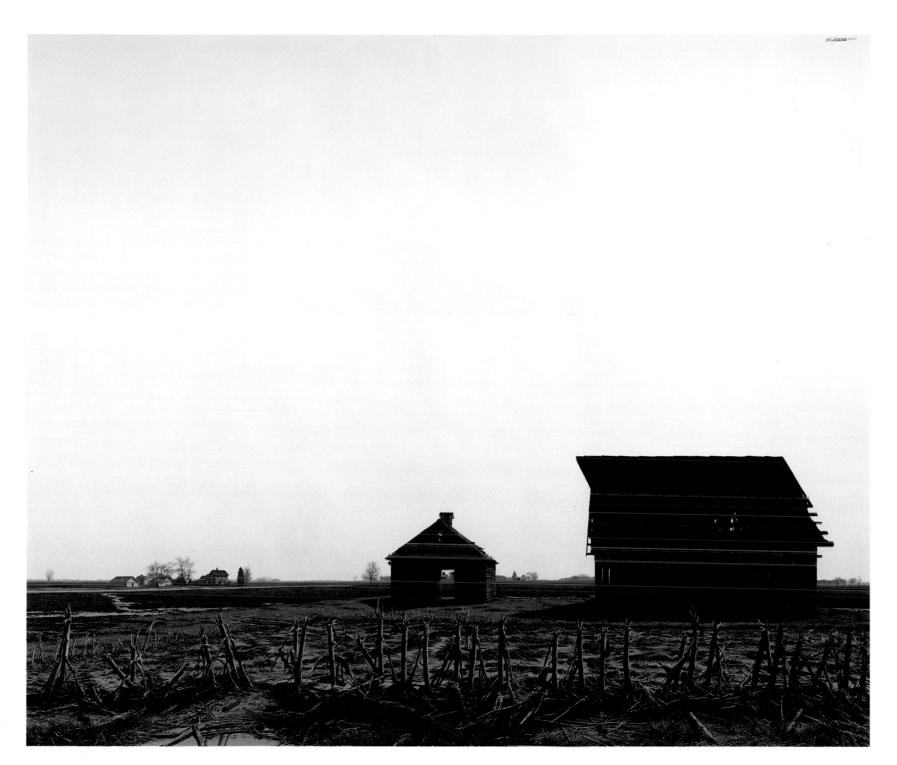

50. *La Place,* 1984

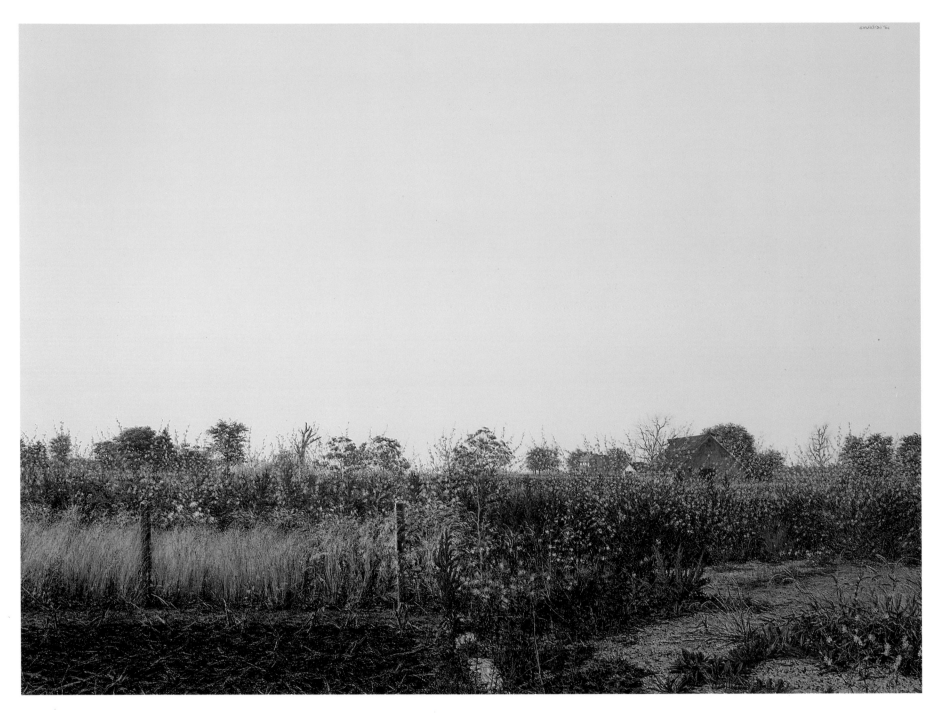

51. *August, 1984*

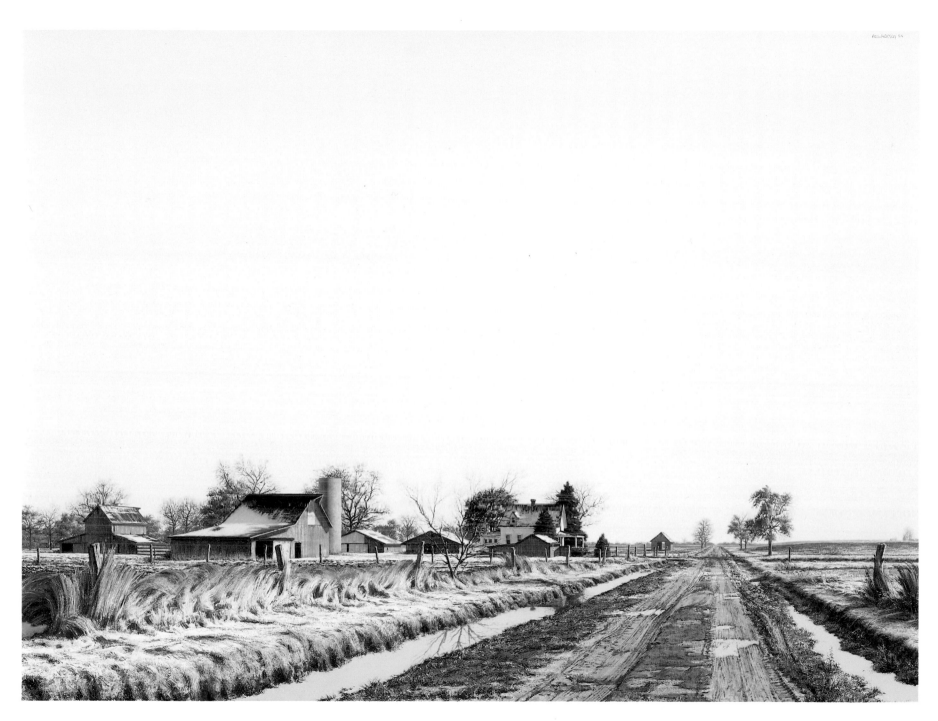

52. *Champaign, 1984*

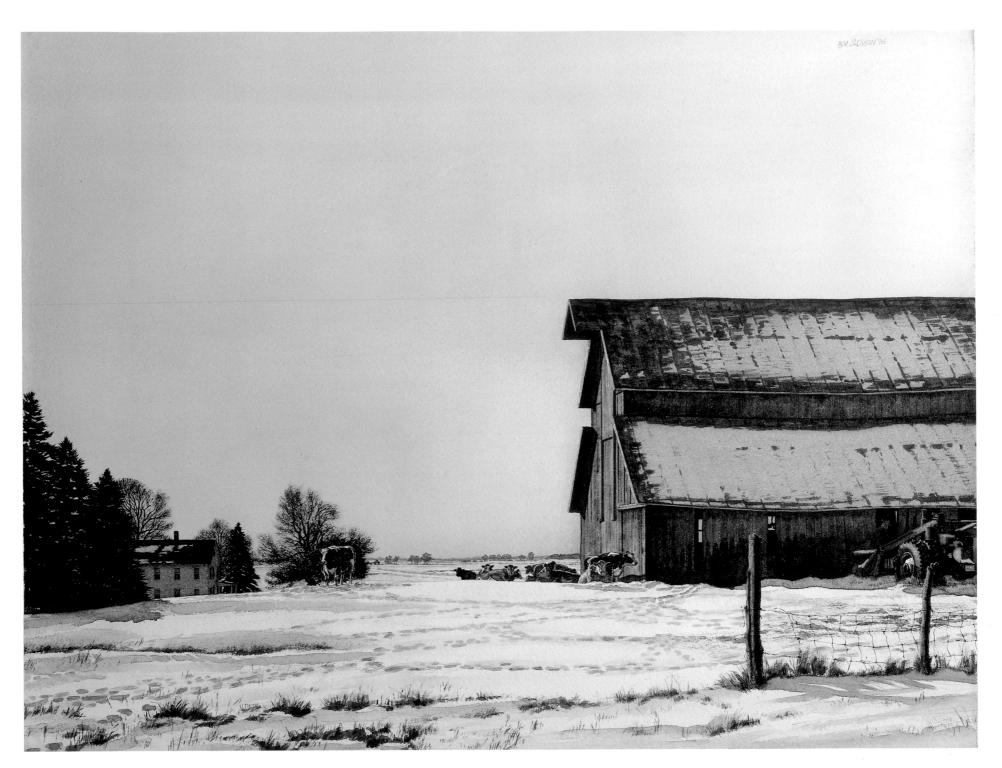

53. *Prairiescape #5*, 1986

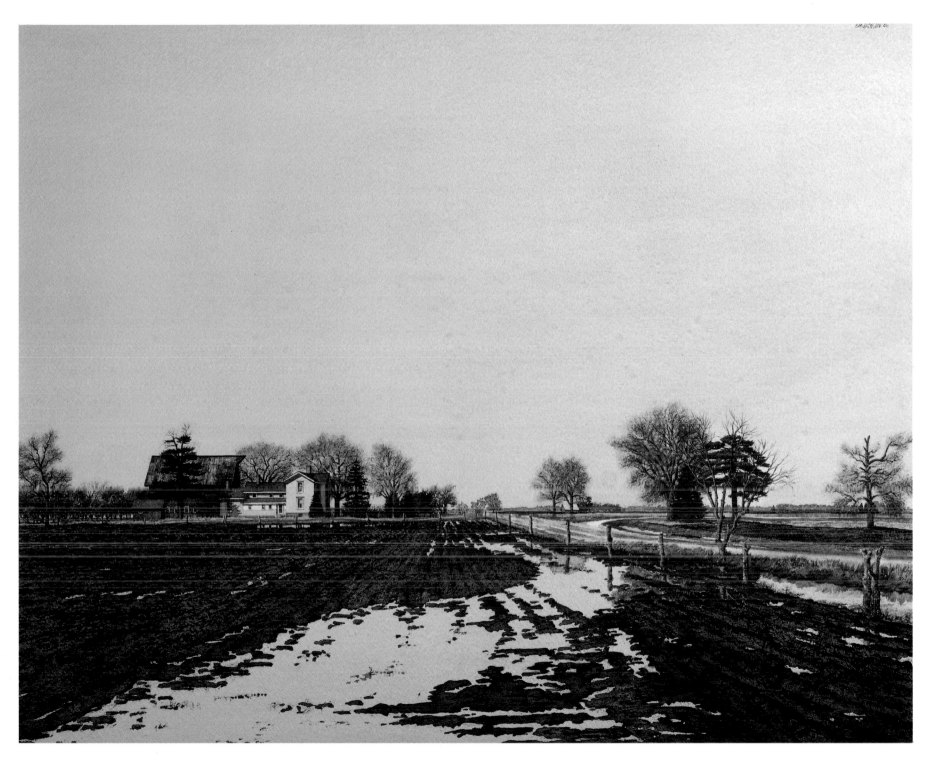

54. *Prairiescape #6*, 1986

5

Cityscapes
and Street Scenes

In addition to his many prairie landscapes, Jackson has also executed a number of interesting cityscapes and street scenes. These are based on detailed studies of the architecture and physical layout of real places, as well as on the carefully observed activities of groups and individuals who live and work there. As might be expected, many of the formal elements employed in these paintings are carried over directly from his landscapes, such as the use of frontal composition; the delicate gradation of light as the all-embracing, unifying agent; and the rendering of minute detail, leaving nothing unnoticed that might contribute either to the artist's intended feeling and meaning or to our better understanding of the composition.

Although Jackson is unquestionably an admirer of the quaint and familiar pattern of American life that prevails on the farms and in the communities of the Midwest, he also finds much that is interesting, exciting, and intellectually stimulating in the turbulent, often seamy aspects of everyday urban life, where customs and behaviors seek entirely different outlets. We recall, for example, how he enthusiastically documented life in the small Mexican towns where he lived in 1949 and 1950, soon after graduating from Washington University in St. Louis. Of course, his boyhood years in St. Louis also afforded him the opportunity to see and experience the core of city living.

Jackson's first street scenes were painted in the Spanish town of Palma, on Majorca, during the summer of 1962. He had accepted an invitation

by the Harmon School of Art to teach a painting course there, and he used the occasion to produce a number of works that capture his impressions of the town and of Spanish culture (with which he was acquainted only through his earlier visits to Mexico and southern California). On his return to the United States, many of these paintings were publicly exhibited and received widespread attention. Two oils in particular merit comment here. *Palma Streets* (fig. 55), a detail of a town plaza the Plaza de Coll—includes typical Spanish shops and house façades, an outdoor café, and a commemorative marker. *Palma at Night* (fig. 56) is a view from above of a domestic section of the town and shows people living leisurely outdoor lives amid the thick, fragrant Mediterranean vegetation that adorns the area. Both of these pieces clearly disclose Jackson's interest in people and their customs, and both indicate the importance he places on the architectural setting of a street scene and on the role of light, artificial as well as natural, in defining form and creating mood. Yet they otherwise make no claim to a close compositional affinity with the cityscapes that would follow beginning in the late 1960s.[15]

Jackson's stylistic approach to street scenes during the late 1960s and thereafter derived from his early experience as a painter of three-part landscape compositions consisting of a human incident enacted in a dominant architectural setting presented against a landscape backdrop. However, an even more dominant role is assigned in his cityscapes to the architectural environment, where in many instances older, timeworn struc-

55. *Palma Streets,* 1962

tures line the streets of towns often undergoing urban change. As in his landscapes, the architecture in his street scenes is raised to an exalted level, used to heighten awareness of time and often to function as a vehicle for social commentary. In these compositions, we see the drama of daily living and how that drama is colored by the magic of the lingering past.

56. *Palma at Night,* 1962

Clearly, Jackson has mastered the technique of combining the past and the present, using art to symbolically comment on a wide spectrum of social issues ranging from urban renewal and political scandal to racial bigotry and illicit drug traffic. He almost invariably treats his subjects from the psychological posture of silently watching and patiently waiting—an issue he addressed in his 1966 application for associate membership in the Center for Advanced Study at the University of Illinois (discussed in chapter 3). Perhaps because his most significant statements are those addressed to change or the imminence of change, in his works executed since the mid-1960s he has assigned roles to his human figures that are clearly a testament to his personal sympathy for those who must wait—with anticipation, disappointment, and often grief—for any type of social change to occur. In many respects, then, the waiting figure is the key to fully understanding the underlying meaning of his cityscapes.

It is interesting to note that by 1968 the street scene was a thoroughly logical theme for Jackson to pursue. By its very nature, it could readily accommodate the architectural framework for human figures that he had just eliminated from his landscapes. Moreover, he had just begun to focus serious attention on the use of the waiting figure, and cityscapes or street scenes certainly seemed to be appropriate settings for expressing the behaviors he associated with that image.

Jackson's first major street scene, *Main Street* (fig. 57), was completed in 1968. This composition consists of a frontal view, with a long stretch of handsome, stylistically mixed late Victorian

façades extending across more than three-fourths of the total length of the painting. Every detail is rendered with meticulous precision, as in the châteauesque turret with its dignified conical roof, which overhangs a shop that had been converted into Democratic headquarters but is now vacant.[16] Through the shop window we see a man who appears to be walking in the misty distance, and we can also glimpse the interiors of second-story tenement apartments—reminiscent of Jackson's many earlier studies of curtained windows with faintly visible interior forms and ghostlike figures peering outward. The street, still wet from a recent rainfall, offers up muted reflections of the storefronts, a flag, and two people waiting near the corner.

The setting of *Main Street,* though lonely and gloomy, is not unfamiliar; indeed, it engages our attention and our vicarious participation in the scene being presented. We are drawn into the composition by the receding lines of the street pavement and, even more, by the reflected forms and figures from the spectatorial plane that appear in the store windows facing us. The ambiguity thus introduced adds an arresting dimension to the composition, for we are confronted by figures that do not exist in the pictorial space itself and therefore do not represent actual participants in the situation being depicted. Of special interest is the fact that, just as the partially dilapidated buildings symbolize the past, so the immediate present is represented by the young man seated on a bench and by the report of murder that prominently headlines the newspaper he is reading, which is visually accented by a narrow red line to catch our attention.

57. *Main Street,* 1968

A nineteenth-century architectural backdrop frames life in the present in what is certainly one of Jackson's finest street scenes, a painting titled *Downtown* (fig. 58), which he executed in 1972–73.[17] The open central space of the composition is bordered by the corner of a brick building, by a three-story French revival structure, and by the rear of a block of old buildings that present a variety of interesting and colorful abstract geometric patterns. The enormously stretched space between the frontal plane and the stately dome of a beaux arts courthouse furnishes dynamic depth and allows the viewer to focus on activity in the foreground while remaining ever cognizant of the dome itself, clearly silhouetted against a delicately graduated luminous blue sky, which in turn is reflected in a nearby puddle. The carefully articulated light, which serves to intensify our awareness of detail, is fascinating in its convincing exactness, though it is also subordinated by (yet assuredly contributory to) the overall mood of the composition—a mood that on the surface seems still and quiet.

The people on the street in *Downtown* appear to be indifferent to each other's presence, although an aged woman with a cane has turned her head toward the young pregnant woman who is about to cross the street in our direction. From a third-story corner window, a woman—barely visible—draws aside the curtain and peers out onto the street below, while in another building a hard hat leans on the window sill and looks down as though an event of special interest has attracted his attention. Near the center of the composition, a woman sits quietly on a bench, reading to the child who leans against her. The young man who

stands behind the pair completes the triangle, one side of which carries the viewer directly back to the courthouse dome. An artist—Jackson himself—although he appears to be objectively observing and sketching, is formally linked to the family group by a small section of yellow-painted street curb that outlines the shallow platform on which the family group is waiting.

As we explore the composition more carefully, a new level of awareness emerges and the mood seems less relaxed. Indeed, it appears that something is either about to happen or is already happening beyond the limits of the pictorial space yet within the space we, as spectators, occupy. A peace symbol inscribed on the façade of the French revival structure alerts us to a major politi-

cal and social issue of the mid- and late twentieth century; and a barely legible sign advertises drugs and sundries, with the word *drugs* perhaps meant to elicit an awareness of a social issue even more crucial now than in 1973. Although we can barely make out the white graffiti scrawled on the restored wall of the brick building on the right, close observation reveals the word *TAPES* and the fragment *DIX PLU[MB]ERS*, obviously referring to certain political issues during the Nixon administration of the early 1970s.

In the end, we are left with more questions than answers: about the phantomlike figures gazing from the windows; about the family linked

formally to the courthouse dome; about the elderly woman who has turned toward the young woman. Is there more here than meets the eye? Or are our own uncertainties merely a reflection of our unresolved, disquietingly ambiguous feelings—perhaps universal human feelings that are lived out every day on every street corner in every town?

The sense of time and change expressed in *Downtown* is carried considerably further in *Moments* (fig. 59), a large painting executed by Jackson in 1976–77.[18] In one sense, *Moments* can be viewed as a fantasy construction of past and present. The scene is again a midwestern town, but the architectural emphasis is on both Victorian and contemporary structures and the thirty-eight human figures represented include ghostlike presences of identifiable historical as well as contemporary men, women, and children. All are juxtaposed within a single setting and enact their respective roles within a psychological time frame that encompasses both today and a past century.

Compositionally, *Moments* is closely related to *Downtown*, with bold masses receding into the distance along a sharp diagonal. In addition, by virtue of the powerful pouring forth of pictorial space onto the frontal plane, the viewer's presence is more completely integrated into the scene itself; and this relationship is strengthened further by the athlete who is racing toward us. The light in *Moments* is also strong, though treated with extremely subtle nuances of color tone, especially with regard to the sky, and the technique throughout is exceptionally precise. Both works are crowded with a wealth of symbolism, necessitating careful

scrutiny in order that the various meanings might unfold fully and the aesthetic significance be sufficiently appreciated.

As in *Downtown*, the impact of past experience on present behavior and of the ambiguities so typically characteristic of social transition are given concrete form in *Moments*. What is especially different and interesting in *Moments*, however, is the manner in which Jackson accomplishes the temporal displacement: not only does he place old and new buildings in close proximity to one another—a phenomenon found in almost any town or city at any time—but he introduces ambiguity into the seasonal moment as well, as suggested by patches of snow near green grass and bushes and by the simultaneous depiction of some figures dressed in winter clothes and others obviously in summer attire.

The compression of time is further emphasized by the introduction of a modern automobile and a Conestoga parked close to one another on the

same side of the street; and again by the intrusion of ghostlike figures from the past, such as the rebellious Carry Nation, standing proudly as a symbol of righteousness and moral order. Yet in accord with present-day societal norms, the shop signs on the opposite side of the street prominently advertise "Happy Hour!" and "Drugs and Sundries," the latter carrying the same double meaning as in *Downtown*. The sense of time passing is also present in the deep, long shadows and in the man who is glancing at his wristwatch as he hurries across the street.

The mood of urgency and imminence that permeates *Moments* is stressed by the people who are seated on benches and who appear to be waiting and watching—but for what? The activity apparently lies outside the bounds of the painting and is suggested by the young man standing in profile who is looking intently down the street, as well as by the enchained black man who peers in the same direction, shading his eyes with his right hand. A seemingly dispirited woman stares directly into our space; and nearby a man leans against a flagpole and looks toward us with a sardonic grin on his face. On the right, serving as a repoussoir figure, is the artist himself, who looks probingly into our space for data that he will perhaps translate into visual imagery on the sketchpad he holds in front of him.

Several other aspects of this painting warrant some mention. Although *Moments* is in every sense a street scene in a busy American town, Jackson obviously felt the need to momentarily shift our attention to the countryside. Therefore, in the center of the composition and hoisted on three tall supporting poles, is a large placard on which he has depicted a hilly landscape. Of equal interest is the tall supporting pole on the right, for it falls across the adjacent wall painting of four U.S. presidents and functions visually to divide the images of the two Republicans from the two Democrats.

In 1982, Jackson was commissioned to produce a large painting for the Busey Bank in Urbana, Illinois. That composition, completed in 1983, is titled *Reflections* (fig. 60) and is one of the most engaging—and, like *Moments*—among the most anachronistic and complex paintings ever executed by Jackson. As the title suggests, the composition is actually a study of reflections, though the term carries a double meaning, referring both to optical images and to lingering memories. Strong surrealist tendencies must also be acknowledged by virtue of the temporal and spatial dislocations clearly in play.

The ambiguity in this work is immediately apparent as we attempt to identify the objects and relationships within the spaces around the contemporary bank building that dominates the composition, for both interior and exterior views are seen simultaneously and flow together. That phenomenon is most apparent in the pictorial space between the bank building and the frontal plane, much of which is taken up by streets and sidewalks, and by the merging of pictorial space and spectator space. We are struck especially by the figures of the woman and the young boy, seen in the immediate foreground, who we assume must be inside the bank lobby from which they peer outward through a glass wall at us, the viewers. The same might be said of the man who appears to be standing next to them, but careful observation reveals that the *back* of the man is reflected in the glass wall, and he therefore must be *outside* the bank, within the viewer's space.

Toward the left of the composition, in what could be the lobby of the bank, a Union soldier talks to a man dressed in a modern business suit. In the background is the façade of a small nineteenth-century brick building whose front windows reflect images of a streetcar and two nineteenth-century bankers. All of these are but memories of the past: the Union soldier represents Colonel Busey, the founder of the bank; and the brick structure is the original Busey bank building.

Temporal interchange is also evident in the façade of the contemporary bank structure, where we see two long strips of reflected older buildings—buildings from the past that haunt the present, projected from the viewer's space. What is especially interesting here is the way Jackson has so masterfully handled the reflections from an optical standpoint. Several of the buildings are slightly taller than the others, and their reflections therefore spill over onto the adjacent stone enframement. Since the surface of the stone is not level with the glass window strip, the reflected images are understandably refracted, thus adding further ambiguity to the work even as the flavor of actuality is intensified.

The central Illinois prairie, having captivated Jackson over the years, is incorporated into *Reflections* by means of the small landscape in the upper left corner. Here, too, the artist employs temporal interchange in his depiction of a large round barn in a snow-covered field that is juxtaposed with a rich summer cornfield. In addition, the viewer is carried from the prairie directly onto the tellers' desks in the adjacent view of the bank, and from there along a railing that leads to the outside of the bank itself, thereby linking both the interior and exterior of the building with the surrounding imaginary prairie.

Prairie imagery is repeated in the upper right corner, where the artist himself is seated on a scaffold, painting a prairie view in the sky. Conceptually, this may be the most enigmatic segment of the composition, for we are left wondering whether this is a reflection of something that is actually taking place across the street or whether Jackson is in the process of overpainting the entire work and substituting a prairie scene in its place. The feeling of actuality is intensified by the comparatively large scale of the artist at work and by the trompe l'oeil effect of the two pulley ropes that hang down across the frontal plane.

It is interesting to note the relationship of *Reflections* to works by Richard Estes, who has executed many stunning and thoroughly successful pieces that are essentially careful studies in optical reflection. Estes, of course, is often called a photorealist, and many of his paintings readily disclose his imaginative use of photography as an aid in artistic creation. Jackson also uses photography to make visual notations, but he depends

on that medium to a considerably lesser extent in the actual production of his paintings. Certainly, the technical skill displayed by both artists compares most favorably, for they each depict images with high fidelity and scientific precision. Yet Estes's presentation might often seem artificial and somewhat sterile—and correspondingly depersonalized—in contrast to Jackson's work, which displays comparable achievements in optical imagery but depicts a more inviting, personal setting that easily accommodates everyday human interaction.

From the standpoint of spatial and temporal interchangeability, *Greater Downtown* (fig. 61), executed in 1986, is certainly quite closely related to *Reflections*, although the former is perhaps interpretively less complex. Once again, surrealist elements dominate the prevailing mood of the entire work. The theme of the painting is a farmer's market, here inseparably linked to everyday activity within a modern bank building (in this case, the First of America Bank Champaign County, Illinois). Our attention is focused on the normal banking procedures conducted in the open space of the lobby—where two women stand, one wearing a bright red jacket, the other wearing a red sari—yet we cannot help but notice that the counters are covered with beautiful flowers and luscious, fresh vegetables and fruits, and that the

walls of the interior lobby tend to dissolve, conveniently allowing farmers to unload their trucks and openly display their produce to enthusiastic buyers.

The entire setting in *Greater Downtown* is reminiscent of a dream world where startling, strangely impossible combinations of events do occur, often to the amazement and sometimes the delight of the dreamer. This phenomenon is particularly well expressed by the tall, exterior flagpole in the center of the lobby; or by the flag itself, on which none of the fifty stars appears; or by the green carpet, which seems to transform itself almost imperceptibly into a red brick floor. Even more astounding is the single ghostlike figure from the past: an elderly man with long white hair who sits inconspicuously in the center of the lobby selling apples and who is actually the image of the founder of the bank. Another strange and certainly unexpected detail is the tiny, barely noticeable antefix of the adjacent building on which Jackson has painted his own image in the form of a stone carving.

Whether he is painting cityscapes or landscapes, Jackson uses delicate tonal colorations to execute the sky. And when a body of water, even a puddle, is included in the composition, the reflected sky matches the sky itself in terms of deli-

cacy of color; yet at the same time it significantly amplifies the quality of space, adding a sense of fullness and balance throughout the composition. This is particularly evident in a fairly large 1982–83 oil painting titled *Day Trippers* (fig. 62), in which land, sea, and sky combine formally and thematically to create one of Jackson's most memorable works. This is not a street scene, of course, but an outdoor scene looking toward the sea and set in Gay Head Village, on Martha's Vineyard, where the artist has maintained a summer studio for more than a quarter century and where he has found inspiration for many of his most origi-

nal compositions, especially such watercolors as *The Landing of the Unkatena* (fig. 63). *Unkatena,* painted in 1978, is of special interest since it is one of Jackson's earliest depictions of a large concentrated group of people. By contrast, *Day Trippers* includes but three figures assembled on a wooden deck customarily used for community events. The three may be related to one another in some way or may have crossed paths only by accident. And it may be that once they leave the wooden deck, they will never meet again. The world of a painting is, as we know, a world unto itself, and the laws that prevail are necessarily *not* those that govern the so-called real world in which we live.

One of the figures, a man, stands at the railing with his hands crossed behind his back, looking out over the light blue sea. A woman is seated on a bench, eyes closed, her bandaged foot propped up, and a white cane—perhaps signifying that she is blind—rests against one knee. On the outer edge of the deck, clutching the railing, is a little girl in summer attire who is staring at her reflec-

tion in a nearby puddle of water. Sea gulls come and go over the open sea, and the overall mood is tranquil but melancholy, for nothing seems to be happening. Metaphorically, however, youth and blindness can be seen here as twin entities of life that are only as real as a reflection and that pass through time as fleetingly as the sea gulls in flight. And the promise of eventual fulfillment can be found in the endless expanse of the sea—traditionally regarded as the source of life—and the eternally radiant, all-embracing sky.

It is in these terms, expressed within the context of the natural environment, that *Day Trippers* emerges as one of Jackson's most gripping philosophical statements. He has used this composition to comment so poignantly on both the inseparability of humankind and nature and on the height of human tragedy and the realities of human destiny. Yet despair is completely absent. We can view the scene and accept the statement simply as the pictorial expression of an excursion in time.

The site chosen for *Day Trippers* furnishes an unusual setting for a Jackson painting that includes a human activity theme. Generally, he places subjects of this type on the fringes of the prairie, where most of the small communities and activities familiar to him are found. Yet, while both the prairies and the small towns are geographically close to one another, distinct differences in their daily life patterns can readily be observed—and his cityscapes and street scenes clearly reflect those differences. Understandably, human figures are portrayed and clearly recognizable close-up views of both architecture and everyday human experiences are depicted in sharp focus. Perhaps one reason for Jackson's enthusiasm in selecting such settings is the close proximity of the town to the nearby surrounding prairie, as well as his acquaintance with the inevitable interchanges between the urban and rural modes of life. Another factor certainly is the pattern of human interaction found in the town setting that would tend to appeal to the artist's perceptive outlook on human behavior.

It is in the interior setting, however, that human beings conduct a related, but quite different, mode of behavior, for that is where they experience both personal privacy and physical protection from the elements, even as they retain visual contact with the pulse of life in the space outside. Indeed, since the late 1950s and early 1960s, when he first began to study house windows and people on the inside looking out, Jackson has focused just as much time and attention on interiors as he has on prairie scenes or cityscapes. Certainly in contrast with all exterior scenes, his interior settings present entirely different color and light effects, textural qualities, and spatial experiences. And all of these contribute significantly to the creation of a different dimension of aesthetic expression to which we now turn our attention.

58. *Downtown, 1972–73*

59. *Moments*, 1976–77

60. *Reflections, 1982–83*

61. *Greater Downtown, 1986*

62. *Day Trippers*, 1982–83

63. *The Landing of the Unkatena,* 1978

6

Interior Views

Thus far, our emphasis has been on the development of the prairie landscape and the street scene or cityscape in Jackson's oeuvre; indeed, since his early days at the University of Illinois, these themes have commanded much of his attention. However, through the years he has also painted the interior view, which he regards as one of the most rewarding settings within which to construct a compositional statement at a sophisticated aesthetic level.

Not only does interior space furnish a pictorial enclosure for the theme, but once the size and general format of the work has been established, the particular interior space the artist has conceptualized most generally defines the limits within which the composition will proceed. As we shall see, however, in his interior views Jackson finds ways to extend these limits and to circumvent restrictions in order to fully accomplish his objectives. He is able to integrate composition, drawing, and color to produce the desired luminous quality and the tranquil, time-defying mood that so effectively characterize many of his most significant works.

One of his very early interior views, executed in 1953 and titled *The Offering* (fig. 64), depicts a man and woman seated at a small round table within the confines of a large curved arch. Their tragically despondent facial expressions, as well as their large almond-shaped eyes and the overall figural distortions, are understandably consistent with the style Jackson employed in his prints and other very early paintings executed during his stay in Mexico and soon after his return to the United

States. Other early interior scenes include his expressively abstract works based on the jazz theme he painted during the early 1950s, culminating in *Duet*, his 1954 thesis painting. But in most of these early interiors the setting is incidental and decorative; it in no instance dictates the aesthetics of the total composition.

Jackson's mature interior scenes were painted beginning about a decade later and include a splendid work, executed in 1966–67, titled *Today Is* (fig. 65). This is a lonely and mysterious painting, offering us a rather haunting view of a female office worker, seen through the wide, round-headed window of a late Victorian building, toiling far into the night. Although much of the picture plane is devoted to a close-up, detailed architectural rendering of a small segment of the building's exterior, it is the artist's use of light that captures and fixes our attention. The warm, yet piercing, glow of the interior room throws the woman's figure into silhouetted relief against the strongly illuminated background of her office and, at the same time, creates varying levels of light intensity on the half-raised window blind and on the exterior brick surface. This contrasts sharply with the adjacent corridor, dusted with a dim light that appears to spill out from the nearby office and contributes to the eeriness of the composition. On the far wall, immediately behind the woman, is a barely visible calendar that contains the phrase from which the title of the painting is derived.

Another of Jackson's interior scenes, painted in 1968, is *The Union* (fig. 66). It relates closely to *Today Is* in compositional plan as well as in the handling of light. But it is somewhat more ad-

vanced in that it both communicates the mood and includes a number of compositional and iconographic features typically found in many of the artist's finest works. The two male figures—one young, the other elderly and black—along with the large American flag that hangs at the right, definitely speak to attitudes prevalent in the unsettled social climate of the late 1960s. Yet the feeling of separation to which that era was so sensitively opposed is here beginning to dissolve, for the two figures, while looking in opposite directions, are physically close to one another. Indeed, the title, which refers most obviously to the actual physical setting—the lobby of the student union on the campus of the University of Illinois—apparently is also a plea for the cause of uniting all peoples, regardless of their color, creed, or ethnic background. Jackson has acknowledged that he was thinking of the "State of the Union" when he titled this painting and, in fact, sometimes called it that.[19]

Thematic content is of major importance in this work, and in almost all of Jackson's paintings, and certainly must not be ignored. However, there are aspects of *The Union* that stand out prominently in the evolution of the artist's interior scenes and must be commented on. For example, there is a sense of classical balance and compositional simplicity that is very interesting; and the rather distinctive light-dark contrasts, as well as

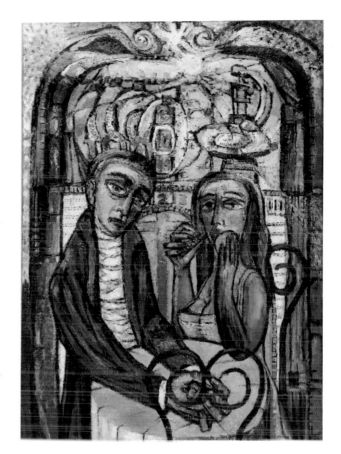

64. *The Offering*, 1953

the suggestion of expanded space created by the architectural setting and by the strong reflections from the polished surfaces, are important aspects of compositional treatment. We have already observed how these devices are used in landscapes and cityscapes, yet it is their usage in interior views that clearly testifies to the technical and aesthetic integrity of Jackson's work.

Many of his interiors consist of a single nude female figure occupying an open compositional space that includes one or more windows, which function as principal light sources, and one or two partly open hinged doors, which supply the coordinates essential to the definition of relationships in compositional space. *The Young Widow* (see chapter 3), executed in 1960–61 and apparently Jackson's earliest interior with a seated nude, is one example of this genre. Another early and equally interesting work is *The Roomer* (fig. 67), sometimes known as *The Divorcee*, which was painted in 1963.

The Roomer is actually a seminal work in that it establishes both the compositional setting and the basic features Jackson would assimilate into subsequent works. But it does not quite fully realize his potential for using light as a unifying agent, and it scatters the viewer's interest across a variety of incidental details. Although it is exquisitely executed and effectively achieves the intended mood of tragedy and loneliness, it appears to be more of a composite than a fully integrated visual statement of relationships.

Of the many interior views that include a single human figure, the first to achieve full expressive unity is *Daily News* (fig. 68), painted in 1968. In a very real sense, this composition is the prototype for all the others painted during the ensuing decade or so. The setting is the artist's university studio where, from a wide hallway, we are invited to peer through an open doorway. Seated in the room is a relatively young female nude, her head resting against the wall behind her. A penetrating light from outside casts a flat geometric design—reminiscent of a Mondrian painting—onto the translucent yellow blind that is lowered completely across the multipaned window. Sunshine floods the interior space with a dramatic light that differentially reflects from the various surfaces and produces complex shadow patterns throughout the composition. On the floor, tossed into the space closest to the spectator, is a newspaper bearing the provocative headline "Questions Still Unanswered"—which almost surely refers to the 1968 assassination of Martin Luther King, Jr., and should remind us of the cityscape *Main Street*, also painted in 1968, which employs this same device.

Although social commentary is frequently found in Jackson's paintings, regardless of thematic type, the enduring strength of his works rests securely in formal geometry. The interior scenes under discussion, almost without exception, are rendered frontally with strong horizontal lines parallel to the picture plane. The feeling of enclosure is relaxed, although the architectural setting itself is rather tightly structured, and the sense of

space is expanded by the presence of open doorways leading to unseen adjacent spaces or windows with lowered (or partially lowered) blinds that permit sunlight to penetrate and reflect at varying densities and intensities. Interior doors are generally ajar, thus expanding the dynamic space while drawing the spectator into the composition.

These techniques, which are well executed in *Daily News*, can also be seen in the structural organization of Jackson's most successful interiors of the 1970s and thereafter. Among them is *3:30 P.M.* (fig. 69), painted in 1970–71, which is closely related to *Daily News* yet is a perhaps more highly developed statement on controlling the ambience of light and the dynamics of spatial continuity. *HWA* (fig. 70), completed in 1973, carries the statement even further with its heightened attention to opaque and translucent color reflections, as well as its marked contrast between the warm light streaming through the yellow blinds and the cooler light seen through the partially open window.

Compositionally, *HWA* is certainly Jackson's most complex interior view up to the time it was painted in 1973, with all components subordinated to the relaxed foreground nude—which, with the exquisite play of light across the form itself, embodies the central conception of the entire work and indeed summarizes many of Jackson's principal aesthetic objectives in general. Of

special interest is the sense of expanded space achieved by the introduction, in the center of the composition, of a tall mirror that reflects not only foreground portions of the composition but also events and situations—including the figure of the artist himself, seated before an easel—that are conceptually regarded as being within the spectator's space. We have seen this same technique employed in many of Jackson's earlier paintings, whereby reflections expand the compositional space and introduce ambiguities that compel us to penetrate deeply into the scene in an attempt to unravel those ambiguities and clarify certain compositional relationships, and thus participate more fully in the life of the painting.

Ten O' Nine (fig. 71), completed in 1976, signals a marked advancement in Jackson's work. Here, the dynamics are more complex by virtue of the exaggerated, dizzying perspective that pulls us down a steep staircase to a landing where a woman stands majestically silhouetted against the warm light from the windows behind her. In the murky darkness at the extreme right edge of the composition, a barely visible male figure, reflected in a door frame, observes silently, adding a dramatic counterpoint to the brilliant, all-pervasive light, and at the same time reinforces the ominous mood of the composition.[20]

The powerful formal structure of Ten O' Nine tempts us to consider other representational artists who may well be regarded as a source of inspiration to Jackson and whose works have been widely known and admired throughout the United States in recent years. To some extent, Andrew Wyeth should be acknowledged here, especially when we consider Jackson's meticulous care in rendering detail. Far more relevant, however, is the possible influence of Edward Hopper, which may not seem evident on the surface yet cannot be ignored in an analytic comparison of the two artists.

Certainly, Jackson introduces far more particularistic detail than does Hopper, and at the same time he is more concerned with creating ambiguity by manipulating relationships between pictorial space and spectator space. More important, though, is the fact that both Hopper and Jackson use light as the controlling force in structuring their compositions. Both flood interior spaces with light, which defines form but also introduces strong abstract patterns that function as principal design elements within each composition. Hopper's light generally creates sharply defined geometric patterns of bright and tonally homogeneous areas, whereas Jackson's light is less sharply defined, somewhat more personal, and generally covers a wider range of color values as it scatters across varying shapes. When comparing Hopper's and Jackson's treatment of human figures, the most important aspect to note is their use of gestures to accurately convey the feelings and concerns of the individuals being portrayed as well as the pursuits in which those figures are engaged, no matter how insignificant. Each figure in Jackson's work—and in Hopper's—is deep in thought, though Jackson gives much more attention to facial features and facial expressions, while Hopper focuses more on simplicity and leaves much to the imagination, creating essentially anonymous faces.

By far, the most accomplished of Jackson's series of interior single subjects is Reading (fig. 72), painted in 1979–80. Conceptually, the scene is symmetrical, with a frontal compositional plan; and, as with Ten O' Nine, we can see several interior levels at the same time. Our initial impression is that the intended mood is one of tranquility, for the artist has portrayed a lovely teenage girl seated alone on a staircase, consumed by the book she is reading. As we probe more deeply into the work, however, we discover that it is charged with deliberately introduced visual ambiguities. These serve not only to arouse our interest and curiosity and to divert our attention from pure representational subject matter but also to sensitize us to the recognition and appreciation of the composition's purely abstract qualities. Of significance in this connection is the central hallway, where depth is greatly exaggerated by the use of a sharp one-point perspective that carries us away from the subject and toward the window, then out to the prairie landscape beyond. But even as the eye begins to move into the pictorial depth, it is diverted by an open door near the end of the hallway, which momentarily shifts our attention laterally. At the same time, competing pictorial forces on the left direct us toward the massive hall staircase where, just as we are about to ascend, we are once again diverted by an open doorway through which we glimpse still another staircase, this one leading downward.

What we experience most fundamentally in *Reading,* however, is the poetry of light—light that floods the entire work with brightness, with clarity, and with life. Indeed, the spatial dynamics are determined as much by the artist's treatment of light (and reflected light) as by his formal manipulation of the architectural members. Jackson takes extensive artistic license here, imparting a vitality and a harmony of contrasts that is especially evident when we compare the left side of the composition with the right. On the left, the mood is relatively serene: the teenager seated quietly on the stairs is resting against a perfectly balanced triangle of wall—one that seems to be evenly illuminated but for the delicately subtle, barely visible shadow cast by the stair rail. The right-hand wall is far more active, for it is covered by a flickering pattern of multiple, often overlapping reflections that vary in size, shape, color, and intensity. The reflections are distributed not in imitation of any purely naturalistic situation but rather as they would be in a fully abstract painting. And it is the reflections that serve the purpose of resolving conflicting pictorial forces and achieving compositional unity. For example, the open door at the far end of the hall casts a shadow on the hall floor and also is reflected in the polished wooden enframement of the adjacent threshold—but the reflection stretches across the wall, all the way to a tall closed door nearer the spectator. That even a casual observer might ignore this unexpected, rather improbable situation is unlikely since the receding lines of the door closest to us direct the eye to the very point of that reflection.

Unquestionably, one of the most gratifying instances of Jackson's use of artistic license is the exquisite tonal nuances of cool light that reflect on the ceiling above the hallway, originating from an open window. Another is seen in the invigorating reflections of warm yellow light from the wall in the upper right corner, echoing the light that penetrates the stair windows immediately above the seated figure. What is especially satisfying is the encompassing glow which inseparably links more passive areas with those that are more active and which also establishes an empathic unity throughout the composition.

One other aspect of *Reading* warrants comment since it so typifies Jackson's interest in selecting titles for his work that carry double meanings, as in *Mansfield, The Union,* and *Reflections,* among others. Here the title applies most obviously to the activity of the girl on the stairs. But, like the verbal language of a book, the formal language of a painting also must be read in order for the painting to be fully understood and appreciated. And in this instance, it is through the selection of a title that the artist advises us to penetrate deeply into the life of the painting in order to experience its full aesthetic significance.

Soon after Jackson completed *Reading,* he embarked on another major work, *Station* (fig. 73), to which he devoted his primary attention for nearly eighteen months, from the early spring of 1981 until the end of the summer of 1982.[21] *Station* is an interior view, but unlike the others discussed so far, it includes a considerable number of human figures—thirty-five, to be exact. Two of these figures are standing just outside an exit door,

in the dark of night, waiting for their bus to arrive. Yet in the deep distance, to which the eye is drawn by an open space at the far right of the composition, we see the barely visible image of a man who is looking out into the bright sunshine. The unexpected combination of night and day in an otherwise integrated composition is unusual but at the same time typical of the artist's interest in creating ambiguity.

Both in execution and in conceptualization, *Station* is one of Jackson's most masterfully composed works of recent years. Drawing and modeling arc rendered with meticulous care, and the individualized facial features and body gestures express the diversity one might expect to find in a public waiting area. Also, the lighting and strong colors he has employed are so orchestrated as to emphasize the definition of individual features and at the same time ensure compositional unity and create a mood of harmony and serenity throughout the scene. But what makes this painting especially interesting is the fact that most of the subjects portrayed are identifiable members of Jackson's family or else close personal friends, although in the context of *Station* they are not a cohesive social group. Their only shared goal here is apparently the boarding of buses that will take them home, or at least to the next stop on their journey. While they may breathe the same air and, on occasion, chat with the person next to them, for

the most part they remain psychologically isolated, thinking their own thoughts, reading their own newspapers or magazines.

In addition to its merit as a work of art, *Station* is therefore an aesthetic model that serves to illustrate the human isolation we encounter on a massive scale in modern society. Jackson invites us to see each individual or each couple as a tiny, isolated unit—his message, in its simplest form, being that we are all inevitably absorbed in our own condition. As we examine the scene, we find ourselves asking how—or if—the people portrayed will be influenced by their presence in this particular bus station; or the extent to which they, as individuals, might be influenced and their lives changed if they were to interact with their fellow passengers. We may be inclined to gaze deeply into their faces, to more closely observe their behavior, in an attempt to guess what destiny holds in store for each of them, or what they will contribute, or what they will experience, or how they might narrow or broaden their own lives and the lives of those they meet along the way. We are, in short, encouraged to do what the artist hoped we would do when he named this work: to consider both the station gathering and the station in life of the people so gathered.

Another especially interesting interior view, quite unlike any of the others, is *Time, Space, and Columbia* (fig. 74), one of a series of watercolors painted in 1981 under the auspices of the Na-

tional Aeronautics and Space Administration.[22] This was the second time NASA had invited Jackson to record events related to the various space shuttle programs at the Kennedy Space Center in Florida (the first time having been in 1967, when he documented the Saturn V program and rocket launch). *Time, Space, and Columbia* depicts the interior of the Kennedy Center pressroom on November 12, 1981, with reporters and artists sitting amid telephones, tape recorders, cameras, and sketchpads, capturing the spirit of the occasion. Jackson includes himself in this work, seated in the foreground with his back toward us, studying a large sketchpad on which he had just recorded his impressions of the ongoing events. What is especially interesting is that he has painted on the various TV monitors the entire sequence of shuttle activity, showing the different phases of the mission, some at night and others during daylight hours. Works such as this are certainly invaluable as permanent documents of one of the nation's most historic twentieth-century accomplishments.

Still another of Jackson's relatively recent interior scenes is *Reflecting* (fig. 75), executed in 1985–86. This is a tightly composed close-up view of the interior of an artist's studio. On the left we see a man who is obviously deep in thought, his head slightly lowered. Nearby stands an easel on which the artist has set a tall, narrow old-fashioned mirror that reflects the figure of a man wearing a multicolored hat. At the extreme right is a portion of a second easel and the metal reflector of a flood lamp, which throws a strong light on the mirror and casts heavy shadows against the wall in the background. The forms are rather

cramped together, yet the grouping ensures the clear identity of each element. Exactitude in drawing and modeling, typical of all of Jackson's work, is evident throughout, as is the effective variation of color intensity.

The principal focus of interest in this work is the mirror, which vividly captures the colorful hat and the face, arms, and hands of the man whose image it reflects. Comparable attention is given to the elaborately carved and gilded frame, the floral design etched into the glass surface near the top, and the decorative rosette heads of the small screws that secure the glass to the frame's backing. The reflected image is readily linked to the man who sits with his head lowered, by virtue of the strong lighting on his folded hands and the coffee cup they hold, as well as by their overlapping the format of the mirror. We easily recognize that the two images—the seated man and the one in the mirror—are of the same person, in this instance the artist himself. And it is at this point that the composition, which at first seems to be a simple, clear-cut presentation, becomes one of Jackson's more puzzling, for we realize that the image in the mirror cannot be a true reflection of the seated fig-

ure. Instead, what the mirror may very well hold is a projection from Jackson's mind of his image of himself.

The artist was sixty years of age at the time he finished this work, and he could rightly look back on his career as one of significant accomplishment. Here is a man whose mind is quite active, as the many and varied colors of his hat suggest; a man who has discovered the answers to many of the questions in his professional life, as symbolized by the key that dangles from his left hand. In a sense, by the title he has given it, *Reflecting* suggests precisely this interpretation.

Although Jackson has produced many stunning paintings of prairie views, as well as cityscapes and street scenes, in many respects the interior setting has constituted one of his great-est achievements as well as one of the greatest challenges he has faced throughout his painting career. To accomplish what he defined as his objective, he was forced to explore varying methods and techniques for introducing both natural exterior light and artificial interior light—two markedly different sources—into each individual interior composition. That he has succeeded is readily demonstrated by the paintings just reviewed. Indeed, as we have witnessed, Jackson's interior views physically encompass not only the individuals and events depicted but the full sweep of interior appointments; and those appointments, with very few exceptions, include one or more windows or doors which admit exterior light and most often furnish a clear view of the prairie as seen from within. It is the interplay of interior and exterior light, coupled with the powerful geometry of space, that makes these interior settings so very distinctive.

In almost all of his works Jackson also presents social or political commentary—sometimes overt and other times covert, though the message is always intended to promote human well-being and human betterment. It should thus prove rewarding for us briefly to focus systematic attention on some of the more significant political and social issues about which he has spoken so effectively through his art. What is especially interesting, and what we shall see clearly in the next chapter, is that so many of Jackson's greatest aesthetic accomplishments appear in conjunction with his social and political commentary.

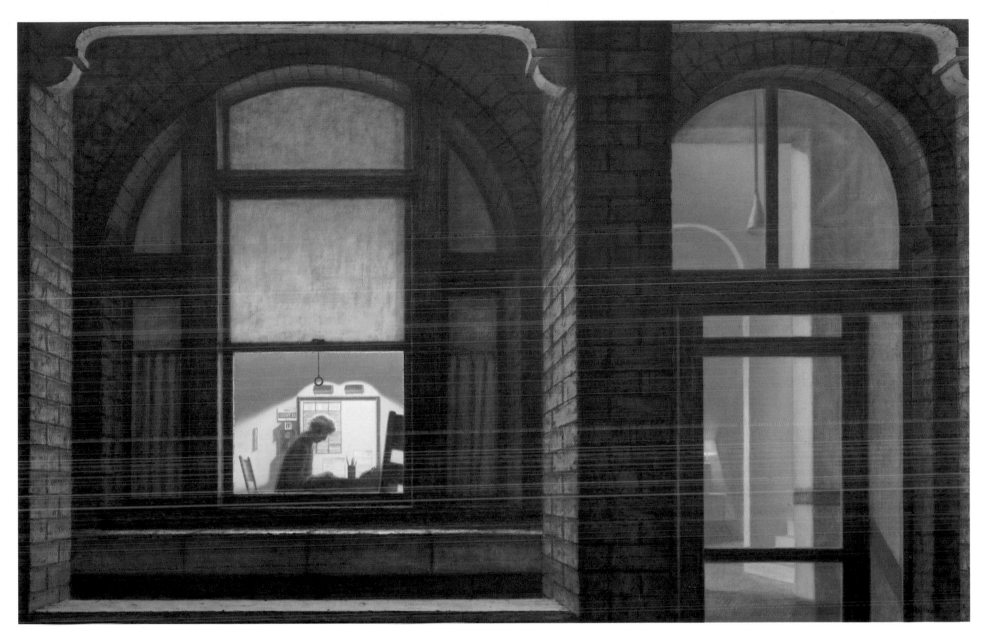

65. *Today Is*, 1966–67

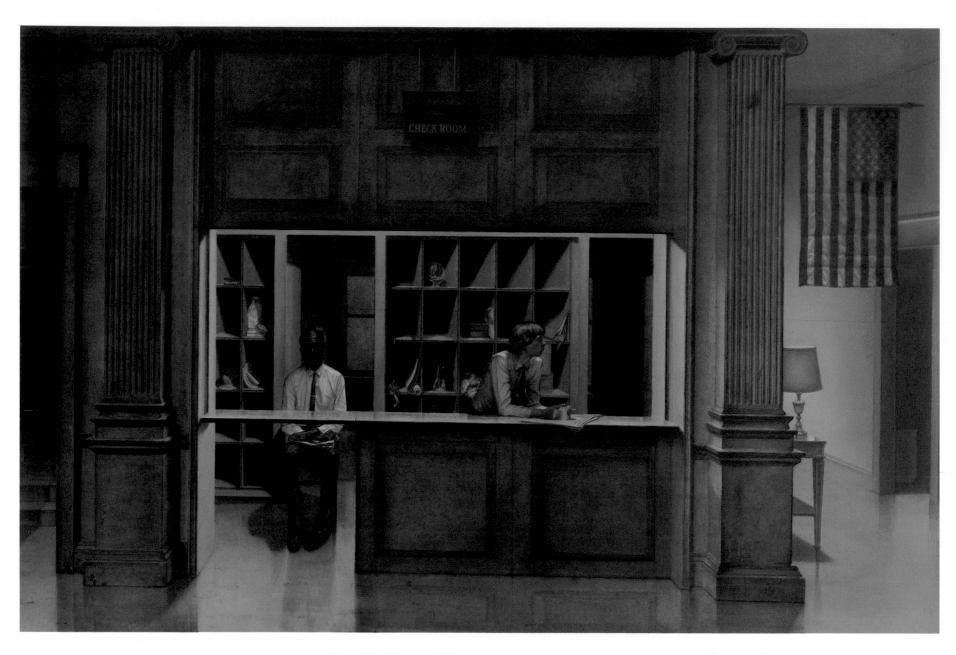

66. *The Union*, 1968

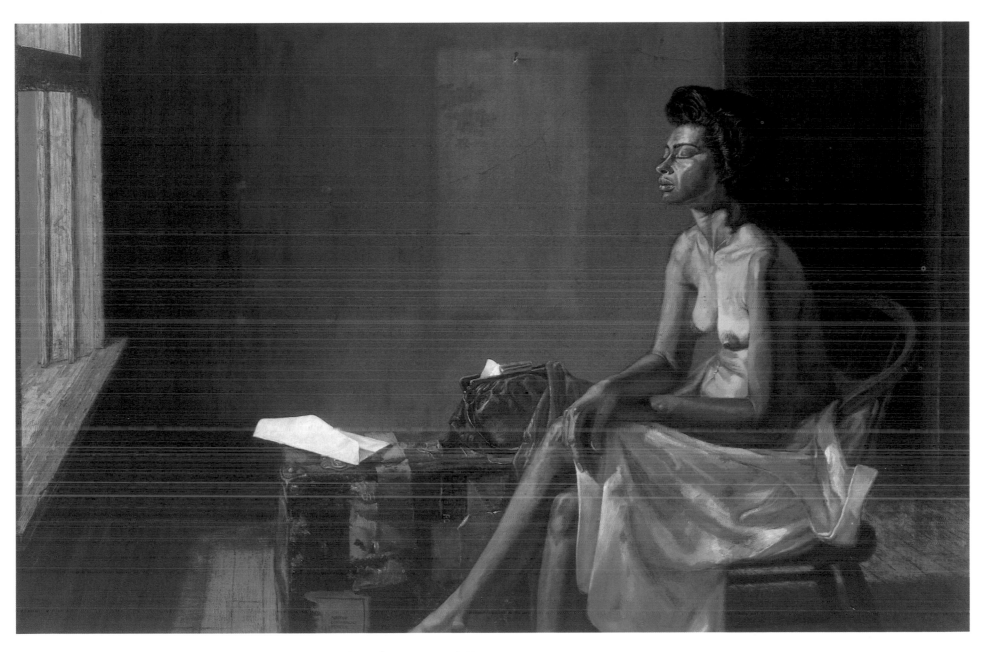

67. *The Roomer*, 1963

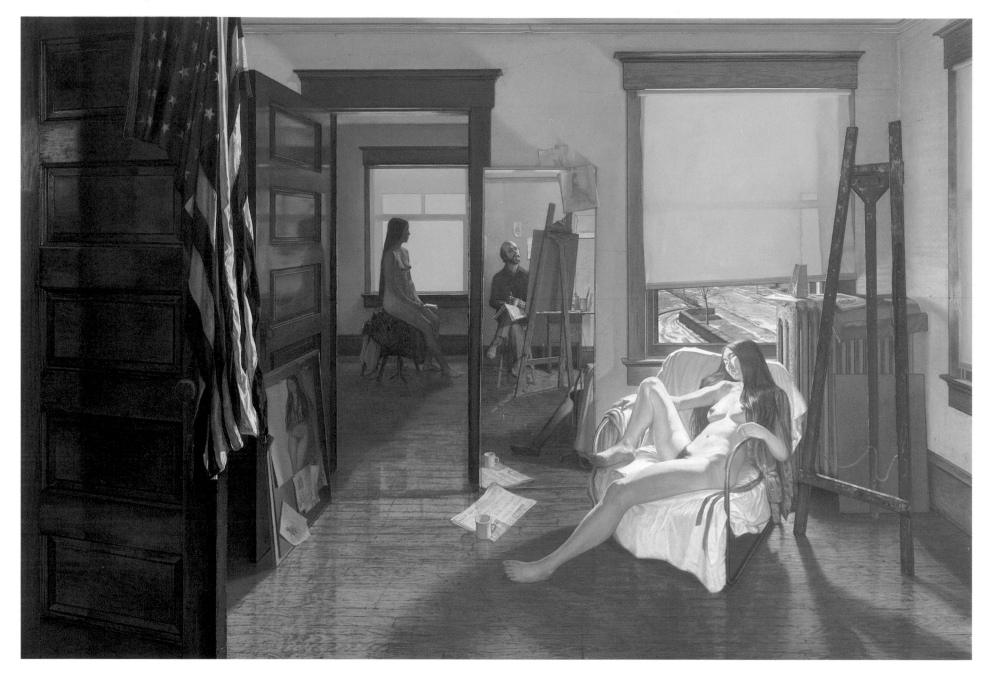

70. *HWA*, 1973

71. *Ten O' Nine, 1976*

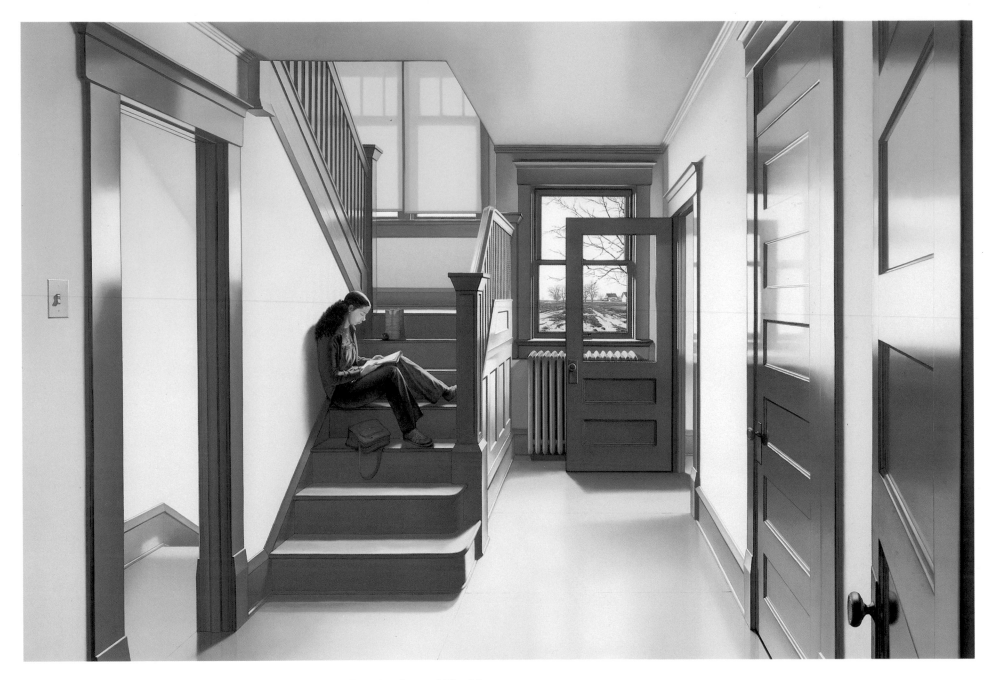

72. *Reading,* 1979–80

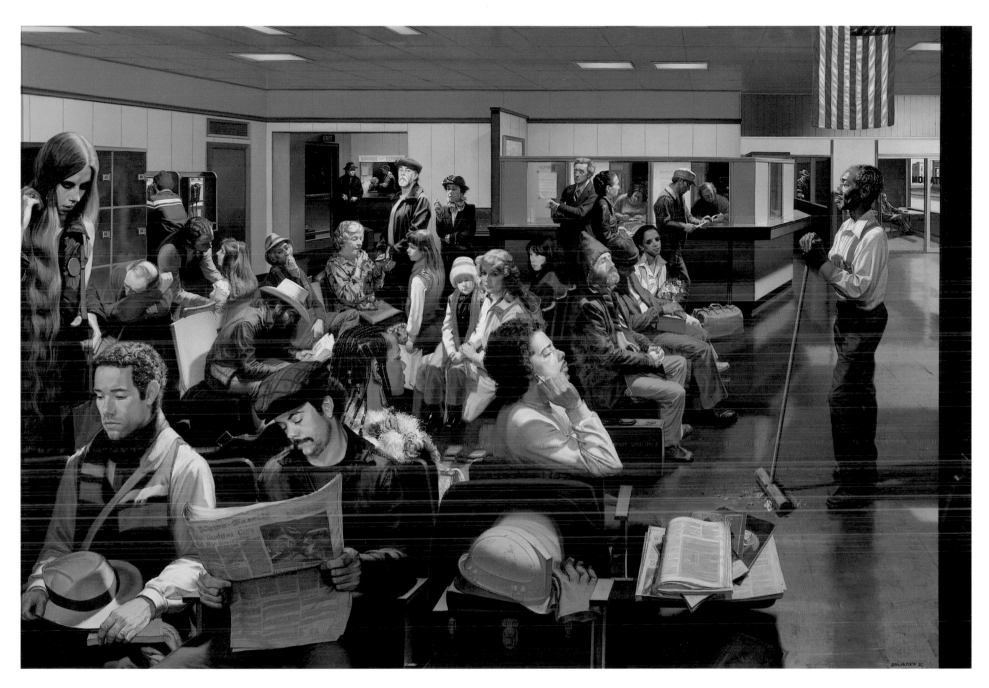

73. *Station*, 1981–82

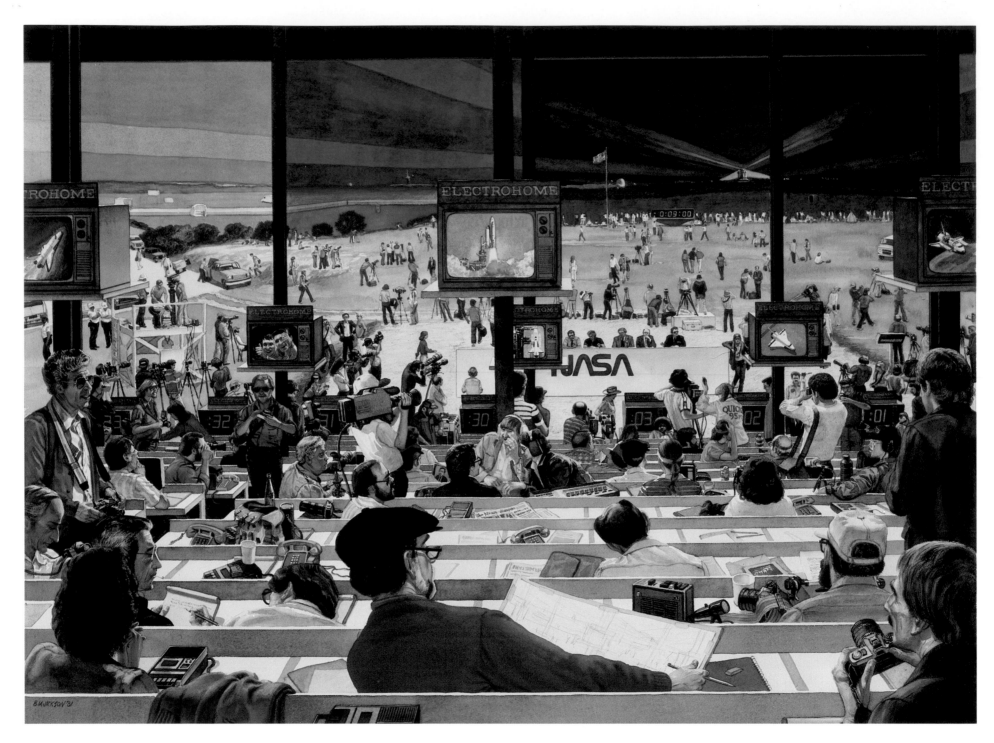

74. *Time, Space, and Columbia,* 1981

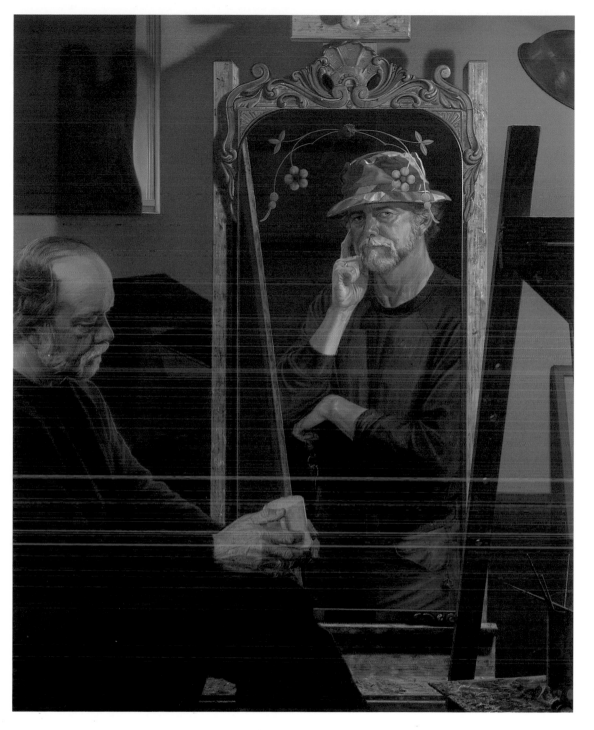

75. *Reflecting*, 1985–86

7

Social and Political Commentary

Throughout his career, Jackson has used his art to make significant and deeply felt comments of a social and political nature. In some instances these personal statements are mild, or they are intentionally masked by more obvious and familiar themes; at other times they are rather strident and appear in the form of direct protest related to issues he considers offensive and contrary to the societal health and integrity of the nation. It is obvious to those who know him and who view his work critically that he cares deeply about the nation and its people—indeed, about all peoples.

We have already traced to some degree Jackson's tendency to mix social and political concerns with aesthetic statements built around recognizable themes, beginning with the woodcuts inspired by his experiences in Mexico in 1949 and 1950. We have also seen how he frequently communicates a significant but veiled aspect of his concerns, whether aesthetic or sociopolitical, through his delightfully perceptive choice of equivocal titles. Both of these aspects of his work are readily apparent to the careful observer. For example, racial injustice in America is an issue about which Jackson is especially sensitive, and a cityscape like *Downtown* enables him to address that issue rather inoffensively yet at the same time very pointedly, even as he comments on other issues that dominated the national political scene during the early 1970s, including the first resignation of a United States president. *Moments* and *Main Street*, two other cityscapes, also carry secondary references to what Jackson readily perceives is social in-

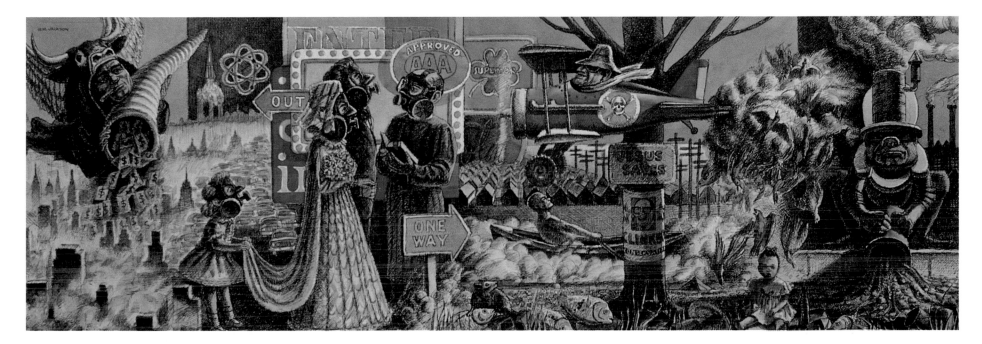

76. *American Litter-ature*, 1965

justice, but the commentary is far less obvious and goes altogether unnoticed by most viewers. Among his interior views, *Daily News* is perhaps the one that most directly captures a spirit of discontent, so well registered in the provocative newspaper headline and so sensitively echoed in the futility evoked by the seated figure.

Very early in his career, Jackson reacted vigorously against those forces that were steadily encroaching on the natural environment and seriously threatening conservation. It is therefore logical that his philosophical glorification of nature might be implicitly linked with his dedication to the landscape theme he was developing in his art. Indeed, in all of his nature studies of the late

1950s, and of the ensuing thirty years, he never deviates from this conservationist point of view. He executed one of his most carefully planned visual conceptions about littering and the uncontrolled abuse of our natural environment in a work titled *American Litter-ature* (fig. 76), which he was commissioned by the *St. Louis Post-Dispatch* to paint in 1965. The work was reproduced in color, along with an article titled "Land, Air, Water: Our Abused National Treasures," written by then U.S. Secretary of the Interior Stewart Udall, in a special supplement of the newspaper.[23]

Compositionally, and to some extent thematically, *American Litter-ature* harkens back to several of Jackson's earliest landscape paintings—those that seem to be little more than neutral visual comments on the nationwide proliferation of signs and billboards amid natural settings. However, *American Litter-ature*, although a kind of pop-fantasy montage, is actually an acrimonious statement rendered in cartoon style about a blighted

world where the land, the water, and the atmosphere are polluted to the point of no return, where beasts of monetary greed have dominated at the expense of vegetation and of fish, fowl, and humanity, and where human beings themselves appear like monsters out of science fiction, surviving only with the aid of gas masks. The *Post-Dispatch* reproduction of the work is highlighted by the timelessness of Udall's words: "We have gained a peak in prosperity, but the view from the heights is a distressing panorama of smudged landscape spotted with the blinking of neon signs; a land often smothered under a pall of exhaust gases and blemished, scarred, eroded and tarnished."

An inventory of the images in *American Litterature* is really quite significant: a modern city totally engulfed in a sea of opaque smoke; a barren tree standing amid a landscape of city refuse and heaps of dead fish, with the only living creatures being a bewildered, innocent child and a large rat; smokestacks belching heavy clouds of black and brown soot; an emaciated man rowing a boat across a polluted river; a flock of dead birds falling from the sky, asphyxiated by poisonous exhaust

fumes from a small plane; a large poster that carries the glaring symbol of atomic power; a wedding at which all the participants wear gas masks; and a greedy human figure wearing the mask of a vicious beast and holding a horn of plenty from which money flows endlessly. Thematically, this is a caustic visual comment, but a truly prophetic one in view of ecological developments during the intervening quarter century.

Over the years, Jackson has been asked regularly to donate his time and talents to numerous political and social causes for which he has consistently demonstrated sympathy. For example, he has produced several sensitive portrait posters of Martin Luther King, Jr. (fig. 77), since the latter's tragic assassination in 1968, and he designed and printed a quite handsome yet classically simple three-color poster titled *Come Home America* in support of the presidential candidacy of George McGovern in 1972. However, he saved perhaps the finest, most original graphic art of his entire career for a group of eight stinging protest statements that deal with the civil rights movement.

Jackson's civil rights drawings, completed in 1962–64, were published as a series of posters with proceeds donated entirely to various civil rights organizations.[24] Both the drawings and the

corresponding posters received widespread newspaper and magazine coverage and were publicly exhibited on numerous occasions, almost invariably provoking considerable controversy and sometimes outrage. A brief article in *Jet* magazine stated that, in recognition of the urgency of the civil rights struggle, Jackson had come up with "the most controversial Negro protest drawing in some time. But in his effort to stand up and be counted, he was counted out. Billy Morrow Jackson's work could not even be given away." *Jet* further noted that earlier the NAACP in Chicago had turned down free use of the drawings, inasmuch as "nothing practical could be done with them."[25]

In late October 1964, during a University of Illinois faculty lecture titled "A Graphic Response to the Civil Rights Drama," Jackson displayed the entire series of drawings and won strong support. His opening comments are particularly significant:

As the drama of the Great Civil Rights movement grew to more and more dramatic proportions, the pressure on the conscience of sympathetic Americans grew as well . . . expanded in many cases to outright heroic deeds and sacrifices. Being concerned and feeling deeply involved as an American: shocked and angry at the garish and often bloody crescendo of injustice and atrocities: irritated at the casual acceptance of this insult by so many Americans as a permanent part of our social fiber: appalled at the apathy of a nation in the face of overt inhumanity: . . . I was stricken by all this . . . stricken because in this dark mirror I saw my own reflection and was not pleased. Indeed, I was stricken at my own apathy . . . as a human person, as an artist, as an American.

. . . this brazen brutality coupled with this Siamese in-grown apathy . . . prompted me to become concerned as to how I might respond as an artist. . . . How I might take my posture in the growth of this drama.[26]

Understandably, Jackson treated all of the forms in these eight drawings in an entirely representational manner, since his objective was "solid reference," as he put it. In each piece, both his drawing and his compositional plan are enviable, yet the stylistic character of most of them is markedly different from that which he had been developing throughout at least the previous decade and may account in part for their generally harsh reception outside the academic and black communities. However, as far as Jackson was no doubt concerned, the creation of such works was justified as a means of expressing strong personal and aesthetic beliefs.

Several of these civil rights drawings—among them *Stars and Bars* (fig. 78) and, to a lesser degree, *The Sovereign Scarecrow* (fig. 79)—possess a near-universal interest and, within the generalized context of racial inequality and injustice, can still be appreciated and understood after more than twenty years. However, the other pieces, more interesting and compositionally more complex, demand a high level of erudition and a thorough familiarity with specific events. Assuming the required erudition and familiarity to be absent,

those pieces are likely to be ignored or misunderstood, much as they were when Jackson executed them. Instead, only at some later date, and after careful study, will they be appreciated as historical documents of a period of extreme social unrest.

The more complex of these drawings are stylistically reminiscent of the superb but often stinging nineteenth-century political cartoons of Thomas Nast. Like Nast, Jackson unapologetically points his finger directly at specific situations and specific individuals, some of whom are portrayed as the valiant, often sacrificial heroes or heroines and others who are presented as the principal culprits in the various scenarios. The heroes include John F. Kennedy and Martin Luther King, Jr.; the culprits, George Wallace, Ross Barnett, and Barry

Goldwater. But without accompanying explanations, the scenes depicted lack interpretive clarity, and the individuals, although clearly recognizable, play roles in an allegorical and symbolic context that is puzzling to all but the most informed viewers.

Because of their reference to the loss of innocent children and young adults, the two works that most likely had the greatest impact at the time are *The Tattooed Man* (fig. 80) and *Merry Kristmas and Philadelphia* (fig. 81). *The Tattooed Man* depicts the four young girls—Carole, Addie Mae, Denise, and Cynthia—who were killed in the bombing of the Sixteenth Street Baptist Church in Birmingham, Alabama, in 1963. *Merry Kristmas and Philadelphia,* the last drawing in the series, includes four wreaths formed from nooses, three of which encircle the portrait heads of civil rights workers Michael Schwerner, James Chaney, and Andrew Goodman, who were slain by the Ku Klux Klan in Philadelphia, Mississippi, in 1964; the fourth wreath is empty, symbolically awaiting the next victim.

Although civil rights issues consumed much of Jackson's time and energy in the early to mid-1960s, he did execute a certain number of comparatively minor, though nonetheless effective, socially and politically oriented works that promoted other goals to which he has always been dedicated. One such example is the "Support Fair Housing" project in which he was an active participant, working with neighborhood councils to provide information on the socioeconomic effects of fair housing for all people, regardless of race, creed, color, or national origin. To assist in that project, he designed a decal, 10,000 copies of which were printed and distributed widely in the Champaign-Urbana area in 1965.[27]

As we shall see in the next chapter, Jackson's socially conscious art has again found expression in one of his most recent major paintings, which thematically features the noted reformer Jane Addams and Hull-House, the social settlement she co-founded in Chicago in 1889. This work, commissioned in 1988 and completed in 1989 for installation in the Illinois State Capitol in Springfield, promises to be one of Jackson's most significant contemporary works.

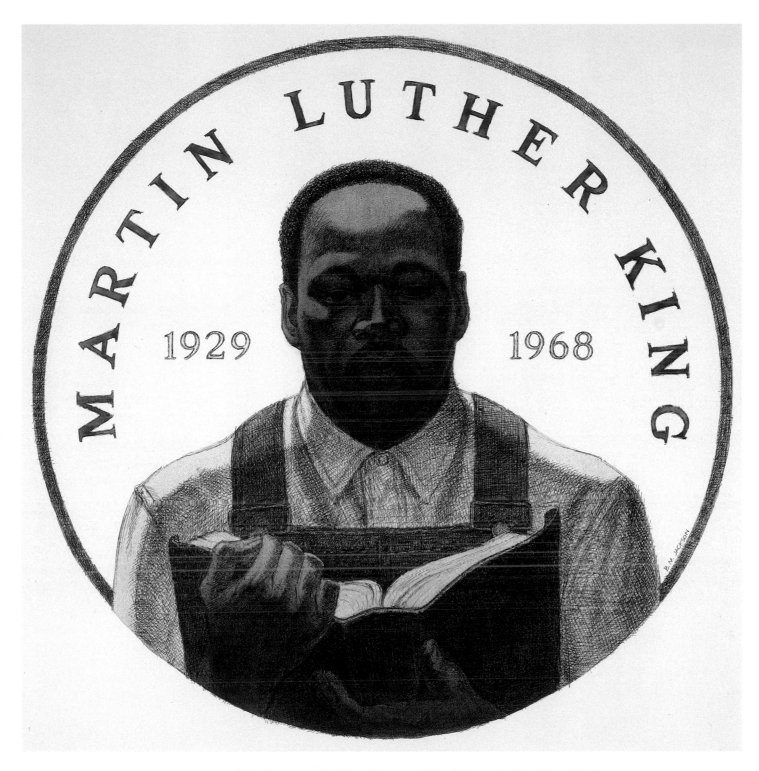

77. *Symmetrical Man: Portrait of Dr. Martin Luther King,* 1968

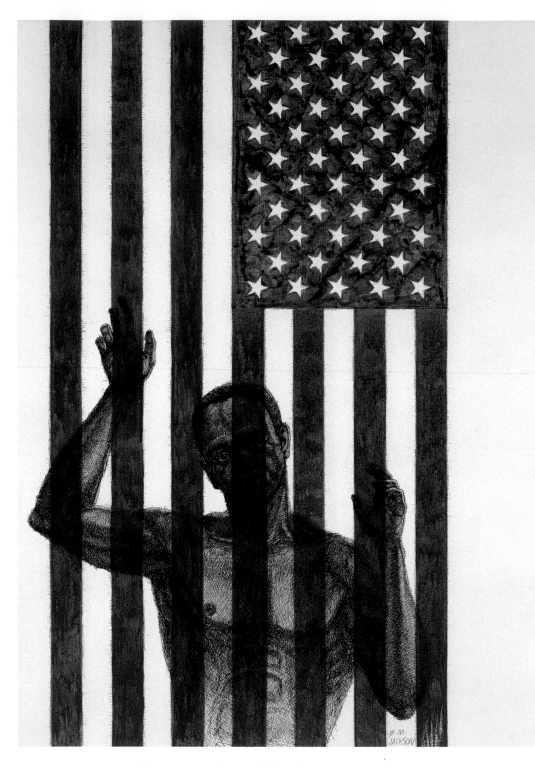

78. *Stars and Bars, 1962–64*

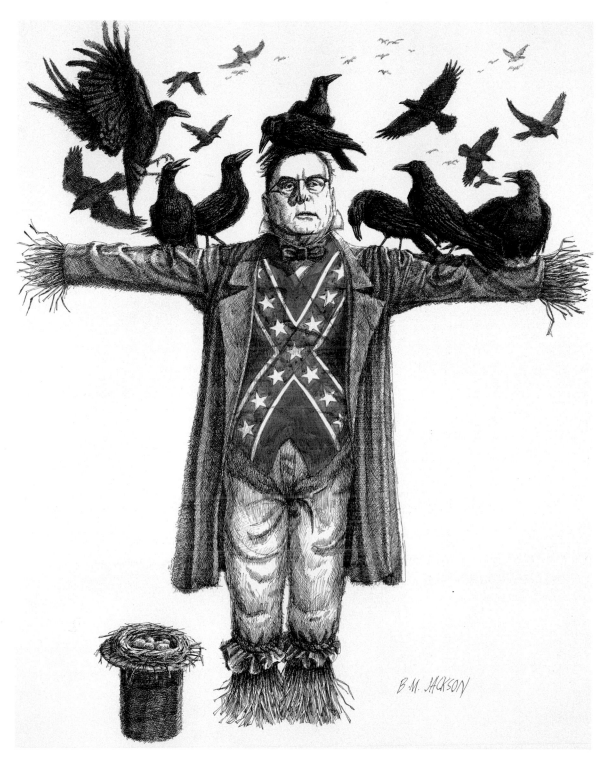

79. *The Sovereign Scarecrow, 1962–64*

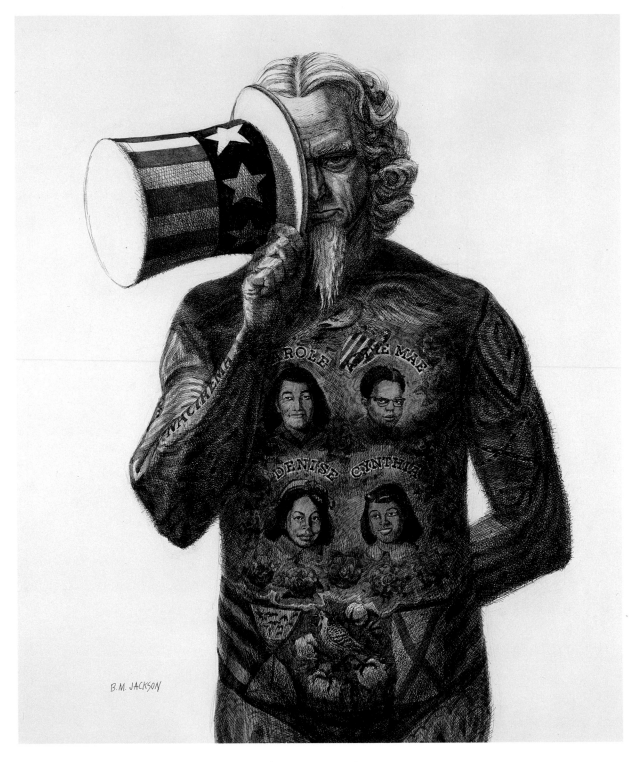

80. *The Tattooed Man*, 1962–64

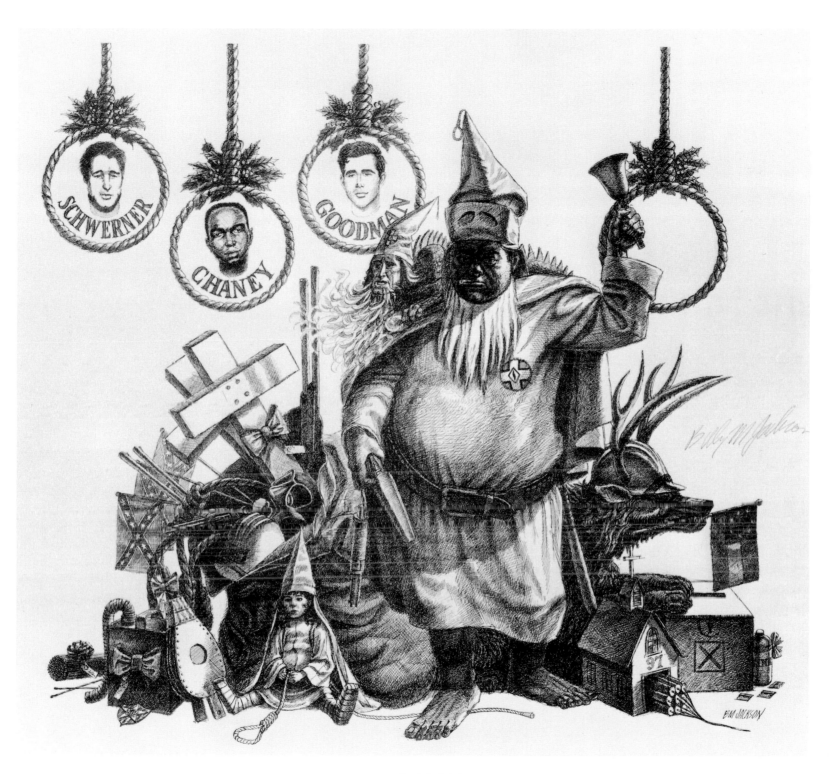

81. *Merry Kristmas and Philadelphia, 1964*

8

Recent Murals

Since 1986, Jackson has been commissioned to paint three large murals of a commemorative, historical nature. As we would expect, all three works are rendered in a familiar representational style, yet all three overtly display surrealist overtones through the juxtaposition of related but distinct thematic units and by the complete disregard for temporal and spatial accuracy. Moreover, the thematic content of each is presented in multiple figurative scales; and, in complete accord with the American mural tradition of the 1930s and early 1940s, each also employs bold forms that occupy foreground space and largely dominate all other compositional components. Of particular significance is the fact that these three murals, in addition to offering aesthetic interest, are most fundamentally oriented to providing historical information. That information is expressed in terms of the titanic leadership roles of certain specific historical figures and is communicated through a narrative based upon symbols that weave the formal composition, the theme, and the variations in scale into an integrated whole.

Even a cursory examination of these murals demonstrates convincingly that the production of such works must have imposed tremendously challenging demands on Jackson. In each case, extensive and long-term research was obviously required to gather the relevant factual data by which he organized each composition and rendered a fully meaningful and historically accurate

visual statement. Certainly, the execution of each work depended not only on the active use of his technical skills but also on his imagination. Most essentially, however, it is clear that one fundamental principle lies at the root of all three murals, namely, the reassuring promise of achieving a better life and a better world through the advancement of an intellectual understanding of our relationship to the physical environment, to the celestial universe, and, through public service and social reform, to our fellow human beings.

The first of these three works, commissioned in 1986 by the University of Illinois for its permanent collection, is titled *We the People: The Land-Grant College Heritage* (fig. 82) and was unveiled in October 1987.[28] The artistic intent is evident: to graphically depict the land-grant mission, as fully incorporated into the Morrill Act of 1862, which led to the founding of the University of Illinois and approximately 130 other colleges and universities in America. Dominating the composition are the three figures—Abraham Lincoln, Jonathan Baldwin Turner, and Justin Smith Morrill—who led the way.

Compositionally, the plan is frontal and entirely symmetrical with the towering figure of Lincoln, who occupies the central, pivotal position. He stands with Turner, whose ideas formed the basis of the Land-Grant Act, and Representative Morrill from Vermont, the bill's congressional sponsor, in an open space that accommodates the various professional and vocational activities made possible by the provisions of the land-grant program. Yet Lincoln is set apart from the others by a long line of people passing beneath his right arm in pursuit of educational opportunities, by a procession of faculty and graduates beneath his left arm, and, in the immediate foreground, by the figures of an artist, a mathematician, and a scholar, representing the many professionals to emerge from the land-grant system.

A balanced distribution of similar formal arrangements is stressed throughout the composition. There is, for example, a stack of books in front of each of the main figures; and the books, in turn, support secondary forms that symbolically elaborate a salient aspect of the role of the towering figure with whom they are physically associated. Against the document Lincoln holds is silhouetted the *Alma Mater*, Loredo Taft's well-known 1929 bronze sculpture that personifies the University of Illinois. In much the same manner, Turner holds before him books that deal with agricultural theory and practice of the mid-nineteenth century; and the widely recognized benefits of the land-grant mission are suggested symbolically by farmers and their families who are figuratively climbing their own ladder of success aided by those who are already approaching the top. Before Morrill is an open book with an illustration of a well-managed farm and the figures of a farmer working the soil and his child planting a tree; while in the foreground are a variety of individuals who symbolize cultural and professional pursuits attainable by virtue of land-grant educational opportunities.

Along the edges of the composition, and in the background, are a number of well-chosen forms covering the range of accomplishments, direct and indirect, that have resulted since the inception of the land-grant program more than a century ago. Although agriculture and the various activities related to farming, including international commodity marketing, are emphasized, in no sense are the arts, sciences, and technology, in all their forms, excluded. The mural thus summarily acknowledges the past while clearly linking it to the present and the future.

There is, of course, no way by which form and content can be separated in this composition, for the artist's intent becomes increasingly clear as we analyze the formal elements themselves. Aesthetically, a symmetrical system such as this establishes a definite reference point and thus controls the

location and direction of our attention. A mere glance at the composition forces the eye to pause along the center vertical line where the image of Lincoln is located, for the strong symmetry of the plan is such that the various balancing elements both to the right and to the left of the Lincoln figure momentarily tend to cancel one another formally. Furthermore, the erect figure of Lincoln looks directly out at us, while the heads of the two flanking figures are slightly tilted and rotated away from the Lincoln figure, thus confirming the focus on the center. Admittedly, this focus on Lincoln is strengthened in part by his easily recognized facial features. More important, however, is the presence of the *Alma Mater,* which, by virtue of its own powerful symmetrical stance and its outstretched arms, reinforces the commanding strength of the central vertical line.

Another aspect of considerable significance is the shift in scale between the three monumental figures and their comparatively small attendant figures. This arrangement avoids role confusion and is vital in disentangling the many different but closely related figural groups crowded within the same composition. It also contributes to a

clear understanding of the philosophical outlooks of each of the dominant figures, graphically designating their respective contributions to the program. The fact that their heads reach beyond the limits of the pictorial format—especially evident with Lincoln—suggests that the vision of these three men has reached beyond the current accomplishments of the land-grant program. Finally, the marked contrast in spatial dynamics and in color intensity between the foreground forms and the more delicately treated and less densely grouped forms in the background and in the various rainbow-colored skies unquestionably orients the entire program toward a promising future.

In 1988, Jackson was commissioned by the Parkland College Foundation in Champaign, Illinois, to execute a mural for the Staerkel Planetarium, named after William M. Staerkel, the college's first president. *Cosmic Blink* (fig. 83), completed and mounted early in 1989, chronicles the momentous scientific strides made over the centuries in opening doors to an understanding of the universe and the rich rewards such knowledge offers all of humanity. Like *We the People,* this mural employs bold, dominant forms and multiple scales; and it, too, totally disregards spatial and temporal exactitude. The thematic content has far-reaching implications for its use as a teaching tool, most particularly for students of science and astronomy.

Even a superficial exploration of this work leads us to discover that its compositional dynamics operate in quite a different manner from those in *We the People*. Although *Cosmic Blink* includes five dominant figures, no one of them takes precedence over any of the others since all are essentially the same size and all occupy equally significant locations. Moreover, *Cosmic Blink* displays no rigorous aesthetic plan geared toward controlling the viewer's attention by directing it at any one figure in any one location. *Cosmic Blink* thus may be classified as an *open* aesthetic system, whereas *We the People* is better classified as a relatively tight, or *closed,* system.

By virtue of its fairly conventional arrangement, we can read *Cosmic Blink* from left to right as a continuous, chronological narrative. The titanic figures of Copernicus, Galileo, Kepler, Newton, and Einstein—who stands between the latter two but along the lower edge of the picture plane, and therefore slightly closer to the viewer—appear as visions in a celestial space, surrounded by signs of the zodiac, whirling starlike masses, and various vignettes that are only remotely interrelated yet clearly contribute to the wealth of information presented here.

Without question, this is an exciting work to behold, one that uses light, color, and pictorial massing to charm even the most casual observer. But to fully appreciate this painting, to make sense of the imagery, we must have, in advance, at least a passing acquaintance with the scientific contributions of the five major figures and a basic understanding of the historical periods in which they lived—or, lacking that, we must have access to this information, orally or in writing, at the moment we view the composition.

The first of these five great men of science is the sixteenth-century Polish-born astronomer Nicolaus Copernicus, who used his intellectual prowess, his keen powers of observation, and his fertile imagination to conclude that the Earth and the other planets rotated in circular orbits around the Sun, which he pronounced to be the source of all light and the center of the universe—what we now call the heliocentric theory. Copernicus set forth his beliefs—which did not follow the teachings of the Church, of which he was a canon—in a treatise titled *De revolutionibus orbium coelestium*, written perhaps as early as 1530 but not published until 1543, as he lay dying. It is, of course, on the foundation of the Copernican system that modern astronomy has been built. In *Cosmic Blink*,

Copernicus is seen holding a model of his universe, with the then-known planets rotating in circular orbits around a blinding sun.

To the right of Copernicus is Galileo Galilei, the well-known Italian astronomer, mathematician, and physicist of the late sixteenth and early seventeenth centuries. One of his more far-reaching contributions involves the pendulum as an instrument for measuring time. It is said that, as a youth, Galileo sat in the baptistry of the cathedral of Pisa and timed the oscillations of a swinging lamp by means of his own pulse beats, noting that the time required for each swing remained the same, regardless of the distance traveled. He later confirmed by scientific experimentation that the timing depended on the length of the pendulum, not on the length of the arc, thus making possible the development of precision clocks, which in turn encouraged observational study of the movements of the planets and stimulated rapid advancements in navigation due to increasingly more accurate charting of the stars. Galileo also greatly enlarged humankind's vision and conception of the universe with the construction of the first complete astronomical telescope—which led to his own public confirmation of the Copernican system and his trial in 1633 before the Inquisition. In *Cosmic Blink*, Galileo is shown gently touching his wrist as he takes his pulse, while in the lower range of the composition is an allusion to the Inquisition.

The third figure in the mural is the brilliant German astronomer and mathematician Johannes Kepler, a contemporary of Galileo, whose principal contribution was the formulation of specific laws of planetary motion, three of which bear his name. He refined Copernicus's theory by demonstrating that the Earth and the other planets move around the Sun in elliptical, rather than circular, orbits. In *Cosmic Blink*, immediately above the figure of Kepler, we see those elliptical orbits in which the planets are rotating.

To the right of Kepler stands the great seventeenth- and early eighteenth-century British genius Sir Isaac Newton, whose contributions to science were quite enormous both in number and significance. In the brief period 1665–66, for example, he developed the mathematics of calculus, formulated the theory of gravitation, and discovered by use of prisms that white light is made up of all the colors of the spectrum. His findings and theories truly revolutionized all of the sciences—but especially physics, chemistry, and astronomy—

and are symbolically referenced in *Cosmic Blink* by the traditional apple and falling ball, by a prism-splitting rainbow of color, and by the spectral lettering at the base of his feet (alluding to his monumental *Philosophiae naturalis principia mathematica*, published in 1687).

Finally, we come to the renowned German-born theoretical physicist Albert Einstein, who appears to be looking upward toward Newton. Without Einstein's theory of relativity, all of the contemporary explorations of space would not have been possible. One of the leaders in the development of quantum mechanics, he also worked for many years on a unified field (as opposed to particle) theory that he felt would explain gravitation, electromagnetism, and subatomic phenomena with one set of laws. In *Cosmic Blink*, Einstein holds a collection of mathematical writings; above him, a vision is revealed that takes the form of the equation $E = mc^2$, which links the conversion of physical mass with the concept of energy in relation to the speed of light.

In essence, then, this exceedingly complex painting is a panoramic view of symbolically orchestrated components that tell the story of our eternal wonderment about the heavens, of our insatiable need to study the universe. From the Neolithic observatory at Stonehenge, England, faintly suggested by the small image seen between Kepler and Newton, to the Palomar Mountain Observatory in California, seen immediately to the left of Einstein, to the space shuttle program and Neil Armstrong's walk on the Moon, the vast accomplishments of the distant and recent past—captured here in the blink of an eye—are but a tiny fraction of what the future holds in store for us.

The third of Jackson's recently executed murals was undertaken in response to a competition sponsored by the state of Illinois late in 1988. Jackson was one of four artists each of whom was selected to produce a mural for the Illinois State Capitol as part of its 100th anniversary celebration. *The Key* (fig. 84), which measures approximately 9 ft. x 8 ft. 6 in. and is actually incorporated into the architecture of the building, was completed in August 1989. The central theme of the painting is social reform, the artist having taken his inspiration from the ideological outlook of the early twentieth-century Progressive Movement in America. Specifically, the work focuses on the social reformer Jane Addams.

Born in Cedarville, Illinois, in 1860 and educated at the Rockford Seminary,[29] Addams was appalled by the slums and poverty and human suffering, especially of children, that she witnessed in the factory towns of England and America. Her dedication to bettering the lot of the working class, and her love of children, led her in 1889 to co-found Hull-House in an industrial district on Chicago's South Side. Addams was a lifelong pacifist and an early activist on behalf of woman suffrage, and her reform efforts frequently targeted extremely unpopular social and economic issues—including programs for assimilating foreign immigrants, improved working conditions in factories, and crime and political scandals in Chicago. Yet it was her deep compassion for children and her belief that one could combat poverty through education that are most frequently recalled.

Two stages in Addams's life are depicted in the center foreground of the mural, arranged along a dominant vertical line. In the first, she appears as a young woman caring for the exhausted child who is stretched across her lap. In the second stage, she is older, more statuesque, and she

reverently holds aloft an infant whose life is presented symbolically as a sacred trust and a sound investment for all of humanity. To her right, small groups of people work cooperatively amid closed books—the knowledge they must acquire in order to liberate themselves from poverty—while above her, others struggle with a weighty key, toiling to unlock new opportunities via education. To the left we see the original Hull-House, and immediately in front of it are groups of people who, through their own efforts and as a result of the knowledge and compassion offered them at the settlement, have overcome ignorance and are fully prepared to pursue the opportunities made available to them. The struggle for woman suffrage is also depicted by a scene in which several women are standing on very large, open volumes carving the word *suffrage* onto a stone slab. The fact that the books are open rather than closed serves to emphasize once again the power of knowledge in which Addams so strongly believed.

In many respects, *The Key* conforms closely to the pictorial tendencies of Jackson's two earlier murals. The entire work is meticulously rendered in a representational idiom with all forms clearly recognizable. Multiple figurative scales are employed, temporal and spatial accuracy is totally disregarded, and the foreground space contains boldly treated thematic material of sufficient visual interest to excite and sustain viewer attention. As in *We the People* and *Cosmic Blink,* the large number of secondary figures and the many activities depicted contribute significantly to the integrated narrative while in no way diminishing the impact of the principal pictorial forms. *The Key* is, however, the most structurally complex of the three murals in that it consists of three intersecting axes: a central vertical line; a diagonal that runs into the pictorial depth from the bottom right to the upper left, linking the two sections that contain the most densely concentrated figural groups; and a less-pronounced line, compositionally but not thematically weaker, that runs into the spatial depth of the painting from the lower left to the upper right.

One noteworthy feature of all three murals is the consistent recognition of the fundamental role of leadership as the basis for introducing and achieving change and, in particular, for making positive contributions to social, cultural, and technological progress, and thus the advancement of humankind. But perhaps the single most significant message is the glorification of knowledge and learning as bases for liberating the individual. All three compositions, of course, possess strong narrative qualities that result from serious research on the part of the artist, and all three require an informed audience, or at least an audience that is willing to devote time and effort to deciphering the various images and messages. It is somewhat unfortunate, therefore, that these complex works of art and education are not accompanied in every instance by written or oral texts, for the murals are illustrations in the very best sense of the word and should be treated as such.

Of special interest is the fact that Jackson's recent murals have much in common with the great murals of the depression years, when artists, often working under federally sponsored work relief programs, were painting large-scale murals in post office buildings, schoolhouses, city halls

and statehouses, libraries, and other public buildings in towns and cities across the country. The themes they chose were most often rendered in a representational style and related to the history or life-style of the particular community. Having large-scale pictures to remind people of their common ground was thought to generate strong social cohesiveness, yet not everyone understood fully the thematic content. Many people came to depend on local historians, schoolteachers, building employees, and the like to answer their questions and broaden their understanding of the themes treated.

An appreciable number of the murals from the 1930s and early 1940s remain with us and are regarded as significant historical artifacts: for example, Thomas Hart Benton's series of murals in the Missouri State Capitol; John Steuart Curry's well-known John Brown series in the Kansas State Capitol; and, among the very best preserved, the giant mural series on "The Story of the Recorded Word" that was painted in 1938–40 by the noted artist Edward Laning on the walls and ceiling outside the reading rooms of the main building of the New York Public Library. Yet it would be accurate to say that most of the people who see these murals today are quite bewildered by the figures portrayed and cannot, without accompanying texts of some sort, truly understand or appreciate the inspiring stories that unfold before their eyes.

Jackson's three recent murals are not only stylistically and thematically reminiscent of the great depression-era murals but also conceptually similar. He, too, seems to be advocating a return to regionalism—echoing his own call from earlier in his career when he was a newly appointed member of the fine arts faculty at the University of Illinois. It is interesting, and of some significance, that he appears ready to assume an active role in the revival and development of the mural tradition, with its emphasis on the social and cultural interests of specific groups.

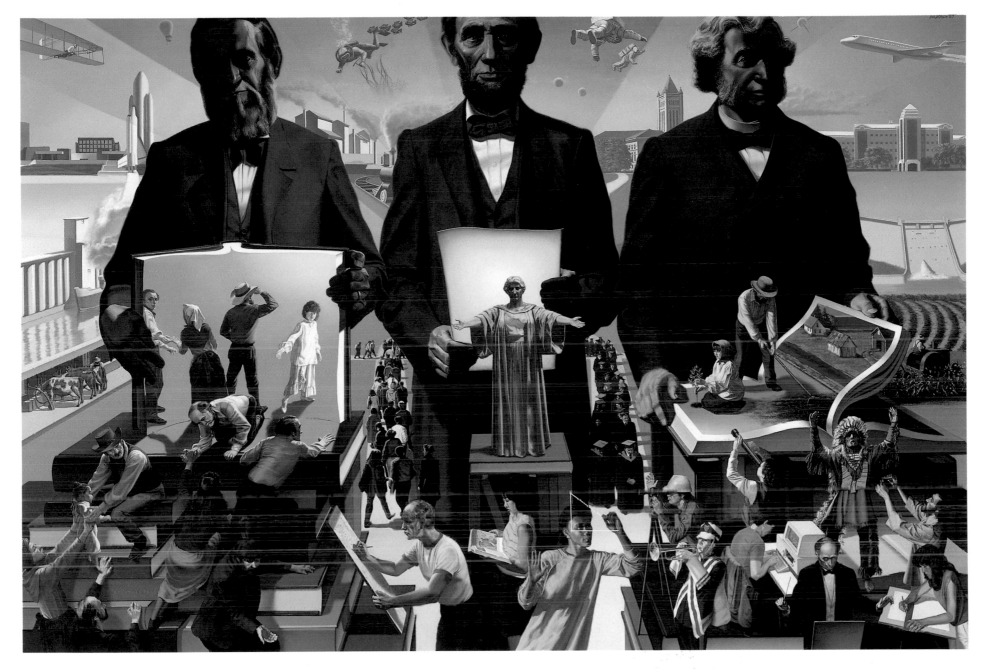

82. *We the People: The Land-Grant College Heritage, 1986–87*

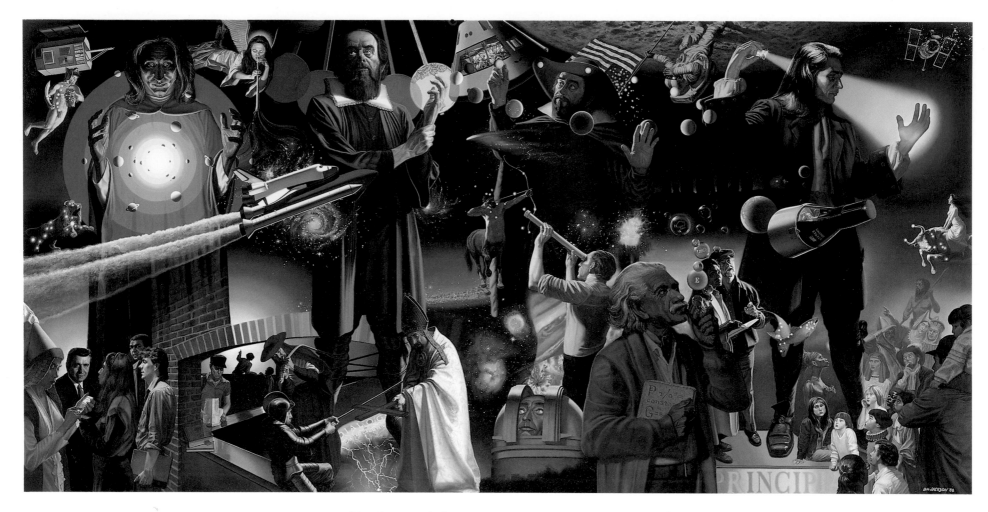

83. *Cosmic Blink, 1988–89*

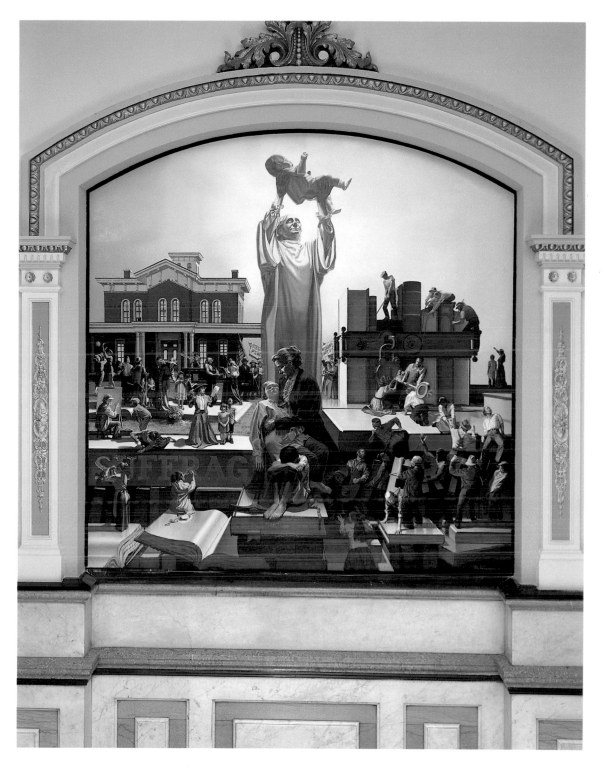

84. *The Key,* 1988–89

9

Conclusions

The foregoing chapters have surveyed the stylistic and technical development of Billy Morrow Jackson's art, beginning with his early black-and-white woodblock prints, executed in Mexico in 1949 and 1950, and ending with the three large murals he painted in the late 1980s. We have seen how the abstractionist idiom of the 1950s momentarily took command of his imagination during a brief yet thoroughly rewarding period that served him well by furnishing a deeper understanding of the geometry of form and space and of the controlled use of abstract light as both an agent of illumination and an autonomous compositional entity. We have also witnessed his journey into the visual world of nature, where he discovered the new realities and new possibilities that eventually formed the core of his artistic treatment and ultimately determined the character of his impressive landscape series, his interior views, and his powerful cityscapes.

For purposes of discussion, Jackson's work has been divided into a number of arbitrary, often overlapping categories: landscapes with and without human figures, experimental combinations of natural forms, studies of light variants, interior views, cityscapes, visual statements of social protest, and large murals. While these cover the vast majority of his compositions, in no sense are they all-inclusive. He has, in addition to the works discussed here, produced a wealth of quite handsome oils and watercolors, including seated nude studies, exotic floral still lifes, outdoor scenes from

Martha's Vineyard, where he has maintained a summer studio for many years, and historical portraits as well as portraits of children and adults, which convincingly demonstrate his capacity for keenly interpreting individual personalities.

Certain distinguishing characteristics are manifested in all of Jackson's work, perhaps the most significant of which is his intelligent, enviable use of light to create drama and achieve compositional unity. His skill in this area is quite evident in his interior views and in his landscapes and cityscapes, where he takes free license, allowing color to play wherever it must to achieve the desired effects of light. Metaphorically speaking, we might say that light is his medium, and he grants it complete autonomy whenever it is appropriate and meaningful to do so.

While Jackson's use of light effectively contributes to a sense of all-inclusive space and of spatial balance within the pictorial limits of each composition, he also employs the more conventional technique of controlling formal geometry by stretching pictorial space and allowing it to flow toward us, even as it pulls us into the picture. Supportive aids such as tire ruts or twisted snow fences—which, over the years, have become something of a cliché but are nevertheless engaging touches that never go unnoticed—direct our attention to specific elements or draw us deeply into the composition. Equally significant is his use of reflective surfaces—for example, highly polished floors, puddles of water, mirrors, storefront windows, or a complex arrangement of angled glass walls—to amplify internal compositional space and sometimes introduce an ambiguous interplay

between the interior and exterior of the painting itself. At the same time, these reflective surfaces function to bring into the pictorial space various images that, from a conceptual standpoint, are situated outside the painting in the viewer's space.

Perhaps Jackson's most unusual means of effecting a dynamic spatial relationship is his depiction of one or more human figures staring directly out from the canvas, as though observing us or some event in which we are participants. This serves not only to link the physical and psychological spaces of the painting with those of the spectator, but it creates a somewhat eerie, unsettling mood—as in *Downtown, Moments, and Reflections,* which involve us (directly or indirectly) in certain unsolved problems from the past.

Surely, one of the most impressive characteristics of Jackson's work is his meticulous rendering of detail, not to entertain us or to furnish nostalgic escape from reality but rather to heighten our vision and deepen our understanding. Through his intervention, we are given the opportunity to see so much that we might otherwise ignore. As the distinguished art historian E. H. Gombrich has stressed, it is often through paintings that we learn to see reality.[30] If there is any doubt as to the merit of this premise, we need only observe and experience Jackson's paintings. Every brushstroke records the fact that his is a keen eye and that each of his observations has been carefully filtered through the eye of his mind.

Throughout his career, Jackson has intentionally introduced ambiguity into many of his paintings, both formally and thematically, in a wide variety of ways. He stretches and shrinks distance at will and intensifies the dynamics of pictorial space by playing a warm light against a cool one or by introducing multiple light sources—some direct, such as open windows; others indirect, such as reflective surfaces. For the purpose of communicating ideas at more than one level of understanding, he frequently introduces equivocal references—for example, with words advertising drugs and sundries on the rear of an old building in *Downtown,* or simply by his choice of titles, as in *Reading, The Union,* or *Station.* Perhaps his most ambiguous statements are made via multiple reflections, whereby the viewer is challenged to sort out the objects reflected from their own reflections. Many of his larger compositions also contain an air of mild suspense, as when the gestures of his figures, as well as their perplexing facial expressions, lead us to believe that something is about to happen, or that we are being watched. Yet in all cases we are given no clear-cut clues for interpreting these intended meanings, which only adds to our uncertainty even as it intensifies our urge to search deeply into the life of the painting to discover its hidden messages.

One recurring metaphor in Jackson's paintings involves the passage of time, which is introduced in a number of interesting ways. In *Moments,* for example, a man hastily crosses the street while looking at his wristwatch. In works such as *Class of '64, Before My Time,* and *The Roomer,* we are made keenly aware of time, and of the changes it brings about, by the old buildings and building appointments. Another approach Jackson takes— beginning with *Moments* and in many of his later major works—is to juxtapose the past and the present, which suggests both the everyday intersection of time within the social setting and the collision of major time periods and their opposing social correlates. With the latter approach he creates a fantasy world that often lies on the periphery of surrealism.

A strong humanitarian bent has understandably led Jackson to introduce a dimension of social awareness into his work, beginning with the woodcuts, etchings, and lithographs executed in the early 1950s after his stay in Mexico. His use of social commentary became far more explicit, and in some instances stridently candid, in 1962–64, when his theme was civil rights, and only slightly less so in 1965, when he chose to comment on environmental pollution. Since the late 1960s, he has introduced obvious political and social references into his works, for the most part in the guise of visual statements about human disappointments and frustrations. However, in all cases, except for the civil rights pieces, these references are subtle and are clearly subordinated to aesthetic content. Dominance of the aesthetic factor is displayed in such works as *Daily News, Main Street,* and *Downtown,* even though the social message of each is direct and inescapable to the sensitive viewer.

An underlying classical structure is found in most of Jackson's work, yet the mood he creates is essentially romantic. Both his technique and his style, though completely contemporary, demonstrate a definite affinity with many of the traditions of nineteenth-century art. The carefully measured elements, regardless of subject, the pervasiveness of light, and, most especially, the quiet, stable horizon line of his landscapes are all reminiscent of the nineteenth-century American luminist painters. Moreover, the immaculate rendering of even the most minute detail, the use of windows or reflections to amplify space and escape confinement, the characteristic narrative quality that demands that his paintings be "read," and the introduction of graffiti or newspaper headlines to reinforce meaning—these are all common features of the nineteenth-century pre-Raphaelites in Britain and, to some extent, the New Path Ruskinians in America who actively clamored for what they called "truth in art."[31]

Most certainly, there is a common thread that passes through all of Jackson's paintings and drawings, linking the early works with those that were executed only yesterday. He has never blindly followed a prescribed version of any painterly style, nor has he ever shifted abruptly—even in the mid-1950s—from one style to another. Rather, his work has *evolved* over the past four decades, ever mindful of where it began and where it might still go. Clearly, Jackson allies himself with no group, no school, no ism.

Because his work is so very precise and his forms so meticulously rendered, viewers are often mesmerized by what they behold, inevitably leading them to categorize Jackson as a "realist." This is unfortunate, though inevitable and fully understandable, especially in view of the large group of New Realists who have come on the scene during the last decade or so. For example, Ben Schonzeit's completely balanced compositions built around one small segment of his field of vision are truly exciting paintings of things that are physically present and can certainly be seen yet would generally be ignored but for his unorthodox compositional approach. To some extent, the same is true of Robert Bechtle, who largely de-emphasizes competitive elements within his field of vision so as to focus attention exclusively on the object he has chosen to explore and record on canvas.

As a group, the New Realists are without doubt technically quite proficient. Certainly, one of the most prominent is Robert Cottingham, whose

works derive largely from techniques of commercial draftsmanship used in advertising. Sometimes these realists, including Cottingham, depend heavily on color photography and in the end produce works that are so exact and so clean that they smack of scientific sterility and, lacking the human touch, may seem cold and lifeless. Yet those works nevertheless meet the criterion of "true" reality as something known through the phenomenal world of the senses.[32]

While criticisms of the New Realists are voiced in terms of their work being cold and depersonalized, such criticisms by no means apply to all of them, for there are a number of artists of the contemporary realist school, like Sidney Goodman, Aaron Shikler, and, in many of his works, Gregory Gillespie, who have successfully captured truly humanistic feelings on a par with artists of the past. Moreover, they regard a personal sense of humanity as an essential ingredient in any work of art. Often, these people resent being classified as realists since they do not wish to be regarded as imitationists or copyists—and that is what the term *realism* frequently suggests. Billy Morrow Jackson is one of these artists, and his comments about realism are telling: "Laymen and painters as well attach dubious criteria to the term Realism, the more obvious one being that the artist emulates or imitates that which is there before him, the way it is, and purports to transfer that, in a two-dimensional facsimile sense, to the surface of his canvas or panel; a concept that sublimates or diminishes the creator while ironically enhancing the process."[33]

Jackson has apparently always found joy and excitement and stimulation in nature, yet his compositions transcend nature—which true works of art must do. As an artist, his accomplishment is his ability to change significantly what he sees into something that allows us to see more fully and more clearly and to feel more deeply. Even though the individual images we discover in his paintings relate to objects in the real world, those images, regardless of the degree of formal or thematic distortion, emerge as transformations of his mind. As with all works that can honestly be classified as creative art, when we encounter works such as Jackson's, and when we view them carefully and critically, we unavoidably begin to appreciate what art really is. And it is then that we discover that images of sight are registered on the retina of the eye but that it is in the mind of the artist that a work of art originates.

Appendix

Procedures in Painting

Billy Morrow Jackson

I would like to thank my wife, Siti-Mariah, for her assistance in finding much of the reference material, written and visual, that went into the making of this book. Beyond that I am indebted to Siti-Mariah for the long hours spent in the library gathering information that helped fortify the concepts of my last three murals.

I require a great deal of preparation before applying oil paint to a panel. Many compositional ideas are considered before arriving at one that finally supports and sets the acts of painting in motion. Uppermost in my mind is a graphic feel for the final mood or expression of the painting, and every move I make should, mistakes and emendations aside, lead me closer to that end. The myriad problems of composition and other fundamental needs are dealt with first as a line concept, as a linear organization of surface and deep space. This is the real battleground and very crucial to the painting, because every development after that hinges on the success of these initial decisions.

Having resolved the linear composition on tracing paper, I then transfer the drawing to a gessoed Masonite panel and either reinforce the drawing with waterproof black ink or spray the transferred image very lightly with retouch varnish to prevent it from dissolving when it comes in contact with the paint.

From this point on, the development of dark and light patterns is emphasized. Keeping the expression of the total painting in mind, I paint a small area almost to completion in order to sense or find the range of lightest light through darkest dark. This understanding affords a constant source of reference for all the dark and light passages and for color control. In turn, my color discipline becomes one of warm and cool relationships, and within that concept the pattern and mood are carefully orchestrated until the piece is completed.

My basic palette, though limited, allows for infinite variation in color and value control: Titanium-zinc White, Cadmium Yellow Medium, Cadmium Orange, Cadmium Red Medium, Rose Red or Alizarin, Burnt Umber, Ultramarine Violet, Ultramarine Blue, Cobalt Blue, Cerulean Blue, Permanent Green, and Viridian. My choice of painting medium is one-third Damar gum varnish (heavy), one-third sun-thickened linseed oil, and one-third rectified turpentine, which I use for thinning paint, glazing, and preparing the gessoed surface for wet-in-wet painting. I apply paint with a variety of sable brushes, including Brights, Rounds, and Fan Blenders. To a lesser degree I use bristle Flats, and my painting knives are also invaluable tools for scumbling, certain detailing, and special glazing effects.

When painting with watercolors, I generally follow the same procedures I use for oils, namely, careful preparation to ensure authority over the medium. Ideally, I am after a picture that is a painting first and, incidentally, a watercolor. My watercolor palette is similar to that used for oils, with the following additions: Sap Green, Hooker's Green, and Payne's Gray. Sable watercolor brushes, mainly Brights and Rounds, a small bristle Flat for scrubbing out small areas, a knife for scraping and scratching, and Maskoid are indispensable. I use a handmade 300-pound textured paper.

The Illinois prairie, cityscapes and street scenes, and interiors continue to excite me and comprise the content found in most of my work. My previous studio, a room in an old house, has

The artist at work in his university studio. Photograph by Charles Mercer.

been the subject of several of my paintings, and although I have since moved, the interiors of that structure still intrigue me. *Ten O' Nine*, in fact, was done two years after I had moved from the old studio. The stairwell there, the incredible warm light that passed through the yellow shades and illuminated the whole area, were irresistible to me, and I finally brought that into my university studio in *Ten O' Nine*. Later on, I worked on the compositional drawing of the same stairwell looking upward from the ground floor. That painting, with its single figure—a girl with a book—was originally titled *What Is the Time?* but later became the painting *Reading*, at present in the permanent collection of the Wichita Art Museum.

Ten O' Nine took nearly a year to complete, and it had lingered at the fringes of my mind for several years before I actually started to work on it. Many preliminary compositions were roughed out—and discarded or built upon—in the studio, or sketched on the backs of envelopes or on paper napkins while I was out having coffee, or in the classroom on sketchpads, whatever. Once the painting took shape in my mind, I worked out to scale a line drawing that embraced composition, perspective, proportion, and vital details necessary to the reality of the painting. Finally committed

to the basic idea, I spent as much as a month to six weeks on the drawing structure before ever touching paint to the surface. I also developed comprehensive color layouts that included the general dark and light passages. These were *working* sketches and were meant for that purpose alone; they were not art for art's sake and probably could be understood and interpreted only by the artist. As any of my paintings progresses, I find it necessary to do more detailed drawings for unforeseen changes, corrections, or something new that I think might enrich the piece.

When I finally brush paint onto a panel, I apply it direct and wet-in-wet. I first wet the surface with a thin layer of the medium, the purpose of which is to lubricate the gessoed panel, thereby allowing paint to adhere to it with a stronger bond, which in turn allows for greater facility in handling the paint. Because of the properties of the medium, this also ensures a longer lasting luster to the paint and to a large degree prevents the drying out and subsequent flatness of color that usually accompanies a dry, unprepared surface. In a year and a half, or after the painting is thoroughly dry, I apply a protective coating of Soluvar satin finish, specifically two-thirds mineral spirits to one-third Soluvar. In years to come, should cleaning or revarnishing be necessary, one simply removes the coating with mineral spirits and repeats the process.

When using color, I am constantly balancing complementary relationships; that is, a warm-cool interplay as the hues move up and down the value scale. For instance, Ultramarine Blue and Cadmium Orange mixed sensitively can give an intense neutral dark. If the blue, or cool color, dominates the orange, the result is a cool, or bluish, dark; conversely, if the orange dominates the blue, the result is a warm, or orangish, dark. This kind of control becomes more evident if the same approach is used as one moves from darkest darks to lightest lights by adding white. Careful control is imperative in mixing color this way, and especially so when adding more complements to one's palette. A good exercise for the novice painter is to take Ultramarine Blue and Cadmium Orange and, by selective mixing, see how many warm-cool colors can be discovered, from darkest dark to lightest light. Doing this with other sets of complements as well will aid in the development of an acute color sensitivity and dominance over color and value. Chances are, as in my work, that black paint will not be needed on the palette.

An earlier, expanded version of this essay appeared as "Procedures in Painting" in *Palette Talk*, no. 41, © 1979 by M. Grumbacher, Inc.

Preliminary sketches for *Station*. The ultimate success of any painting depends on visual research and on preparatory and exploratory drawings—the real battleground for the creative struggle and the structural anatomy on which the final expression of the painting rests.

Notes

1. Lon Allan Jackson was born on January 21, 1952; Robin Todd, on January 22, 1956; Aron Drew, on March 7, 1957; and Sylvia Marie, on September 3, 1964. Billy and Blanche Jackson were divorced in 1988. He married artist Siti-Mariah that same year.

2. Billy Morrow Jackson, "A Report on a Thesis Painting Entitled 'Duet'" (Urbana: Graduate College of the University of Illinois, 1954), pp. 2–7.

3. Billy Morrow Jackson, "Proposed Project: The Central Illinois Landscape as Subject Matter for Contemporary Art . . . Extended and Amplified in Conjunction with the Human Figure" (Urbana, Ill., 1958), pp. 1, 2.

4. Ibid., p. 2

5. Various, often diametrically conflicting interpretations of this painting were voiced within the first year or two after it was completed and publicly exhibited. The deceased was said to be either an artist, an art dealer, or an allegory for an art movement disapproved by certain artists; the figure of Jackson was seen as a self-satisfied art dealer or as an artist celebrating the end of a movement. When the painting was on view at the Art Mart Gallery in Clayton, Missouri, in 1960, George McCue, the *St. Louis Post-Dispatch* art critic, interpreted the title to mean "after death" and described the scene as "an art gallery, in which a painter lies in an open coffin, placed before a wall hung with paintings. The dealer stands with one hand resting, in a proprietorial manner, on the flowers that are on the casket." McCue further stated that "Jackson painted a fellow faculty member as the artist, himself as the dealer." See George McCue, "Billy M. Jackson Show at Art Mart," *St. Louis Post-Dispatch*, November 4, 1960.

In 1961, *A.D.* was included in an exhibition at the Butler Institute of American Art in Youngstown, Ohio. Curator and local art critic Clyde Singer wrote to Jackson on July 17, 1961, that many museum visitors had interpreted *A.D.* to mean "the death of art." Jackson responded to Singer on July 19, 1961: "I must admit that my intention was to equivocate . . . to engulf the viewer with flexible or plastic connotations, so to speak." He also reported what Fred Conway, his former teacher at Washington University, had amusingly commented to him: "Glad to see you're fighting back. . . . Somebody finally buried the G.D. dealer!" Singer replied on

August 8, 1961: "your painting is a crowd stopper, and that too is a rare thing these days. . . . Again thanks, good painting, knockem [sic] for a loop." See also Clyde Singer, "Death Scene in Butler Show Arouses Curiosity," *Youngstown Vindicator,* August 6, 1961, p. A-16.

6. Jackson, "Proposed Project," p. 1

7. Unfortunately, the whereabouts of *Winter Walkers* is unknown and the only available photographic print of the painting is of very poor quality. The original is a 36 in. x 66 in. oil on panel, painted in 1961–62.

8. *Class of '64* was exhibited by the Kenmore Galleries in Philadelphia and was included in numerous exhibitions across the country. It also was the recipient of many awards and, as indicated in the text, was used as the central architectural feature in Jackson's *Philo Bound,* painted in 1965. *Class of '64* was in the collection of Bruce Llewellyn of New York City at the time of its destruction by fire in 1979 and is known today only from black-and-white prints and small color snapshots.

9. *Eve* is unquestionably one of Jackson's most important works from before his pure landscape period. Acquired in 1970 by the National Gallery of Art on the recommendation of Dr. H. Lester Cooke, curator of painting, it has been loaned repeatedly to American embassies in numerous European locations and, unfortunately, is only rarely exhibited in America.

10. Letter of November 17, 1966, from BMJ to Dean Daniel Alpert, Department of Art, University of Illinois, in which Jackson officially applied for associate membership in the Center for Advanced Study.

11. For a discussion of several early prairie paintings by Jackson, as well as aspects of his technique, see Glenn R. Bradshaw, "Jackson's Prairie," *American Artist* 33 (no. 5, May 1969): 60ff.

12. The development of Jackson's pure landscape style, as outlined in chapter 4, is understandably limited to principal works that have been identified. Because most artists seldom follow an absolutely straight line in their development, and in view of Jackson's frequent experiments, it is highly likely that he produced study pieces before 1968 that included landscapes without human forms and without strong, close-up

architectural emphasis. Assuming that this is the case, such pieces must have been trial works rather than serious undertakings and did not establish a specific direction at the time. Regarding the use of early prints as experimental prototypes see Howard E. Wooden, "B. M. Jackson: Prints of the Early Period," *Journal of the Print World* 13 (no. 2, 1990): 16ff.

13. *Monee* was also known as *Tolono* during the period soon after it was painted.

14. See Jackson's watercolor titled *Prairiescape #5* (fig. 53).

15. It is noteworthy that, while in Palma, Jackson executed many watercolors depicting marine subjects. These attracted widespread interest once he returned to America.

16. Inasmuch as this painting was completed in 1968, quite likely the visual reference is to the defeat of the Democratic party in that year's elections.

17. This work, completed in December 1973, was commissioned in 1972 by the Sheldon Swope Art Museum in Terre Haute, Indiana, under a matching grant from the National Endowment for the Arts, a federal agency. The site selected by the artist was a location undergoing urban renewal in downtown Terre Haute. The entire composition was determined solely by the artist, without interference or suggestions by any of the museum staff or board members. *Downtown* was included in the invitational exhibition titled "Man and Environment" at the 1974 World's Fair in Spokane, Washington.

18. *Moments* was commissioned by the Wichita Art Museum, Wichita, Kansas, in 1976 and completed in 1977. The work was a gift to the museum from the Volunteer Alliance of the Friends of the Museum on the occasion of the completion of a new museum building which opened to the public in 1977. The site selected by the artist was a location in downtown Wichita, and the entire composition was completed without interference or suggestions by the museum staff or board members. All of the architectural features included do indeed exist, though not in the locations shown in the painting. The landscape scene on the billboard is of the well-known Flinthill region of east-central Kansas. For a more detailed discussion of this painting, see Howard E. Wooden, "Wichita Moments," *ARTgallery* 20 (no. 6, August/September

1977): 69ff. See also Howard E. Wooden, "Billy Morrow Jackson—Figures in a Landscape," *U.S. ART* 8 (no. 4, May/June 1989): 44ff.

19. See Mary King, "Jackson Art at Gallery," *St. Louis Post-Dispatch*, November 8, 1968, p. 3B.

20. Prototypical of this barely visible figure is *The Watcher No. 2*, one of a short series of experimental multimedia drawings executed by Jackson some thirteen years earlier, in 1963. *The Watcher* is a self-portrait, but the physical features are indistinct, indeed almost totally lost in deep black shadows. See Margaret Harold, *Book II: Prize-winning Graphics* (Fort Lauderdale, Fla.: Allied Publications, 1964), p. 35.

21. For a rather detailed analysis of the compositional development of this work, see Klaus Wirz, "A Breakthrough in the Development of Billy M. Jackson's *Station*," *Visual Arts Research* 11 (no. 2, Fall 1985): 1–20. For an exhibition review, see Jo Ann Lewis, "Jackson's 'Station' Break," *Washington Post*, October 28, 1982, p. D-7.

22. See Robert Schulman, "The Artist and the Space Shuttle," *Air and Space* 5 (no. 4, Summer 1982): 13ff.; Steve Alexander, "Columbia on Canvas," *Illinois Technograph* 97 (no. 5, April 1982): 6ff.

23. Stewart L. Udall, "Land, Air, Water: Our Abused National Treasures," *St. Louis Post-Dispatch* (a special supplement titled "Challenges and Choices: The State of Man in an Anxious Era"), September 26, 1965, pp. 34–36.

24. Two thousand sets of posters, in color, were produced by a printing firm in Chicago and sold for ten dollars per set, with all proceeds going to Civil Rights Aid in the South and to the Congress of Racial Equality. The eight posters were titled: *X's Diary, Stars and Bars, The Infernal Triangle, The Sovereign Scarecrow, The Prometheus Ballet, The Tattooed Man, The Right Society,* and *Merry Kristmas and Philadelphia*.

25. Peggy Robinson, "Artist Provokes Controversy," *Jet* 27 (no. 3, October 1964): 46ff.

26. Quotations are from a two-page single-spaced introductory essay titled "A Graphic Response to the Civil Rights Drama" prepared by Jackson and read before the faculty forum on October 29, 1965. After the reading, slides of the

drawings were shown and an open discussion was held concerning the artist's philosophy and his work. The same program was presented at numerous other locations in the Midwest through 1966.

27. See "Fair Housing Decals to Be Distributed," *The News-Gazette* (Champaign-Urbana, Ill.), February 14, 1965, p. 24

28. A twelve-page descriptive, well-illustrated booklet on *We the People* was prepared by Laurie A. McCarthy and privately published in October 1987 on the occasion of the unveiling of the painting during the Fifty-second Annual Meeting of the University of Illinois Foundation. The booklet was distributed to members of the Foundation and its Presidents Council donor recognition organization.

29. For an authoritative account of the work of Jane Addams, see Allen F. Davis, *American Heroine: The Life and Legend of Jane Addams* (New York: Oxford University Press, 1973).

30. E. H. Gombrich, *Art and Illusion* (Princeton: Princeton University Press, 1969), pp. 311ff.

31. The Pre-Raphaelite dedication to meticulous precision as a means of expressing truth in painting is discussed widely in the literature on the British Pre-Raphaelite movement. See in particular George P. Landow, *William Holman Hunt and Typological Symbolism* (New Haven: Yale University Press for the Paul Mellon Center for Studies in British Art, 1979). For information on the New Path Ruskinian movement in America, see Linda S. Ferber and William H. Gerdts, *The New Path* (New York: Schocken Books for the Brooklyn Museum, 1985), esp. pp. 11–36.

32. See W. H. Auden, "The Real World," *New Republic*, December 9, 1967, pp. 25ff.

33. Quoted in Norman Geske, *Things Seen* (exhibition catalog published jointly by the Sheldon Memorial Art Gallery, Lincoln, Nebr., and the Mid-American Arts Alliance, Kansas City, Mo., 1978), p. 80.

List of Figures

A Partial Listing
of One-Man Exhibitions

1952 Peoples Art Center, St. Louis, Missouri
1956 Millikin University, Decatur, Illinois
 Art Mart-Clayton Gallery, St. Louis, Missouri
1958 Art Mart-Clayton Gallery, St. Louis, Missouri
1960 Art Mart-Clayton Gallery, St. Louis, Missouri
1962 Art Mart-Clayton Gallery, St. Louis, Missouri
 Arnold Finkel Gallery, Philadelphia, Pennsylvania
1963 Banfer Gallery, New York, New York
 Antique Gallery, Champaign, Illinois
1964 Banfer Gallery, New York, New York
 Krannert Gallery, University of Illinois,
 Urbana-Champaign, Illinois
 Kenmore Galleries, Inc., Philadelphia, Pennsylvania
1965 Hillel Foundation, Champaign, Illinois
1966 Lehigh University, Bethlehem, Pennsylvania
 Premier Art Gallery, Springfield, Illinois
 Menemsha Gallery, Martha's Vineyard,
 Massachusetts
 St. Louis Gallery, St. Louis, Missouri
 Jane Haslem Gallery, Madison, Wisconsin
 State College, Springfield, Missouri
 Decatur Art Center, Decatur, Illinois
1967 Four Arts Gallery, Evanston, Illinois
 Lakeview Center of Art, Peoria, Illinois
1968 Krannert Art Museum, University of Illinois,
 Urbana-Champaign, Illinois
 Martha's Vineyard National Bank, Chilmark,
 Massachusetts
 Painters Gallery, St. Louis, Missouri

1969 Jane Haslem Gallery, Madison, Wisconsin
1970 Sheldon Swope Art Museum, Terre Haute, Indiana
 Jane Haslem Gallery, Washington, D.C.
1971 Jane Haslem Gallery, Washington, D.C.
 Jane Haslem Gallery, Madison, Wisconsin
1972 Martha's Vineyard National Bank, Chilmark,
 Massachusetts
1973 Jane Haslem Gallery, Washington, D.C.
1975 Sheldon Swope Art Museum, Terre Haute, Indiana
1976 Jane Haslem Gallery, Washington, D.C.
1980 Wichita Art Museum, Wichita, Kansas
 University of North Dakota Art Gallery,
 Grand Forks, North Dakota
1981 Sheldon Swope Art Museum, Terre Haute, Indiana
 Parktower Gallery, Peoria, Illinois
1982 Jane Haslem Gallery, Washington, D.C.
1983 Shepherd College, Shepherdstown, West Virginia
 Parkland College, Champaign, Illinois
1984 Jane Haslem Gallery, Washington, D.C.
1986 Jane Haslem Gallery, Washington, D.C.

A Partial Listing of Public and Corporate Collections

Many of Billy Morrow Jackson's works may be viewed in the following public and corporate collections:

AT&T, New York, New York
Artists' Guild, St. Louis, Missouri
Boston Public Library, Boston, Massachusetts
Bradley University, Peoria, Illinois
Busey Bank, Urbana, Illinois
Butler Institute of American Art, Youngstown, Ohio
Champaign National Bank, Champaign, Illinois
Connecticut Academy of Fine Arts, Hartford, Connecticut
Duke University, Durham, North Carolina
Environmental Protection Agency, Washington, D.C.
Evansville Museum of Arts and Sciences, Evansville, Indiana
FEDCO Foods Corporation, Bronx, New York
Field Enterprises Educational Corporation/World Book Encyclopedia, Chicago, Illinois
First of America Bank–Champaign County, Illinois
Governors State University, Park Forest South, Illinois
Hunterdon County Art Center, Clinton, New Jersey
Illinois State Capitol, Springfield, Illinois
Illinois State Museum, Springfield, Illinois
Joslyn Art Museum, Omaha, Nebraska
Knoxville Museum of Art, Knoxville, Tennessee
Krannert Art Museum, University of Illinois, Urbana-Champaign, Illinois
Lakeview Center of Art, Peoria, Illinois
Library of Congress, Washington, D.C.
Lincoln College, Lincoln, Illinois
Martha's Vineyard National Bank, Vineyard Haven, Massachusetts
Metropolitan Museum of Art, New York, New York
Mississippi Art Association, Jackson, Mississippi
Museum of the Legion of Honor, San Francisco, California
NASA Art Program, Washington, D.C.
National Gallery of Art, Washington, D.C.
National Museum of American Art, Washington, D.C.

New York Hilton Hotel, Empire Suite, New York, New York
Norfolk Museum, Norfolk, Virginia
Northern Illinois University, DeKalb, Illinois
Ohio University, Athens, Ohio
Parkland College, Champaign, Illinois
Philadelphia Free Library, Philadelphia, Pennsylvania
Rose-Hulman Institute of Technology, Terre Haute, Indiana
Sheldon Memorial Gallery of Art, University of Nebraska, Lincoln, Nebraska
Sheldon Swope Art Museum, Terre Haute, Indiana
Sioux City Art Center, Sioux City, Iowa
Society of American Graphic Artists, New York, New York
Springfield Art Museum, Springfield, Illinois
Texas Western College, El Paso, Texas
Union League Club of Chicago, Chicago, Illinois
University of Illinois, Administration Building, Urbana-Champaign, Illinois
University of New Hampshire, Durham, New Hampshire
U.S. Department of the Interior, Bureau of Reclamation, Washington, D.C.
Washington State Capitol, Olympia, Washington
Wichita Art Association, Wichita, Kansas
Wichita Art Museum, Wichita, Kansas

Biographical
Outline

1926 Born February 23 in Kansas City, Missouri
1938 Moved with family to St. Louis, Missouri
1940 Enrolled at Washington University in St. Louis,
 Missouri, and studied drawing under Fred Conway
1942 Enlisted in Marines and served as rifleman on
 Okinawa, Japan
1944 Honorably discharged from Marines
 Enrolled again at Washington University and
 studied under Max Beckmann
 Met Philip Guston and Paul Burlin
1949 Awarded B.F.A. degree
 Married Blanche Trice of St. Louis
 Left for Mexico with wife
 Designed a series of woodcuts and linocuts on
 aspects of Mexican life, completing some of the
 prints while in Mexico, others during the several
 ensuing years
1950 Left Mexico late in the year and settled in Los
 Angeles, California
1952 Birth of first child, Lon Allan, on January 21
 Stayed briefly in St. Louis en route to Champaign,
 Illinois, to begin graduate study at the University
 of Illinois
 First one-man exhibition: Peoples Art Center, St.
 Louis, Missouri
1952–54 Actively pursued printmaking, especially
 lithographs and etchings, as well as painting
 Met and studied briefly with Abraham Rattner, a
 visiting member of the university faculty
 Stylistic emphasis was on expressionist work
 Studies culminated in the production of thesis
 painting titled *Duet*
1954 Awarded M.F.A. degree
 Received faculty appointment as an instructor in
 the Department of Fine Arts at the University of
 Illinois, beginning in the fall of 1954

1954–56 Evidence in Jackson's stylistic development of
 Rattner's lingering influence, yet Jackson's interest
 steadily shifted toward naturalistic representational
 work as he systematically pursued exploratory
 studies of natural phenomena, initially applied to
 prints and thereafter to paintings
1956 Birth of second child, Robin Todd, on January 22
 One-man exhibitions: Millikin University, Decatur,
 Illinois; Art Mart-Clayton Gallery, St. Louis,
 Missouri
 Awarded the Mrs. A. W. Erickson Prize for a
 meritorious print (a color woodcut entitled *Prairie
 Blush*) at the 40th Annual Exhibition of the Society
 of American Graphic Artists, New York, New York
 Entered major competitive graphic exhibitions
 (national and regional) throughout the ensuing
 decade and received wide recognition and awards
 for prints and drawings
1957 Awarded the Mrs. A. W. Erickson Prize for a
 meritorious print (an etching entitled *The Offering*)
 at the 41st Annual Exhibition of the Society of
 American Graphic Artists, New York, New York
 Birth of third child, Aron Drew, on March 7
1958 Represented in the 16th National Exhibition of
 Prints, sponsored by the Library of Congress,
 Washington, D.C.
 One-man exhibition: Art Mart-Clayton Gallery, St.
 Louis, Missouri
 Completed *The Interloper*, a pivotal painting in the
 early landscape series, and exhibited it in December
 in the University of Illinois Faculty Art Show
 Technical and stylistic features characteristic of
 Jackson's more mature work, as well as his preferred
 thematic types, developed rapidly during this year
 and throughout the ensuing decade, in connection
 with his determined explorations of light, color,
 texture, and natural form and his increasing interest
 in regionalism in painting

1959 Appointed assistant professor in the Department of Fine Arts, University of Illinois
 Represented in the U.S.I.A. "Contemporary American Prints" exhibition in Manila, Philippines, Tokyo, Japan, and Seoul, Korea
 Represented in the Library of Congress Exhibition in Esslingen, Germany
 One-man exhibition: Lincoln College, Lincoln, Illinois
 Completed the oil painting *A.D.*

1960 One-man exhibition: Art Mart-Clayton Gallery, St. Louis, Missouri

1962 One-man exhibitions: Arnold Finkel Gallery, Philadelphia, Pennsylvania; Art Mart-Clayton Gallery, St. Louis, Missouri
 Special summer appointment as an instructor in the Harmon School of Art, Palma, Majorca, Spain

1962–64 Executed and published a controversial series of civil rights drawings

1963 Appointed associate professor in the Department of Fine Arts, University of Illinois

1964 Exhibited civil rights drawings at the Banfer Gallery, New York, New York
 One-man exhibitions: Kenmore Galleries, Inc., Philadelphia, Pennsylvania; Krannert Art Gallery, Champaign, Illinois
 Birth of fourth child, Sylvia Marie, on September 3
 Executed his last print, an etching titled *Before My Time*, based on a 1964 painting of the same title; focused thereafter on painting

1965 Established summer studio-residence on Martha's Vineyard, Massachusetts

1966 One-man exhibitions: Lehigh University, Bethlehem, Pennsylvania; Premier Art Gallery, Springfield, Illinois; Menemsha Gallery, Martha's Vineyard, Massachusetts; Decatur Art Center, Decatur, Illinois; Jane Haslem Gallery, Madison, Wisconsin

1967 Appointed professor in the Department of Fine Arts, University of Illinois
 Commissioned by NASA to record events related to the space program up to and including the launch of the Saturn V rocket at the Kennedy Space Center in Florida
 One-man exhibition: Four Arts Gallery, Evanston, Illinois

1968 One-man exhibition: Painters Gallery, St. Louis, Missouri

1969 One-man exhibition: Jane Haslem Gallery, Madison, Wisconsin

1970 One-man exhibition: Sheldon Swope Art Museum, Terre Haute, Indiana

1971 One-man exhibition: Jane Haslem Gallery, Washington, D.C. (and nearly annually thereafter)
 Juror, National Scholastic Awards, New York, New York

1974 *Downtown*, executed in 1973 for the permanent collection of the Sheldon Swope Art Museum, was included in the "Man and Environment" exhibition at the World's Fair in Spokane, Washington

1975 Twenty-year retrospective exhibition of Jackson's paintings at the Sheldon Swope Art Museum, Terre Haute, Indiana

1979 Represented in the "Wichita Salutes Orleans" exhibition of contemporary American art at St. Pierre-le-Puellier, Orleans, France, presented by the Wichita Art Museum, Wichita, Kansas, in commemoration of the 550th anniversary of the liberation of Orleans by Jeanne d'Arc

1980 "Moments in Light," a retrospective exhibition of 66 Jackson works, presented by the Wichita Art Museum, Wichita, Kansas

1981 "Moments in Light," a retrospective exhibition of Jackson works, continued at the Sheldon Swope Art Museum, Terre Haute, Indiana
 Commissioned by NASA to record events related to the Columbia Space Shuttle program at the Kennedy Space Center in Florida

1983 One-man exhibition: Shepherd College, Shepherdstown, West Virginia

1987 Retired from the faculty of the University of Illinois, concluding a 33-year teaching career

1988 Divorced Blanche Trice Jackson
 Married artist Siti-Mariah in February

1989 Completed *The Key*, one of four murals by artists selected in a statewide competition, to commemorate the 100th anniversary of the Illinois State Capitol in Springfield
 Continues to reside and work in his studio-home in Champaign, Illinois

Index

Page numbers
in boldface
refer to
illustrations.

A Note on the Author

Howard E. Wooden is director emeritus of the Wichita Art
Museum, in Wichita, Kansas, where he was director from
1975 until 1989. A native of Baltimore, Maryland, he
attended Johns Hopkins University and earned a B.S. in
physics and an M.A. in art and archaeology. He has served as
chairman of the history department of the Evansville
(Indiana) Museum of Arts and Sciences, as director of the
Sheldon Swope Art Museum, in Terre Haute, Indiana, and
on the faculties of Athens College (Athens, Greece), the
University of Florida at Gainesville, the University of
Evansville, and Indiana State University. As a result of his
extensive research in the field of American art of the 1930s,
he was awarded the Gari Melchers Memorial Medal by the
Artist's Fellowship, Inc., of New York City in 1987. Wooden's
research interests focus on the field of art historical writing.
He is currently preparing an extensive text on American
painting from the era of the Great Depression.